Winslow Homer in the 1890s

Prout's Neck Observed

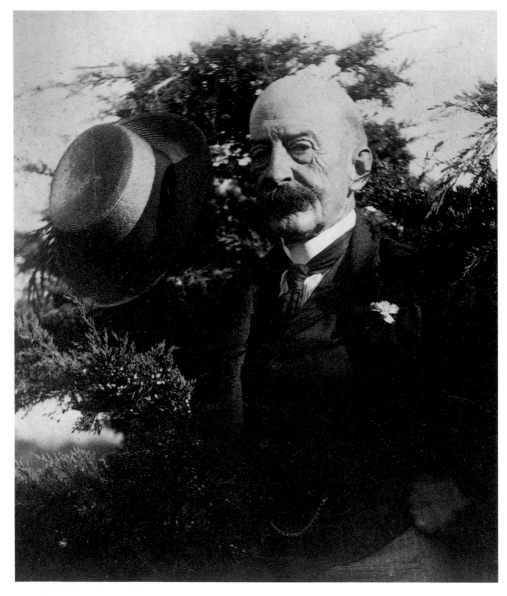

The Life that I have chosen gives me full hours of enjoyment for the balance of my life. The sun will not rise or set without my notice and thanks.

Winslow Homer
Prout's Neck, 1895

Winslow Homer in the 1890s
Prout's Neck Observed

ESSAYS BY

Philip C. Beam

Lois Homer Graham

Patricia Junker

David Tatham

John Wilmerding

HUDSON HILLS PRESS • NEW YORK
In Association with the Memorial Art Gallery of the University of Rochester

Frontispiece: *Portrait of Winslow Homer at Prout's Neck, Maine*, 1908. Silver print by Peter Juley, New York. Bowdoin College Museum of Art, Brunswick. Gift of the Homer family, 1964 .

Editor and Publisher: Paul Anbinder
Copy Editor: Andrea P.A. Belloli
Indexer: Gisela S. Knight
Designer: Gilda Hannah
Composition: Trufont Typographers, Inc.
Printed in Hong Kong

This book was published on the occasion of the exhibition *Winslow Homer in the 1890s: Prout's Neck Observed*, organized by Patricia Junker.

Schedule of the exhibition:

Memorial Art Gallery of the University of Rochester
Rochester, New York
August 18–October 21, 1990

Terra Museum of American Art
Chicago, Illinois
November 17, 1990–January 13, 1991

National Museum of American Art, Smithsonian Institution
Washington, D.C.
February 8–May 27, 1991

Sterling and Francine Clark Art Institute
Williamstown, Massachusetts
June 22–September 2, 1991

The exhibition was made possible by a grant from Mobil Foundation, Inc., and was supported with public funds from the National Endowment for the Arts, a Federal agency; and the New York State Council on the Arts. This publication was made possible by a generous grant from the Elizabeth F. Cheney Foundation. Additional funding was provided by Lois Homer Graham and two anonymous Rochester families.

Library of Congress Cataloguing-in-Publication Data

Winslow Homer in the 1890s : Prout's Neck observed : essays / by
 Philip C. Beam . . . [et al.]—1st ed.
 p. cm.
 "In association with the Memorial Art Gallery of the University of
Rochester."
 Catalogue published on the occasion of an exhibition held Aug. 18–Oct. 21,
1990, at the Memorial Art Gallery of the University of Rochester, Rochester,
N.Y.; Nov. 17, 1990–Jan. 13, 1991, at the Terra Museum of American Art,
Chicago, Ill.; Feb. 8–May 27, 1991, at the National Museum of American Art,
Smithsonian Institution, Washington, D.C.; and June 22–Sept. 2, 1991, at the
Sterling and Francine Clark Art Institute, Williamstown, Mass.
 Includes bibliographical references and index.
 1. Homer, Winslow, 1836–1910—Exhibitions. 2. Prout's Neck (Me.) in
art—Exhibitions. 3. Homer, Winslow, 1836–1910—Homes and haunts—
Maine—Prout's Neck. I. Beam, Philip C. II. University of Rochester.
Memorial Art Gallery.
ND237.H7A4 1990B
759.13—dc20 90-80948
 CIP

ISBN: 1-55595-042-6 (alk. paper)

Contents

Colorplates

Foreword

Critic and educator James Johnson Sweeney noted that "one fine painting thoroughly appreciated, like one great book well read, would have more cultural effect than a world of digests and surveys." This philosophy forms the foundation of the exhibition *Winslow Homer in the 1890s: Prout's Neck Observed*, as Patricia Junker's keen interest in, and thorough study of, *The Artist's Studio in an Afternoon Fog* has initiated new explorations into the genius of Winslow Homer.

From the outset we have felt that the Memorial Art Gallery was in a unique position to organize *Winslow Homer in the 1890s*. As a university-affiliated art museum, we have a significant responsibility to contribute to art-historical scholarship. At the same time the Memorial Art Gallery serves as the region's public art museum with a commitment to its broad, diverse audience. Certainly, *Winslow Homer in the 1890s* meets these criteria. Just as Homer's late landscape and marine paintings have helped to establish the artist's widespread popularity in this country, the exhibition and publication are important contributions to a fuller appreciation of American art. Indeed, this exhibition admirably fulfills the mandate of the gallery's founder, Emily Sibley Watson, who gave it to the citizens of Rochester for both their edification and their enjoyment.

On behalf of the board and staff of the Memorial Art Gallery, I extend sincere appreciation to the many individuals and public and private organizations who have made this exhibition possible. We also thank our sister museums for hosting the exhibition around the country: the Terra Museum of American Art, the National Museum of American Art, and the Sterling and Francine Clark Art Institute.

Finally, our thanks to the many sponsors who have made this exhibition possible, specifically, the Mobil Foundation, Inc.; the Elizabeth F. Cheney Foundation; the New York State Council on the Arts; the National Endowment for the Arts, a federal agency; Lois Homer Graham; and two anonymous Rochester families. We are grateful.

GRANT HOLCOMB
Director
Memorial Art Gallery of the
University of Rochester

Preface and Acknowledgments

At the Memorial Art Gallery we recognize that our permanent collection is a primary point of reference in our efforts to foster appreciation for the highest forms of artistic achievement. In organizing temporary exhibitions we place particular emphasis on projects that enable our audience to see signal works from our holdings in new contexts. This exhibition sprang from concentrated study of Winslow Homer's great oil painting *The Artist's Studio in an Afternoon Fog* as essential to an understanding of the artist's response to Prout's Neck, Maine, his home in the late nineteenth century. Our objective has been to bring together many of Homer's late landscapes and marine paintings to illuminate his perception of the distinctive Maine coast. We also have included documentary material that helps to explain the artist's responses to his environment. These sketches and historical photographs define the varying degrees of Homer's naturalism and artifice in his Prout's Neck work.

Although the exhibition is focused, the issues raised by it are far-reaching and wide-ranging. That we have been able to explore so many facets of Homer's life is due to the assistance we have received from several Homer authorities, each of whom has brought a different investigative approach to bear on our subject. I am indebted to all of our authors for their efforts and insights. David Tatham, Professor of Fine Arts, Syracuse University, initially encouraged me to undertake this daunting study and helped to shape the exhibition in its earliest stages. Professor Tatham also contributed much to my research and inspired me, by his own painstaking methodology, to explore new avenues. Professor Tatham introduced me to Lois Homer Graham, the artist's grandniece and a devoted historian of the Homer family. I am grateful to Mrs. Graham for her unfailing support, financial and otherwise, and for contributing to this publication her knowledge of her granduncle's little-known personal side and her understanding of his family and social life at Prout's Neck. Particular mention also must be made of the invaluable research assistance provided by Philip C. Beam, Henry Johnson Professor of Art and Archaeology Emeritus, Bowdoin College, whose 1966 monograph, *Winslow Homer at Prout's Neck*, has been the documentary basis for all subsequent examinations of Homer's work in Maine. Professor Beam has been a guiding light throughout this project, sharing his perceptions and his vast personal archive of research material and contributing the entries to the checklist of paintings and drawings. Finally, John Wilmerding, Christopher Binyon Sarofim '86 Professor of American Art, Princeton University, has been of inestimable help through his published research into various aspects of Homer's development as a marine painter. I am especially grateful to Professor Wilmerding for contributing to this study an examination of Maine's attraction for Homer and other late nineteenth-century artists.

This exhibition would not have been possible without the generous financial support of many organizations and individuals who are named elsewhere in this publication. We thank them all. The Elizabeth F.

Cheney Foundation made an early commitment to fund the publication and was thus an important catalyst for the development of the exhibition. We wish to thank Lawrence Belles, President; Howard M. McCue III, Secretary; and the other officers of the foundation for their help and to acknowledge their important and farsighted pledge to promote museum scholarship.

That we have been able to include so many "national treasures" in this exhibition is due to the generosity and support of numerous lenders. We express our deep gratitude to the directors and staffs of the participating museums and to the individual collectors for parting with major works for an extended period of time.

In making the exhibition available to audiences beyond Rochester, we have been fortunate to have the collaboration of the Terra Museum of American Art, the National Museum of American Art, Smithsonian Institution, and the Sterling and Francine Clark Art Institute. For their encouragement and assistance from beginning to end we thank Harold O'Connell, Director, and D. Scott Atkinson, Curator, Terra Museum; Elizabeth Broun, Director; Virginia Mecklenburg, Acting Chief Curator; William Truettner, Curator of Painting and Sculpture; and Karol Lawson, Curatorial Associate, National Museum of American Art; and David Brooke, Director; Steven Kern, Associate Curator of Paintings; Martha Asher, Registrar; and Mary Ann McSweeney, Curatorial Secretary, Clark Art Institute.

For their assistance with this publication, we would like to thank Paul Anbinder, President, Hudson Hills Press, and Andrea P. A. Belloli, Editor. Both Mr. Anbinder and Ms. Belloli worked closely with the manuscript and made many useful suggestions regarding the organization and presentation of material.

At the Memorial Art Gallery many of my co-workers contributed to this project. Margaret Hubbard, Director of Development, and her staff merit high praise for their fruitful efforts to gain underwriting for the exhibition, publication, and accompanying educational programs. Bernard Barryte, Curator of European Art, and Marie Via, Curatorial Assistant, aided my work immeasurably by assuming a large portion of my general curatorial duties, thus earning more thanks than I can adequately convey. Ms. Via also helped with the catalogue manuscript, and so I am doubly indebted to her. Nancy Malone, Exhibitions Coordinator, good-naturedly assisted with myriad administrative and clerical tasks. Sandra Markham, Registrar, laid the groundwork for exhibition transportation and insurance before leaving the gallery in 1989; her work was developed in an exemplary manner by Douglas Itkin, Assistant Registrar. Deborah Rothman, Public Relations Manager, with the aid of the volunteer Marketing and Communications Committee of the gallery's Board of Managers, initiated a wide-ranging public-information campaign on behalf of this project. Stephanie Frontz, Fine Arts Librarian, University of Rochester, and Janet Clarke-Hazlett, Gallery Librarian, helped with numerous research queries. Finally, Shawn Donaldson, University of Rochester '89, was a stalwart student assistant during the planning stages and helped to assemble study and publication photographs.

Outside Rochester my research benefited from the diligence and generosity of many individuals. I want especially to acknowledge the invaluable help of Laura Fecych Sprague of Portland, Maine, who has brought to light most of what we know about building by the Homer family at Prout's Neck in the last two decades of the nineteenth century. With Earle Shettleworth, Jr., Director, Maine Historic Preservation Commission, Ms. Sprague made an architectural survey of Prout's Neck which revealed important information about the work there of John Calvin Stevens and about residents who settled there in the 1880s and 1890s. Ms. Sprague has been the source of much of my information on the Neck's buildings and people, and I cannot thank her enough for her guidance. Likewise, Mr. Shettleworth deserves recognition for kindly sharing with me significant material from his research into Stevens's life and work.

In the course of this project heavy use necessarily was made of the Homer collection of photographs and documents at the Bowdoin College Museum of Art, Brunswick, a remarkable archive that helps to elucidate the artist's personal and professional values in his late years. Katherine Watson, director of the museum, allowed me to use many of the photographs preserved there in my research and in the exhibition and this publication. Henrietta Tye, Registrar, was especially gracious and helpful in making the Homer collection available on several occasions. Moreover, she kindly oversaw the photography of material for the exhibition and publication, a Herculean effort.

Also at the Bowdoin museum, Susan Ransom, Editor, shared information on the Winslow Homer–John Calvin Stevens correspondence, now in that museum's collection.

The Cooper-Hewitt Museum, the Smithsonian Institution's National Museum of Design, New York, generously lent from its holdings of Homer's late drawings, works from the large body of sketches donated by the artist's brother Charles Savage Homer, Jr., in 1912. I am grateful to Elaine Evans Dee, Curator of Drawings and Prints, and her assistants, Annie Dean and Megan Smith, for their help with these loans.

Any research into the work of Winslow

Homer depends on the pioneering work of the late Lloyd Goodrich and Edith Havens Goodrich, who devoted much of their lives to compiling a complete catalogue of the artist's oils, watercolors, and drawings. The Goodriches' work is being advanced by Abigail Booth Gerdts under the auspices of the Graduate Center, City University of New York/Lloyd Goodrich and Edith Havens Goodrich/Whitney Museum of American Art Catalogue of Works by Winslow Homer. Mrs. Gerdts kindly made available information on all works from the late period and aided efforts to locate paintings and drawings in private collections. I am indebted to her for her assistance.

For affording me glimpses into the artist's private world, I am particularly grateful to members of the Homer family: Mrs. Graham, Alice Homer Willauer, and Mrs. Willauer's son, Charles Homer Willauer. Their help and hospitality in opening El Rancho and the artist's studio to me deserve special thanks. I shall long remember my wonderful tour of Prout's Neck in their company. Likewise, Doris Piper Homer, widow of the late Charles Lowell Homer, who with Mr. Willauer so generously gave the Homer papers to Bowdoin College in 1964, was helpful in my research at Prout's.

Other aid to my research came from Mr. and Mrs. John Calvin Stevens II of Cape Elizabeth, Maine. A member of the Stevens family architectural firm, Mr. Stevens shared impressions regarding his grandfather's building activity, friendship with Winslow Homer, and work as a landscape painter. At the Maine Historical Society, Portland, Dorothy Martin attended to my numerous queries. In Rochester, Elaine Challacombe, former Librarian, Strong Museum, provided access to Homer's personal book collection, which is preserved there. Painting conservators Dan Kushel and James Hamm, State University of New York College at Buffalo, provided valuable technical expertise regarding *The Artist's Studio in an Afternoon Fog*.

Finally, I wish to give warm thanks to my husband, David, for his untiring support, help, and many kindnesses throughout this project.

PATRICIA JUNKER
Curator of American Art
Memorial Art Gallery of the
University of Rochester

Winslow Homer before 1890

Philip C. Beam

As Winslow Homer lay on his death-bed in his studio at Prout's Neck in late September 1910, he asked whether he might have a drink and a smoke and reminisced with his brothers about the good times they had enjoyed together as boys in Cambridge.[1] He said not a word about his lifelong devotion to his art or about the chances of his work's enduring.[2]

Homer was a modest, though confident, man and also a wise one. He knew that his art, and others, would have to speak for him. And though he had earned his share of honors, he was aware that a reputation can be short-lived. He would have been surprised to know that his name would become a household word. Fortunately for posterity, the recognition of his worth was not long in coming.

In 1914, only four years after Homer's death, Kenyon Cox, an artist and critic who was both eloquent and knowledgeable about the history of art, wrote the following estimate of Homer's accomplishments: "If he had died at fifty, he would be remembered as an artist of great promise and as the author of a few pictures in which prom-ise becomes performance. It is because he lived to be seventy-four that his career is the great and rounded whole we know."[3] Because William Howe Downes had published the first full-length biography of Homer in 1911, Cox confined his opinion to a summary critical assessment, but his perceptions are still essentially true. Amid the thousands of words that have been written since, Cox's assessment provides a valuable guide to Homer's attainments from his modest beginnings to a grand finale. The critic gave us a valuable key to understanding the main outlines of Homer's career by underscoring his capacity for growth and showing how and where his development reached its climax.

In 1936, when the centennial of Homer's birth was celebrated, another penetrating critic, Forbes Watson, furnished additional insights into Homer's development by stressing three characteristics that made it possible: his sensitivity to the elements and forces of nature, his abundant creative vitality, and his talent for learning and refining his art through experience rather than by imitating others.[4] In his biography of Homer published in 1944, Lloyd Goodrich reminds us that the best way to use these keys to understand Homer is to study the unfolding of his life through his pictures, "where like every artist he left the most complete record of himself."[5] One might add that, although Homer was as reticent with words as he was eloquent with pictures, the letters he wrote to members of his family are worth heeding for the way in which they convey what he was thinking while he created his pictures. They shed light on his reaction to his environment, which was so important to that process.[6]

Like many artists of independent nature, Winslow Homer was largely self-taught. His development through observation and experimentation occurred only gradually and in stages. But he learned his lessons well and preserved his originality and freedom.

It would have been hard to foresee genius in the youth who was born in the harbor area of Boston in 1836 and who grew up, after the age of six, in nearby Cambridge. Homer was an indifferent student and spent more time drawing in the margins of his books than reading them. His bent from the

beginning was visual rather than verbal. This inclination never changed.

When formal education beyond the age of eighteen seemed inappropriate, Homer's father allowed him to begin his artistic training by working as an apprentice in the graphic-arts shop of J. H. Bufford in his native Boston. On the completion of his three-year apprenticeship—a normal arrangement at the time—he began his career as a free-lance graphic artist. He never again relinquished his freedom. Moving to New York, he continued as an artist-correspondent for *Harper's Weekly* during the Civil War, gaining experience in life and artistic practice as well as something approaching national recognition as an illustrator for the leading popular journals of the era.[7]

In working as an illustrator for these periodicals, Homer allied himself more with the genre painters of the mid-nineteenth century, such as Richard Caton Woodville, William Sidney Mount, and George Caleb Bingham, than with the historical painters, represented by John Singleton Copley and John Trumbull. When reporting on the Civil War to the readers of *Harper's Weekly*, the *Life* of his day, Homer depicted some violent battles, notably in *The War for the Union, 1862—A Cavalry Charge* (July 5, 1862), *The War for the Union, 1862—A Bayonet Charge* (July 12, 1862), and *A Shell in the Rebel Trenches* (January 17, 1863),[8] but spent most of his time recording the daily lives of soldiers at the front.

After the Civil War, Homer, like most Americans, turned eagerly to peacetime pursuits. He spent much of his time recording the life of vacationers at the new resorts in the White Mountains of New England and along the Atlantic seaboard from Long Branch, New Jersey, to Gloucester, Marshfield, and Cape Anne, Massachusetts. He spent portions of his time in the rural areas

around Houghton Farm,[9] near Mountain-ville, New York, and Belmont and West Townsend,[10] near Boston, where life was equally pleasant.

Interspersed was a visit to France in 1866–67 and the world's fair in Paris, where he may have seen the paintings of Gustave Courbet, Edouard Manet, and the fledgling Impressionists. He exhibited two oils of his own, the Civil War scenes *Prisoners from the Front* (1866; Metropolitan Museum of Art, New York)[11] and *The Bright Side* (1865; Fine Arts Museums of San Francisco), at the Paris world's fair. And he spent some time painting in the farmland Jean-François Millet had depicted. Homer visited the Louvre and exhibitions in Paris and enjoyed the city's night life.[12] But he was too independent to be overwhelmed by the art of the old or modern masters or by European culture. And whereas landscape painting in America at that time featured the panoramic canvases of Albert Bierstadt and Frederic Edwin Church, Homer's interpretations of the countryside continued to be intimate and personal after he returned to his native New England and its coastline.

Homer had been born into a family with seafaring ancestors on both his father's and mother's sides,[13] and during his travels over the years, from the Caribbean to northern Canada, he seldom was far from the ocean. If his ultimate devotion to the sea as a subject was preordained, it was slow in coming, however. During his so-called middle period, from 1866 to 1881, Homer's view of life was primarily social. His pictures in all media were full of people, whether in cities, at resorts, or on farms.[14] In his journal illustrations, which include rural and urban subjects of every kind, a cross section of American life is presented in unmatched detail. There are over three thousand human figures in his magazine engravings alone.

Along the shores, Homer recognized the

presence of the ocean, but seems to have been little stimulated by it. Except for a few references to danger in his magazine illustrations,[15] the ocean only provided panoramic backgrounds for human activities, mostly benign in nature; he barely studied its more complex characteristics at this time. Two fine works, his wood engraving *Homeward Bound*[16] (*Harper's Weekly*, December 21, 1867) and the oil painting *High Tide* (1870; Metropolitan Museum of Art, New York) furnish only faint indications of the Homer of the future.

During these years Homer exploited his versatility to produce a large body of work in nearly all media. In the process he gained experience and sharpened his talents. His creative vitality was never in question. He executed designs for over two hundred magazine engravings for the leading American journals, became the foremost illustrator in that field, and gained national recognition. Although he abandoned the medium later, through it he acquired enormous experience in draftsmanship, in the observation of people, and in the art of design, which he applied for years to come.

During the same period Homer finished at least four oil paintings which, as Cox conceded, fulfilled his promise: *Prisoners from the Front* (1866; Metropolitan Museum of Art, New York), *Snap the Whip* (1872; Butler Institute of American Art, Youngstown, Ohio),[17] *Breezing Up* (1876; National Gallery of Art, Washington, D.C.), and *Camp Fire* (1880; Metropolitan Museum of Art). Although the self-taught Homer developed his handling of oil paint slowly, all of these examples are outstanding. Indeed, *Camp-Fire* is technically brilliant as well as a harbinger of his Adirondack paintings.[18]

By 1875 Homer had reduced his activity in magazine illustration. During the 1870s he devoted his energies increasingly to watercolor. He had a natural talent for that

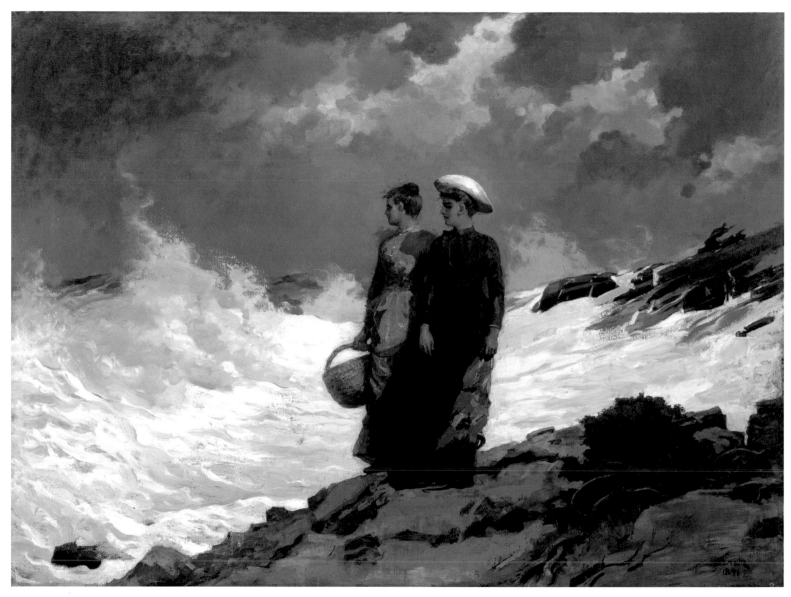

Plate 1. Winslow Homer, *Watching the Breakers*, 1891. Oil on canvas, 30¼ × 40¼ in. (76.2 × 101.6 cm). Thomas Gilcrease Institute of History and Art, Tulsa.

medium and apparently enjoyed it thoroughly, endowing his pictures with freshness, directness, and spontaneity. He gained from watercolor a facility of brushwork which played a large part in his depiction of swiftly moving water in his later oils, striking examples being *Backrush* (circa 1895; Joan Whitney Payson Gallery, Westbrook College, Portland, Maine), *A Summer Squall* (1904; Sterling and Francine Clark Art Institute, Williamstown, Massachusetts), and *Watching the Breakers* (pl. 1).

By the time he was forty-four, in 1880, Homer had amassed a tremendous amount of technical experience and had completed enough respectable or excellent pictures to fill a career for most artists. So the constraint in Cox's assessment of his progress could only have come from measuring Homer by a higher standard—that of greatness. Indirectly, Cox paid Homer the tribute of saying that his potential was far from exhausted. James Thomas Flexner inferred that by the end of the 1870s, Homer, possibly out of dissatisfaction with an unaccustomed state of suspended progress, had arrived at a plateau and was suffering from painter's block, or what Flexner called "aesthetic frustration."[19] Homer's very independence set him apart from the American colleagues who pursued European models and left him out of tune with the critics who favored them. Today one might conjecture that he had burned himself out through the sheer multiplicity of his activities and that, like an athlete in a slump, he needed a rest or a fresh start. In any case the impasse was largely mental. Somehow he had to convert observation to insight, and experience to wisdom, without sacrificing his own way of seeing.

Homer was, as it were, at a crossroad without a signpost. If he was aware of the dilemma, he did not allow himself to become paralyzed by inertia or sink into mere

repetition. Always a man of action, he took positive steps to find a way to move forward. While still a relatively young man, he sought renewed inspiration by exploring two new locales within a short time. Each was to have a profound effect on his development.

In March 1881 Homer went abroad again, on the Cunard liner S.S. *Parthia*,[20] bypassing Paris in favor of England. He lingered in London only long enough to paint a watercolor of the Houses of Parliament (fig. 1) and then journeyed to the area of Tynemouth, near Newcastle on the North Sea. He never revealed his reasons for selecting that site. He may have gravitated to it on the advice of a friend, because its resort and yachting centers resembled those of Gloucester. Far more important is the fact that he discovered a small, quite different town just north of Tynemouth Long Sands. Cullercoats by name, the village was the home of a fishing fleet not unlike that at Gloucester.[21] Owing to the research of John Boon of Tynemouth, the lodging and studio Homer rented near the waterfront have been identified,[22] the first conveniently situated at 44B Front Street and the second at 12 Bank Top, overlooking the sea.[23] In Gloucester, Homer had had ample opportunity to study the blue-water fishing fleet, but painted the carefree *Breezing Up* instead. By 1881 he viewed life more maturely.

During his two years at Cullercoats, Homer produced a flood of pictures, mainly in the "traveler's medium" of watercolor. Significantly, the beach of Cullercoats harbor was occupied on the north by a coast guard lookout station, referred to locally as the Watch House, which was to play more than a symbolic role in Homer's thoughts and pictures, as it did in the lives of the community. The families of fishermen gathered there to wait and watch when a storm threatened the men at sea.[24] The fisherfolk

along that notoriously dangerous coastline not only wrested a living from the sea instead of vacationing beside it, but knew at first hand its threat to human life.[25]

As a visitor from abroad, Homer was especially impressed by the womenfolk, who worked as hard as the men, provisioning the vessels and selling the catch. Far different from the young ladies he had painted at Long Branch, they carried heavy baskets instead of parasols. Even in their coarse woolen garments, they exemplified a strength verging on nobility. Through his art Homer immortalized these people, whom he never forgot.

The change that occurred in Homer's attitude amid these humble residents of the Northumberland coast can be measured in his work by comparing a lithograph entitled *Yachting Girl*, which he drew in Gloucester in 1880, and a watercolor called *Perils of the Sea* (Sterling and Francine Clark Art Institute, Williamstown, Massachusetts), which he painted at Cullercoats in 1881. So great is the contrast between the two that it is hard to believe they were conceived only a year apart. *Perils of the Sea* proclaims the new outlook that was never to be far from Homer's thoughts for the remainder of his career. Seldom has an artist's philosophy changed so rapidly. John Wilmerding has underscored the difference by comparing the outlook of Homer's middle period to that of Walt Whitman and the viewpoint of the following years to that of Herman Melville.[26]

By the end of 1882 Homer had retrieved his integrity and foreseen his future. In November he boarded the S.S. *Catalonia* for home, arriving in New York before Christmas. In 1883 he painted a watercolor entitled *Inside the Bar* (Metropolitan Museum of Art, New York). Through the powerful female figure outlined against a stormy North Sea setting, he confirmed his

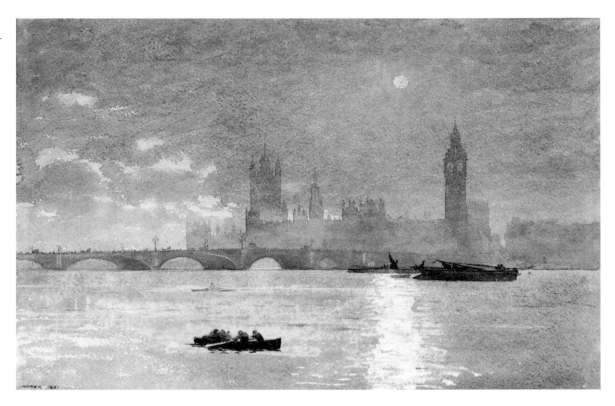

Figure 1. Winslow Homer, *The Houses of Parliament*, 1881. Watercolor on paper, 12¾ × 19¾ in. (32.3 × 50.3 cm). Hirshhorn Museum and Sculpture Garden, Smithsonian Institution, Washington, D.C. Gift of Joseph H. Hirshhorn, 1966.

commitment to the stalwart women he had come to know abroad.

Since Homer declined to discuss his personal affairs, saying that they would not be of interest to anyone else,[27] his immediate motives for traveling to England and returning to America remain unknown. His admirers naturally assumed that he had his share of romantic interests and problems as a young man. The English scholar Tony Harrison believed that Homer was sufficiently attracted to Maggie Storey, his favorite model in Cullercoats, to invite her to return to America with him, but she did not accept.[28] And it has been conjectured that he moved to Prout's Neck because of a disappointment in love. Homer's real reason for the two important moves he made in middle life was probably much more prosaic. He went abroad seeking a new direction for his art, and when he found it there,

he moved to Maine to get on with his work. By that time he was forty-seven years old.[29]

On his return to this country Homer was again at a crossroad. He could remain in Manhattan or make a drastic move. By no means a natural recluse, he had enjoyed the bustling city and the company of convivial colleagues, recalling them nostalgically in later years. But living in the metropolis did not mesh with the direction his thoughts had taken along the shores of the North Sea.

It was at this time that he recalled Prout's Neck, which he had first seen in 1875. Photographs taken of Prout's (as it is popularly known) in 1883 reveal that the interior was settled, but that the cliffs were a barren mass relieved only by three or four wooden buildings. Its development as an affluent summer resort lay in the future. The region could be storm beaten in fall and frigid in winter (fig. 2). Over many months it was not

only isolated but almost deserted. Just meeting the practical necessities of existence could be a drain on time and energy.

Against these formidable drawbacks, two assets must have influenced Homer's thoughts. In addition to being able to join his relatives, who had become summer residents there, in more settled conditions than they had known for years, he could study a colony of fisherfolk from nearby Pine Point. And looming over all were the majestic cliffs of Prout's, scenery more spectacular than Cullercoats. This dual offering must have impressed Homer's instincts even before he had fathomed its full potential.

Before the spring of 1883 had ended, Homer had made the most far-reaching decision of his life. He had closed his studio in New York and committed himself to a permanent residence in Maine. A rugged person by nature and a seasoned traveler,

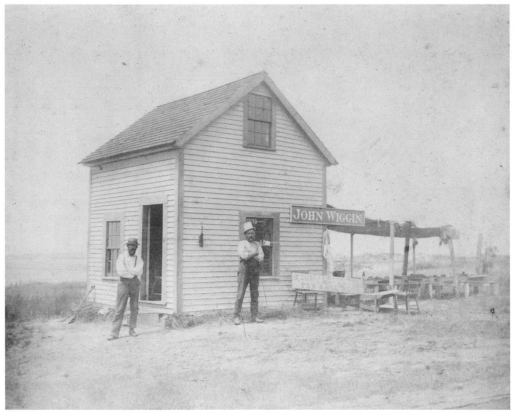

Figure 2. *Henry Lee and John Wiggin of Prout's Neck, Maine*, circa 1890. Silver print by Gardiner Hubbard Scudder, Cambridge, Massachusetts. Bowdoin College Museum of Art, Brunswick. Gift of the Homer family, 1964.*

stages of development during the 1880s and 1890s.

In the 1880s Homer progressed along two parallel tracks, advancing on one more rapidly than the other. He began his study of the cliffs and waves at Prout's Neck tentatively, through a series of watercolors and drawings in pencil and charcoal, using his facility and experience in both. Several more years would pass before he was ready to present the seacoast in oil in all of its power and glory.

By contrast, Homer was well prepared by years of observation of human beings, especially his recent experience of the fisherfolk at Cullercoats, to create human dramas at sea in any medium. He was therefore able to embark immediately on the most powerful subject he had treated to date, producing in 1884 the first of his great maritime illustrations in oil, *The Life Line* (fig. 3). In this landmark masterpiece, which Jules Prown has interpreted in penetrating detail, the cliffs of Prout's Neck are discernible in the background as a *raison d'être* for disaster. But the overwhelming emphasis is on the human participants in this scene of vulnerability, heroism, and rescue.[31] So powerful was *The Life Line's* impact that it was acclaimed by the critics when it was shown at the National Academy of Design, New York, in the spring of 1884. It was purchased on opening day for twenty-five hundred dollars by Catherine Wolfe.

After the encouraging reception of *The Life Line*, Homer began a series of oils dealing with life on the high seas, notably *The Fog Warning* (Museum of Fine Arts, Boston), *The Herring Net* (Art Institute of Chicago), and *Eight Bells* (Addison Gallery of American Art, Phillips Academy, Andover, Massachusetts), which appeared in rapid succession in 1885 and 1886. In this sequence he altered his outlook by moving steadily away from the unconcealed danger

he was ready to adjust to a life with many hardships and few conveniences. Judging by his letters, he did so without complaint, exemplifying Goethe's dictum that "genius can thrive on solitude." It is a tribute to Homer's resilience that he became as hardy as the fishermen, hunters, and guides he portrayed.

During the twenty-seven years Homer resided at Prout's Neck, it became a thriving, popular summer resort. Winslow, with his brothers, had a hand in this process, which affected him in two ways. It supplemented his income for travel and other purposes, but it also surrounded him increasingly with neighbors who were vacationing while he was trying to work. The inevitable

conflicts that arose contributed, whether fairly or not, to Homer's reputation for being testy when he was interrupted during painting hours. Among friends he was courteous, but he did not fritter away his energies on minor or unproductive distractions. The quiet patience and disciplined concentration he devoted to his pictures went far toward making him the prolific master he became.[30] In his greatest pictures he projected an exalted admiration for his native models and for the rugged grandeur of his surroundings.

After Homer settled in at Prout's Neck, established a studio-home in which to live and work, and made it the center of his rise to greatness, he moved through two more

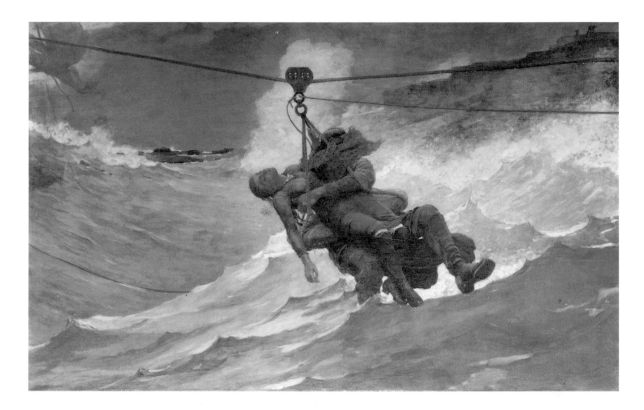

Figure 3. Winslow Homer, *The Life Line*, 1884. Oil on canvas, 29 × 45 in. (73.7 × 114.3 cm). Philadelphia Museum of Art. George W. Elkins Collection.

Figure 4. Winslow Homer, *Undertow*, 1886. Oil on canvas, 20¹³/₁₆ × 45⅝ in. (75.7 × 121 cm). Sterling and Francine Clark Art Institute, Williamstown, Massachusetts.

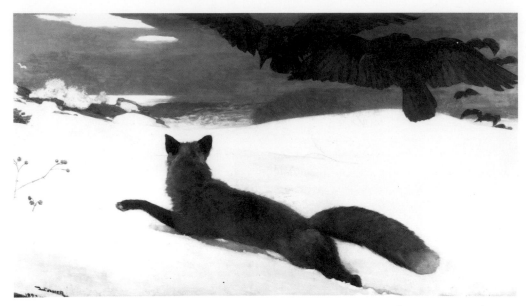

Figure 5. Winslow Homer, *The Fox Hunt*, 1893. Oil on canvas, 38 × 68½ in. (96.6 × 174.2 cm). The Pennsylvania Academy of the Fine Arts, Philadelphia. Joseph E. Temple Fund.

of *The Life Line* toward the implied threat in *The Fog Warning* and, finally, to the understatement of problems at sea contained in *The Herring Net* and *Eight Bells*. In sum, he progressed from high drama to artful suggestion. Similarly, Homer increased the presence of the ocean from a background threat to something approaching a partnership, keeping in mind, nonetheless, that even when the ocean is calm, it cannot be taken for granted.[32]

Ironically, as Homer moved from forceful drama to subtle statement, his public was unable to follow him, and his pictures sold slowly for the remainder of the 1880s. This reception must have caused him further worries about the course his career should take. When he exhibited the oil version of *Undertow* (fig. 4) at the National Academy of Design in the spring of 1887, the critic for the *Tribune* praised the picture, but another anonymous review called it "discordant, hard and lifeless."[33] After such a mixed re-

ception, the picture remained in the artist's hands for some time. It was sold in New York in 1889 to Edward D. Adams for twenty-four hundred dollars less the artist's commission of twenty percent, a fair price for that time.

When the anonymous art critic of the Philadelphia *Telegraph* wrote, in October 1892, a column on the Clarke collection, he said of Homer that he had been "a great painter at one period of his history, during the Civil War," but that "with the production of *Eight Bells* [which had been shown at the National Academy in 1886] Mr. Homer seems to have given up all idea of pleasing the public." This critic called *The Life Line* and *Undertow* mere experiments and denied that Homer had exhibited anything of importance subsequently. He added that Homer had "gone off too far on his own line to care about others who are still lingering in the land of the Philistines, unable or unwilling to follow his hand," concluding, "Se-

clusion may do well for a priest—it is fatal to a painter."[34] Another writer, speaking of *Huntsman and Dogs* (1891; Philadelphia Museum of Art), wrote, "[Homer] has come dangerously near the commonplace,"[35] seeing nothing in the painting but a brutal hunter.

Like most truly creative and progressive artists, Homer was ahead of his time and paid a price for his independence. Sure as he was of his own goals, not even he could have been impervious to the jibes and sarcastic misunderstandings that persisted for a number of years. When, as the Boston *Transcript* reported, again in 1892, seven of twelve watercolors exhibited at Doll and Richards were sold immediately, the more favorable reception may have caused the artist, bent upon earning his living, to continue producing numerous watercolors.[36]

Nevertheless, Homer developed his command over the medium of oil on canvas. No one can know what went on in his mind, but the lapse in appreciation may have inspired him to shift some of his attention from human events to the natural scene. There had been nothing at Cullercoats to compare with the majesty of the oceanfront at Prout's Neck that lay at his doorstep. The time had arrived to give it his full attention.

Homer had begun to take advantage of what the area had to offer only slowly, through such watercolors as *Prout's Neck, Rocky Shore* (1883; Worcester Art Museum, Massachusetts) and many similar watercolors and drawings made during the seven years that followed. These pictures were handsome, but too small for the subject, and its larger meaning eluded him. Moreover, he had absented himself from Prout's Neck often, producing scores of pictures in other areas ranging from the Adirondacks to the Caribbean. Beyond all these considerations, the task before him was a formidable one because of the nature of the cliffs them-

selves. Not even a persistent student like him could fathom how to interpret them all at once.

The approach to Prout's Neck today is an extensive, but unexceptional, area of marshes, fields, and lawns shaped into a triangle by erosion from the waves of Higgins Beach to the north and Saco Bay to the south. The feature that makes Prout's extraordinary is the front of the promontory facing seaward to the south. As the visitor suddenly comes upon the cliffs and open ocean, the effect is striking and sometimes breathtaking. The wall of the front extends from Checkley Point and West Point to Eastern Point along a dark, massive rocky band about one-half mile in length. It is defined by the water's edge and by the cliffs, which rise at a forty-degree angle to undulating crests some sixty to ninety feet above the waves.

When seen along its length at a distance, this grayish brown slope provides a dominant image whose unity seems tailor-made for the creation of pictures. Homer recognized this as early as 1883, incorporating it into his first watercolor studies. Thereafter it ran like a refrain through most of his marines in all media, the ever-present diagonal line endowing them with a stylistic hallmark. Moreover, Homer was able to draw promptly on the division along this slanting axis between earth and water (the dark mass below) and sky (the lighted area above).

The steep slope of the cliffs at Prout's Neck exemplifies the slanting line equated with action by artists for centuries. This effect, in accord with Homer's own dynamic temperament, must have impressed him at once. Added to it was the contrast between the constantly changing conditions of atmosphere, lighting, and moving water and the timeless substantiality of the massive cliffs.

The imagination would not have to go far to recognize in this microcosm the eternal conflict between irresistible forces and immovable masses. Although Homer had mastered this larger image as early as *The Life Line* of 1884, it is to his credit that his instincts warned him against formulaic "surf and rocks pictures." In seeking, instead, the distinctive formation within the larger scheme, he encountered the difficult portion of his quest. For, when seen at close range, the imposing plane of the cliffs is cluttered with rocks and boulders of every size, shape, and inclination, a veritable jumble of natural forms. And the lighting effects Homer sought often demanded days, weeks, or months of waiting. He had to determine in advance what he was after and recognize it when it appeared, a two-fold program that required extraordinary patience.

If Homer's artistic aim was to extract from the superfluity and confusion of Prout's myriad detail a workable balance between variety and unity, the challenge, after a propitious start, was sufficient to occupy him steadily over half a decade, from 1885 to 1890, and to delay the realization of his mastery of marine painting.[37] After 1890 he produced masterpiece after masterpiece.

Before the 1890s ended Homer had added two exceptional paintings to his growing gallery of great works. In 1893 he completed *The Fox Hunt* (fig. 5), in which a moonlit sea forms a subtle counterpoint to the foreground demonstration of natural savagery. In 1899 he finished *The Gulf Stream* (fig. 6; see also pl. 8), in which he

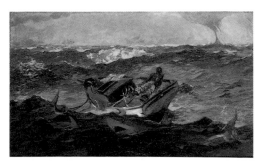

Figure 6. Winslow Homer, *The Gulf Stream*, 1899. Oil on canvas, 28⅛ × 49⅛ in. (71.4 × 124.8 cm). The Metropolitan Museum of Art, New York. Wolfe Fund, Catherine Lorillard Wolfe Collection, 1906.

concluded his study of sharks, the ultimate predators, begun on a trip to Nassau in 1885. This picture also brought to a culmination in oil his long-time recognition of the perils of the sea. *The Fox Hunt* was unlike any of his other Prout's Neck canvases; *The Gulf Stream* contains a veritable encyclopedia of maritime threats to life in the deceptively benign tropics.

In achieving the peak of his own development through understanding, Homer proceeded in ways not open to the average person. A patient man, he was willing to spend hundreds of hours over years of time studying the ocean and its relationship to the cliffs at Prout's Neck. During his study he penetrated meanings both universal and particular. Through his artistic ability he applied his insight to pictures that others could see and enjoy. The many considerations behind Homer's offerings are underscored in a phrase on a bronze plaque at Prout's; it offers grateful tribute to "Winslow Homer, 1836–1910, who with his brush gave Prout's Neck to the World."

NOTES

1. William Howe Downes, *The Life and Works of Winslow Homer* (Boston and New York: Houghton Mifflin Company, 1911), p. 251.

2. This anecdote was recounted by the artist's nephew, Charles Lowell Homer, who supplied the author with a wealth of information about the painter's life and work at Prout's Neck.

3. Kenyon Cox, *Winslow Homer* (New York: Frederick Fairchild Sherman, 1914), p. 2.

4. Forbes Watson, "Winslow Homer," *American Magazine of Art* 29, no. 10 (October 1936), pp. 625–37.

5. Lloyd Goodrich, *Winslow Homer* (New York: Macmillan Co. for the Whitney Museum of American Art, 1944), p. 1.

6. Most of the letters are preserved in the Homer collection, Bowdoin College Museum of Art, Brunswick. They were given to the museum in 1964 by the Homer family as part of the former's collection of Winslow Homer memorabilia.

7. Other artist-correspondents who served *Harper's* at the same time were A. R. Waud and Thomas Nast. Nast later became a celebrity by exposing the Tweed Ring.

8. An exceptional and impressive oil, *A Skirmish in the Wilderness* (1864; New Britain Museum of American Art, Connecticut), which probably alludes to the Wilderness Campaign around Richmond, represents more wilderness than skirmish, but anticipates the kind of realism employed by Stephen Crane in *The Red Badge of Courage* and by Mathew Brady and Alexander Gardner in their uncompromising photographs of Civil War carnage.

9. Homer had a personal interest in the Houghton Farm because it was owned and used as a vacation home by the family of Lawson Valentine, the employer of Winslow's brother Charles Savage Homer, Jr., whose development and sale of the noted product Valspar was a source of wealth for the officers of the firm, including Charles, an industrial chemist by profession.

10. Homer's older brother, Charles, and his wife, Martha (Mattie) E. French Homer, owned a house at her birthplace, West Townsend, which gave Winslow an additional reason for visiting there.

11. On *Prisoners from the Front*, see Nicolai Cikovsky, Jr., "Winslow Homer's Prisoners from the Front," *Metropolitan Museum Journal* 12 (1978), pp. 155–72.

12. Two sides of Homer's stay in Paris are illustrated by *Art Students and Copyists in the Louvre Gallery, Paris*, reproduced in *Harper's Weekly* (January 11, 1868), p. 25, and *A Parisian Ball—Dancing at the Mabille* and *A Parisian Ball, Dancing at the Casino*, reproduced in *Harper's Weekly* (November 23, 1867), pp. 744–45.

13. Homer's mother, Henrietta Maria Benson Homer, was of the Buck family of Bucksport, in down east Maine.

14. During his middle period Homer created a large number of preparatory drawings that are significant as the normal starting point of watercolor. A fine selection of these can be studied in *Winslow Homer Drawings, 1875–1885, Houghton Farm to Prout's Neck*, exh. cat. (Syracuse: Joe and Emily Lowe Art Gallery, 1979; essay by David Tatham). This catalogue's illustrations furnish unusual insight into Homer's thinking during the period covered. The largest single collection of drawings and paintings from the middle period can be found in the Cooper-Hewitt Museum, the Smithsonian Institution's National Museum of Design, New York. It consists of a benefaction from Charles Savage Homer, Jr. For a richly illustrated catalogue of the collection, see *Winslow Homer, 1836–1910: A Selection from the Cooper-Hewitt Collection, Smithsonian Institution* (Washington, D.C.: Smithsonian Institution Press, 1972), with contributions by Lisa Taylor, Lloyd Goodrich, John Wilmerding, and Elaine Evans Dee.

15. *Winter at Sea—Taking in Sail off the Coast*, reproduced in *Harper's Weekly* (January 16, 1869), p. 40; *At Sea—Signalling a Passing Steamer*, *Every Saturday*, reproduced in *Harper's Weekly* (April 8, 1871), p. 321; and *Wreck of the "Atlantic"—Cast up by the Sea*, reproduced in *Harper's Weekly* (April 26, 1873), p. 343.

16. *Homeward Bound*, reproduced in *Harper's Weekly* (December 21, 1867), pp. 808–9.

17. Nicolai Cikovsky, Jr., in "Winslow Homer's School Time, A Picture Thoroughly National," in *Essays in Honor of Paul Mellon* (Washington, D.C.: National Gallery of Art, 1986), pp. 47–67, describes in detail the richness of meaning of Homer's *Snap the Whip* for Americans of the time.

18. If Cox had written his 1914 estimate of Homer's progress in 1984, when a much larger array of Homer's pictures was available, he surely would have enlarged his gallery of pictures of "promise" to include many more representing "achievement" and many that the American public has since made national favorites. However, this larger perspective does not invalidate his thesis that Homer reached the fullness of his powers, or "greatness," relatively late in life.

19. James Thomas Flexner, *The World of Winslow Homer* (New York: Time, Inc., 1966), p. 99.

20. In a letter to the author, the steamship historian William H. Miller identifies the vessel Homer sailed on as the *Parthia*. Homer depicted the boat from fore and aft in two watercolors dated 1881, *Marine* (Bowdoin College Museum of Art, Brunswick) and *Observation on Shipboard* (Lois Homer Graham). Miller added that the boat "had one of the longest careers of any steamer in plying between New York and England for over eighty years, from 1870 to 1955. Specific passenger lists were, however, discarded by the Cunard Line long ago."

21. For a detailed study of Homer's visit to Cullercoats and the artistic background of the area, see William H. Gerdts, "Winslow Homer in Cullercoats," *Yale University Art Gallery Bulletin* 36 (Spring 1977), pp. 18–35.

22. John Boon, "An American in Cullercoats," *America in Britain* 20 (1982), pp. 5–10; J. Boon to author, June 4, 1981.

23. For a wealth of information about Cullercoats and the Tynemouth area conveyed through extensive correspondence, the author is indebted to John Boon, a longtime resident of Tynemouth, North Shields, England.

24. As usual, Homer was spare with words but prolific with images. His visit to Tynemouth has focused more attention on the area, especially Cullercoats, than it normally would have attracted in this country. Without his help, the reasons for his going there have inspired more questions than answers. His pictures supply an abundance of material for objective study that balances the mystery about his subjective reasons for this second visit abroad.

25. Two examples of Homer's recognition of the dangers, real and anticipated, that he conveyed in forceful terms are the *Wreck of the Iron Crown* (private collection), depicting an event that occurred on October 21, 1881, and a similarly powerful watercolor of the same year, *Watching the Tempest* (Fogg Art Museum, Harvard University, Cambridge).

26. John Wilmerding, *Winslow Homer* (New York, Washington, and London: Praeger, 1972), pp. 117–75.

27. Homer's exact words in a letter sent to Downes in August 1908 are: "As the most interesting part of my life is of no concern to the public I must decline to give you any particulars of it" (Goodrich [note 5]), p. 1.

28. Tony Harrison, *An American Artist in Cullercoats, 1881–1882* (Cullercoats: Local History Society, 1982), p. 2.

29. If Homer closed the door to his private affairs to the public, he opened a large window on the status of women in the nineteenth century by representing them in scores of economic and social situations in his pictures of the middle period. These offer a profitable field for study, as extensive and objectively available as his own personal romances are elusive and relatively unimportant.

30. Beatty said that Homer, when concerned with an artistic problem, could be moody, but asserted that with others he was invariably courteous, considerate, and generous. Beatty never heard Homer say a derogatory word about any other artist. See John W. Beatty, "Introductory Note," in Downes (note 1), p. xxvii.

31. Jules D. Prown, "Winslow Homer in His Art," *Smithsonian Studies in American Art* 1 (Spring 1987), pp. 31–45.

32. Two reminders of danger which he created at the same time are *Lost on the Grand Banks* (private collection) and *Undertow* (Sterling and Francine Clark Art Institute, Williamstown, Massachusetts). Both provide dramatic counterpoints to his trend toward subtler statements.

33. The unsigned *Tribune* review (1887) is quoted in Goodrich (note 5), p. 95. A second unsigned review, presumably written at the time of the first showing of the picture at the National Academy of Design, New York, in 1887, is contained in the Homer scrapbook, Bowdoin College Museum of Art, Brunswick, acc. 1964.69.185, n.p., but the actual source of the clipping is not identified.

34. Clipping, Homer scrapbook, Bowdoin College Museum of Art, Brunswick, acc. 1964.69.185, n.p.

35. Alfred Trumbull, *Collector* (December 1891), quoted in Goodrich (note 5), p. 123.

36. Clipping, Homer scrapbook, Bowdoin College Museum of Art, Brunswick, acc. 1964.69.185, n.p.

37. See nos. 1–6. Another of this series of drawings, *Cliffs at Prout's Neck near Cannon Rock*, is in the Homer collection, Bowdoin College Museum of Art, Brunswick.

The Homers and Prout's Neck

Lois Homer Graham

Since 1875 one or another member of the Homer family has been in residence at Prout's Neck. Their association with Prout's, which began with a honeymoon, has continued for well over one hundred years.

Thanksgiving 1865 saw the family together for the first time since the Civil War had begun in 1861. In what was then the family home in Belmont, Massachusetts, the patriarch, Charles Savage Homer, Sr. (fig. 7), sat at the head of the festive board, accompanied by Henrietta Benson Homer, his wife (fig. 8); Charles Savage Homer, Jr., his eldest son (fig. 9); Winslow Homer, his second son (fig. 10); and Arthur Benson Homer, the youngest (fig. 11). The men would go their separate ways through the next decade. In 1875 they would come together again, this time at Prout's Neck.

Charles Homer, Jr., had been employed during the Civil War by the Pacific Mills in Lawrence, Massachusetts. In the 1860s he moved to Brooklyn, New York, to join the Valentine Varnish Company, eventually becoming its chief executive. During his first year with Valentine he developed Valspar, a varnish for use on woodwork on ships and carriages; it is still on the market. In 1867 he married Martha (Mattie) French of West Townsend, Massachusetts.

Winslow had spent some of the war years with the Army of the Potomac as an artist-correspondent for *Harper's Weekly* and was beginning his career as a painter. He returned to his studio in New York after Lee's surrender. In 1866 he sailed for France, spending ten months in Paris and the French countryside. In 1867 Charles and his bride went to Paris on their honeymoon, probably meeting Winslow there. He returned to New York in the fall of that year, continuing his work as an illustrator for *Harper's Weekly*, but doing more and more painting on his own.

In 1875 Winslow took two oils he considered to be among his best to a dealer, telling Charles that if these paintings sold he would give up illustration for good. (Homer's first biographer, William Howe Downes, put this incident a decade earlier, when it would have made little sense). Although one painting sold immediately, Winslow became discouraged as the weeks went by. Suddenly, the other work sold, and he did his last illustration for *Harper's*. Months later the second painting turned up in Charles's apartment; Winslow found it tucked away in a closet. He was angry at Charles for having acquired it and did not speak to him for weeks, but the die was cast.

Arthur Homer spent the war years in the navy. Most of his tour of duty was in the Gulf of Mexico. One of the ports at which his ship docked was Galveston, Texas, which Arthur particularly liked. Although he returned to the family home in Belmont at the close of the war, he decided to go West to seek his fortune, lured by newspaper articles and advertisements promising prosperity to those who settled in Texas. Remembering the beauty of Galveston Island, he established a lumberyard in the port.

The year 1874 found all of the Homer sons well established in their careers. Charles had married. Winslow had courted a pretty school teacher, but lost her to his career. Now Arthur fell in love, and thus began the story of the Homers and Prout's Neck.

In 1874 Arthur asked Alice Patch of Lowell, Massachusetts, to be his bride. The

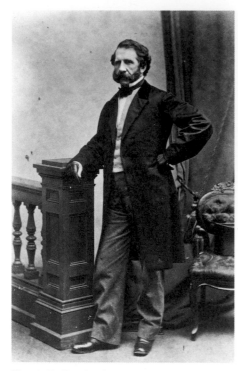

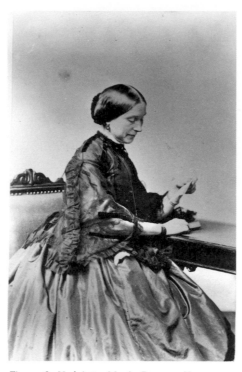

Figure 7. *Charles Savage Homer, Sr.*, circa 1870. Silver print by unknown photographer. Bowdoin College Museum of Art, Brunswick. Gift of the Homer family, 1964.

Figure 8. *Henrietta Maria Benson Homer*, circa 1870. Silver print by unknown photographer. Bowdoin College Museum of Art, Brunswick. Gift of the Homer family, 1964.

Figure 9. Winslow Homer, *Charles Savage Homer, Jr.*, 1880. Watercolor on paper. Private collection.

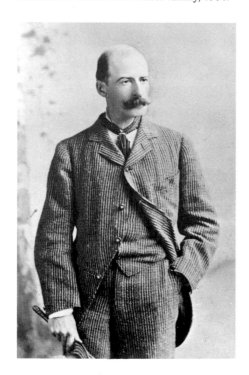

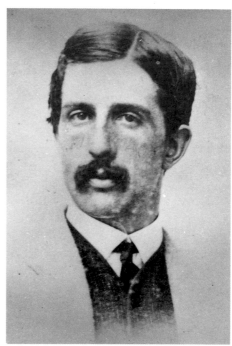

Figure 10. *Winslow Homer*, circa 1880. Silver print by Napoleon Sarony, New York. Bowdoin College Museum of Art, Brunswick. Gift of the Homer family, 1964.

Figure 11. *Arthur Benson Homer*, circa 1880. Silver print by unknown photographer. Bowdoin College Museum of Art, Brunswick. Gift of the Homer family, 1964.

wedding date was set in 1875, and the young man made plans for a honeymoon. Though Charles had taken his bride to Europe seven years before, Arthur was in no position to afford the grand tour, nor did he want to take his New England bride to Texas right after the wedding. It would be hard enough for her to adjust to life on the gulf when the summer was over.

The Patch family spent the summer of 1874 at a hotel on the Isles of Shoals near Portsmouth, New Hampshire. One of the guests there mentioned a wonderful spot on the coast of Maine with three fine summer hotels: Prout's Neck. Arthur Homer rented a horse and buggy and drove the fifty miles to Prout's, found the Willows, a newly completed hotel (fig. 12), and booked a suite for the next summer.

Following the wedding ceremony in Lowell, the bride and groom headed for Maine. The Homer family was a closely knit one, and all went to visit Arthur and his bride at Prout's. Winslow visited several times and drew some charming sketches of the honeymoon couple (fig. 13).

During that summer Charles Homer, Sr., had an inspiration that provided the foundation for the family's continuing love affair with Prout's Neck. He spoke of establishing a home where everyone could be together, with a room for Charles and Mattie, a room and studio for Winslow, and a room for Arthur and Alice.

When September came, Arthur and Alice reluctantly left their honeymoon hotel to go to Galveston. In April their first son, Arthur Patch Homer, was born. As the hot summer of 1876 approached, they boarded a steamer at Galveston and headed for the Willows at Prout's Neck. Once again members of the family came to visit them, and once again Charles Homer, Sr., mentioned his plan for a family summer home. The elder Homer visited some local landowners

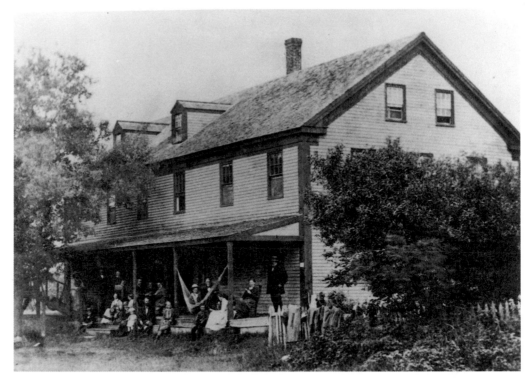

Figure 12. *The Willows Hotel, Prout's Neck, Maine*, 1875. Silver print by unknown photographer. Bowdoin College Museum of Art, Brunswick. Gift of the Homer family, 1964.

Figure 13. Winslow Homer, *The Honeymoon: Arthur Benson Homer and Alice Patch Homer at Prout's Neck*, 1875. Pencil and gouache on paper. Private collection.

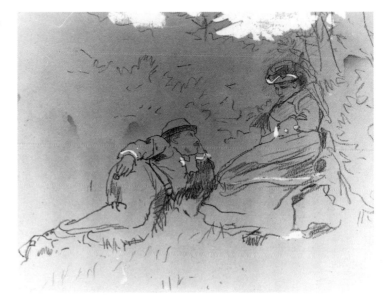

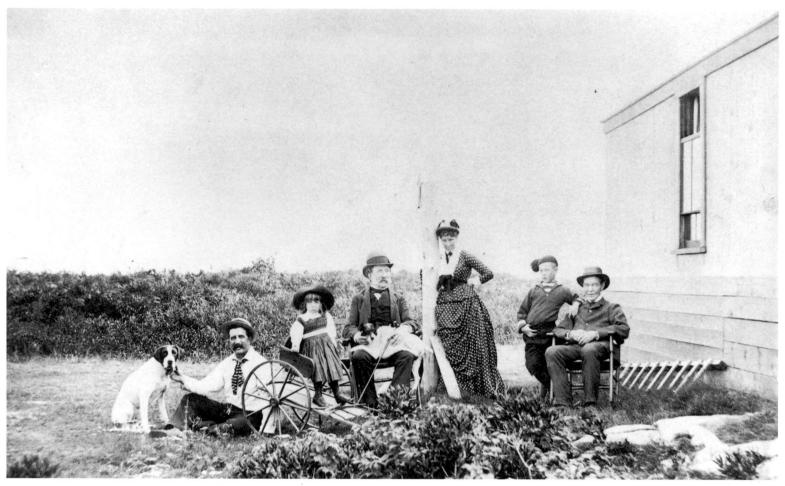

Figure 14. *Arthur Benson Homer and Family at Their House, El Rancho, Prout's Neck, Maine*, circa 1890. Silver print by Simon Towle, Lowell, Massachusetts. Bowdoin College Museum of Art, Brunswick. Gift of the Homer family, 1964. Left to right: Arthur Benson Homer; Charles Lowell Homer, his younger son; Charles Savage Homer, Sr., holding Winslow Homer's dog Sam; Alice Patch Homer; Arthur Patch Homer, Arthur's elder son; Benjamin Patch, Alice's father.

to see what might be available, but had no success acquiring property.

In the late 1870s the Homer family changed their summer hotel to the Checkley House, which was situated on the southwestern point of Prout's Neck, overlooking Saco Bay to the west and the great expanse of the Atlantic to the south and east. Here, the waves crashed on the rocky promontory. Ships could be seen going to and from Portland harbor. At night the lighthouse at

Biddeford Pool flashed in the distance. The outlook from the Willows over the bay and the clam flats had not been to Winslow's taste. At the Checkley House he could see more of the ocean and its moods.

In March 1881 Winslow sailed to England, where he spent twenty months. When he returned to America in November 1882, he found that circumstances had forced Arthur to build a house at Prout's. During the previous summer Arthur had lost pa-

tience with the Checkley House. With the addition of a second son—Charles Lowell Homer—to his family, one room at the hotel was not enough, so Arthur had requested two. But when he and Alice arrived from Texas, they found that only one room had been set aside for them, and no others were available. Arthur stamped out in a huff, saying, "I'll build a house in a week and move out—can't stand those squalling brats— they can sleep on the billiard table." He

Figure 15. *The Charles Savage Homer House, the Ark, at Prout's Neck, Maine, as Seen from Winslow Homer's Studio*, circa 1884–90. Silver print by unknown photographer. Bowdoin College Museum of Art, Brunswick. Gift of the Homer family, 1964.

scoured the lumberyards in Portland to find building materials for a house.

From a local farmer Arthur Homer purchased land offering a view of the ocean from three sides. He set in some boulders as a foundation for the corners, and up went the house. As each board was nailed to the frame it was painted green on the outside and white inside. In one week the structure was complete: one big room with a fireplace, a small master bedroom, and a loft for the two "squalling brats." The family moved in. Thus the first Homer summer home was built and occupied at Prout's

Neck. Arthur named it El Rancho (fig. 14), inspired by his adopted state of Texas.

Although Arthur's relatives still resided at the Willows or the Checkley House, they now spent many hours at El Rancho. In 1883 Charles Homer, Sr., observed an uncompleted house near the Checkley House: a summer boardinghouse being built by Alonzo Googins. This unfinished shell looked promising to the patriarch, for it might fulfill his dream to have his family together in a big summer house. El Rancho was only six hundred feet away. Charles Homer, Jr., readily saw that with his finan-

cial help the family could have their own summer home and, with the purchase and development of the surrounding area, might attract a community of summer residents. It was a fine investment, with Charles, Sr., acting as the entrepreneur and Charles, Jr., as the financier. The Homers bought about two-thirds of the land from the Libby family.

In 1883 the Ark was finished (fig. 15). Situated three hundred feet from the water's edge, it had a beautiful view of the ocean. That summer Charles, Sr., and Henrietta Homer, Charles, Jr., and Mattie, and Winslow moved in for the season. Mattie, who

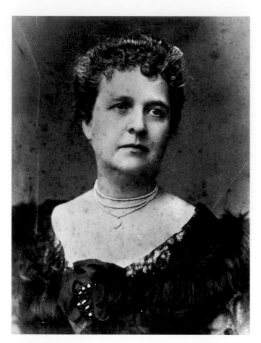

Figure 16. *Martha French Homer, or Mattie*, circa 1900. Silver print by Napoleon Sarony, New York(?). Bowdoin College Museum of Art, Brunswick. Gift of the Homer family, 1964.

was an accomplished hostess, brought her servants from New York for July and August and ensured that the household ran smoothly. Winslow proposed to convert the adjacent carriage house into a home and studio, since more space was needed in the Ark for the servants and he found his studio there inadequate.

Winslow's move from the family house into his own studio has sometimes been seen as an indication of a desire to live like a hermit. This is not correct. Many artists need privacy when working. Winslow also knew that at the end of the summer Charles and Mattie would leave, taking their servants to West Townsend, Mattie's home in Massachusetts, for the fall. El Rancho was closed in September, when Arthur took his family back to Galveston. After his wife's death in 1884, the elder Homer stayed on for awhile at

the Ark, attended by servants provided by Charles, but when the weather turned cold, he left to spend the winter at the Parker House in Boston, and the Ark was empty.

With the summer residents gone, Winslow saw more of his local friends, who were mostly farmers and fishermen—characters like Henry Lee and John Wiggin (see fig. 2). Some acted as models. Those who survived him remembered him as a warm and friendly person who accepted their honest criticisms of his work. Fisherman Henry Lee observed that the dory in the painting *The Fog Warning* did not "set right" on the wave, and Winslow repainted it to the man's satisfaction.

Though he had left the art world in New York, Winslow still had many friends there. Some came to visit him in Prout's Neck, finding his hospitality unchanged from his days in the Tenth Street Studio Building. He often went to Boston to visit his father and to New York to visit Charles and Mattie. It was most convenient to see his dealers and old friends in both cities on these trips. Winslow also spent long stretches of time alone. Maine's stormy winters could make the studio uncomfortable, but the excitement of the storms—the great waves crashing on the rocks—kept him there, often painting.

By 1890 Winslow was well known as a painter of the sea, and his pictures were selling. With fame came the problem of fans. Charles and Mattie had a very active summer social life. Known to everyone at Prout's Neck as "Madam Homer" (fig. 16), Mattie was the local social leader, and the Ark was a gathering place for the well-to-do families who had built on the Neck. Invitations to Mattie's famous afternoon teas were much sought after.

Naturally, the summer people were interested in Winslow Homer, the noted artist. Whenever possible, he stayed away from

Mattie's parties and did not welcome prying guests at his studio door. When interrupted, he was annoyed and gruff, so the word went around that he was an old curmudgeon. This was not true. Within the family Winslow was very different; he always planted a flower garden near his studio, and every day he took bouquets to Mattie, whom he loved very much (except when she was being "social"), and to Alice at El Rancho. He was an ideal uncle to Alice's two boys.

Winslow's friendliness was as large a part of his personality as his insistence on privacy when painting. Philip C. Beam, author of a study of his years at Prout's Neck, wrote to me sometime ago that "Winslow was a generous person and often gave pictures to people he liked, as I discovered more than once." It is interesting that both Homer paintings in the collection of the Memorial Art Gallery of the University of Rochester were given to friends: *The Artist's Studio in an Afternoon Fog* (see pl. 2) to John Calvin Stevens, and *Paddling at Dusk* (1892), a watercolor, to J. Ernest Yalden, a friend at the North Woods Club in the Adirondacks.

Arthur Benson Homer retired following the devastating hurricane of 1900, which destroyed his lumberyard in Galveston. He settled in Quincy, Massachusetts, where his two sons were employed at the Fore River Shipyard. With more time on his hands, Arthur went to El Rancho in May and stayed through September. His son Charles Lowell Homer married a Quincy girl in 1907, and Charles and his bride kept Arthur company at El Rancho, soon with their daughter Alice, born in 1908. Arthur's other son, Arthur Patch Homer, had already married a Quincy girl, Anna Whitman, in 1905. But El Rancho was hardly big enough for another growing family, and since young Arthur's wife's family had a summer home

farther north, on an island in the Kennebec River, Arthur and Anna (my parents) established the pattern of visiting Prout's Neck briefly each summer while staying on the Kennebec.

Winslow spent most of the last year of his life at Prout's Neck. He died there, surrounded by his family, on September 29, 1910. He was still at work during that year. His last painting, *Driftwood* (private collection), shows the rocks near his studio with great waves pounding the shore. This picture—an explosion of bright color on canvas—epitomizes the beauty of his beloved place.

Arthur Benson Homer died in 1916. Charles Savage Homer, Jr., and Mattie continued at the Ark, always staying, as was their pattern, from mid-June to early September. They maintained Winslow's studio, keeping it open to the public during the summer season. Mattie put flowers there daily, in a sense repaying Winslow's bouquets to her. After Charles Homer, Jr., died in 1917, Mattie returned to the Ark each summer through 1936. When Mattie's long life ended in 1937, the Ark passed to her nephew, Charles Lowell Homer, as did Winslow's studio. Charles and his wife moved into the Ark, turning El Rancho over to their daughter, Alice Homer Willauer, and her family. The studio, as in Mattie's time, was open to the public every summer. Charles Lowell Homer modernized the living quarters, adding a new kitchen and a bathroom, but he did not touch Winslow's painting room. He sold the Ark to a friend, a summer resident of Prout's Neck who had long wished to own it, and then moved into the studio with his wife.

In 1955 Charles Lowell Homer died, and the studio passed to Charles Homer Willauer, his grandson, who owns it today. The building has been designated a national historic landmark and is open to the public in the summer. Alice Homer Willauer resides each summer at El Rancho and Charles Homer Willauer, at the studio.

Prout's Neck has changed very little over the years, largely due to the good work of the Prout's Neck Association, which is made up of all of the area's homeowners. The landscape remains the same with one exception: the old summer hotels are gone. Still, fewer than twenty new homes have been built during the past fifty years. Winslow Homer's studio stands as it did when the artist died, its exterior nearly unchanged and the painting room largely as it was during the artist's lifetime.

The Homer family's love affair with Prout's Neck has not ended. My husband and I spent our honeymoon at the Willows in 1935, eighty years after my grandfather and grandmother first resided there. We have returned to Prout's Neck for visits almost every summer since 1935, often with our children.

My earliest memory of Prout's Neck was when, as a small child, I visited my aunt and uncle at El Rancho. I climbed the ladder into the loft where my father and uncle had slept the year the house was built. I remember that my cousin Alice took me to the beach. We were chased by a cow and escaped by running to the boardwalk that goes through the bird sanctuary on the beach side of the Neck. Established by the Homers in the 1880s, the sanctuary remains to this day an unspoiled haven for countless birds.

My next recollection is of awakening in the tower room at the Ark and hearing the wonderful sound of the waves breaking on the rocks below. When we visited Aunt Mattie, my father often woke me early in the morning to go down to the rocks to fish for rock cod. We would take our catch to the kitchen, and half an hour later it would be on the breakfast table, crisp and brown. All of the Homer men were avid fishermen, as family photographs show (figs. 17, 18).

Though he had died before I was born, Uncle Winslow was very real to me. Lewis, a former slave who for many years had been employed as my great-grandfather's personal servant and then served Uncle Winslow until his death in 1910, would meet me at the door of the studio with a deep bow, saying, "Welcome, Miss Lois." He would take me around the studio, finding and telling me about the most unusual things, such as the octant Uncle Winslow had painted into *Eight Bells*, the ship's wheel, the manikins, which he would let me manipulate into different positions, the drawing of a fish hanging on a string by the fireplace, the palette and the brushes. Aunt Mattie put Lewis in charge of the studio every summer.

My father used to take me walking along the rocks, showing me where Uncle Winslow had painted some of his most famous marines: *Eastern Point* (see pl. 13), *High Cliff* (see pl. 9), *Northeaster* (see pl. 17), *Cannon Rock* (see pl. 16), and many others. In the winter he would take me to museums to see the paintings; I especially loved *Cannon Rock* in the Metropolitan Museum of Art. At Prout's Neck, Cannon Rock is easily recognizable. It not only looks like a big cannon, but at high tide, when the waves break against the wall of a cave under the rock, they create the sound of a booming cannon. The pebbles in the cave, which we called lucky stones, roll round and round, becoming smooth and shiny. My children collected them as I had; my grandchildren do so today.

Uncle Winslow came to my father's rescue when he lost his job as well as most of his money in 1900. Fast getting back on his feet, he fell ill. Though he had not apprised his family of his difficult situation, somehow Uncle Winslow learned of it. An enve-

Figure 17. *Winslow Homer and His Brother Charles Savage Homer, Jr., Fishing on the Rocks at Prout's Neck, Maine*, 1900. Silver print by unknown photographer. Bowdoin College Museum of Art, Brunswick. Gift of the Homer family, 1964.*

Figure 18. *Charles Savage Homer, Jr. (left), and Winslow Homer (right) Comparing Catches of Fish on the Lawn of the Charles Savage Homer House, the Ark, at Prout's Neck, Maine*, circa 1900. Silver print by unknown photographer. Bowdoin College Museum of Art, Brunswick. Gift of the Homer family, 1964.

Figure 19. *Saint James Episcopal Church.* From *Album of Photographs of Prout's Neck—C. S. Homer's Cottages,* circa 1908, compiled and annotated by Winslow Homer. Silver print by unknown photographer. Bowdoin College Museum of Art, Brunswick. Gift of the Homer family, 1964.

lope came from Florida with a generous check and a note: "Dear Arthur—No thanks for the enclosed, Uncle Winslow."

Our home in West Townsend was next door to Aunt Mattie's. When she was there in the spring and fall, the house was full of Uncle Winslow's paintings. I knew them all. When Aunt Mattie went to Prout's Neck in late June, the West Townsend paintings went into a bank vault and the Prout's Neck paintings came out of another vault in

Portland to grace the walls of the Ark. I remember going from room to room there savoring the beauty of these different paintings.

Aunt Mattie took me to Sunday services at the little Episcopal church across the road from the studio (fig. 19). Charles Savage Homer, Sr., had been instrumental in having the church built in the late 1880s. Though he was a New England Unitarian, he attended "his" church at Prout's Neck until

his death. The church remains much the same today, and Homers attend every Sunday when it is open in the summertime.

Prout's Neck still has the northernmost mile-long beach in the state of Maine, the craggy rocks and stormy surf that Winslow Homer painted, the quiet peace of the bird sanctuary, and all of the special beauty that six generations of Homers have loved.

Expressions of Art and Life in
The Artist's Studio in an Afternoon Fog

Patricia Junker

The studio has become the crucible in which human genius, at the peak
of its development, brings back into question everything that exists. . . .

Eugène Delacroix, *Journal*

In the spring of 1884, at the age of forty-eight, Winslow Homer converted a simple carriage house on his family's property at Prout's Neck into the modest home and studio that would be the center of his life from that point forward (fig. 20). It also would be the subject of one of the most unusual landscapes produced during his mature years, *The Artist's Studio in an Afternoon Fog* (pl. 2).[1] That Homer's studio would have had special meaning for him is understandable; the large body of studio images in the history of Western art bears witness to the vital role such work spaces have played in defining artistic identity. Homer's unusual view, painted in 1894, derives from the modern tradition of studio self-portraits wherein artists have celebrated the setting of their work, using this setting to represent themselves and their art. These images necessarily offer important clues to personal and aesthetic ideals. In Homer's case this rare view is particularly revealing, articulating issues otherwise left unstated. In its subject and point of view *The Artist's Studio in an Afternoon Fog* presents graphic evidence of Homer's perceptions of place and self at Prout's Neck. A close examination of these elements in this highly personal painting offers insights into the nature and meaning of other Prout's Neck views created in this period of unparalleled achievement for the artist. It offers insights, in other words, into Homer's fully developed genius as a landscape and marine painter.

If, as Delacroix suggested, the studio is a place for reflection on life itself, then the questions raised by Homer's presentation are large indeed. What did he seek, and encounter, in the environment and social conditions of the Maine coast? How did these things and events challenge and sustain him personally and artistically for more than one-third of his life? What was his response to them, and how can we understand and appreciate that response? Significant answers to these questions can be found in an analysis of the form and content of *The Artist's Studio in an Afternoon Fog*.

Prout's Neck Defined: Character and Lure

Even today a visitor to Prout's Neck immediately apprehends the lure of this narrow spit of land for Homer and others in the last decades of the nineteenth century. Named for the farming family that first settled there, Prout's Neck is a most picturesque and varied landscape offering a range of views for the casual visitor or outdoor painter, views influenced by the ever-changing ocean climate. Located ten miles south of Portland, in the township of Scarborough, Prout's Neck extends into Saco Bay and has a long stretch of Atlantic coastline. In its interior are protected, peaceful meadows and marshlands, home in the first part of the nineteenth century to farmers who raised small herds of dairy cattle and harvested the wild grasses for fodder. On the east and west sides of Prout's Neck are broad beaches, which accommodated the dories of early herring fishermen and later attracted fashionable bathers. For Homer, as for most visitors, the magnificent headlands

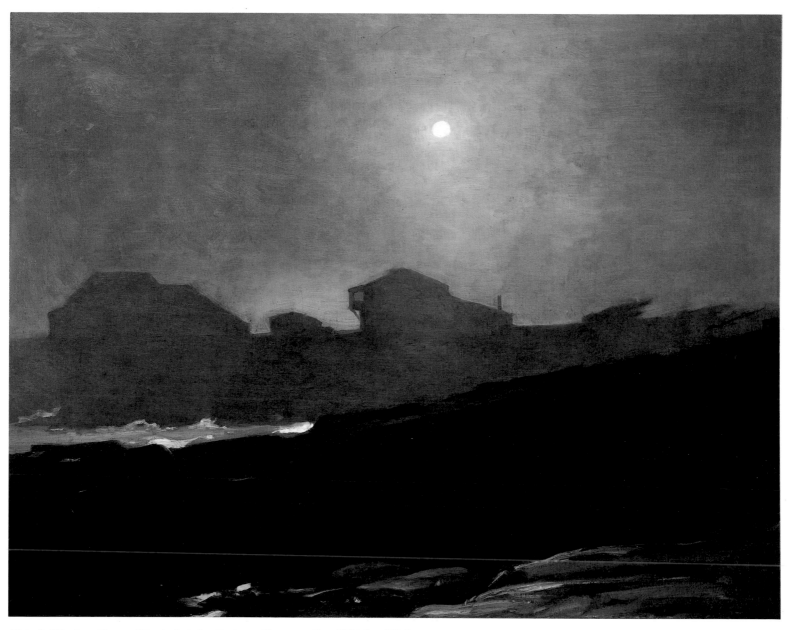

Plate 2. Winslow Homer, *The Artist's Studio in an Afternoon Fog*, 1894 (no. 22).*

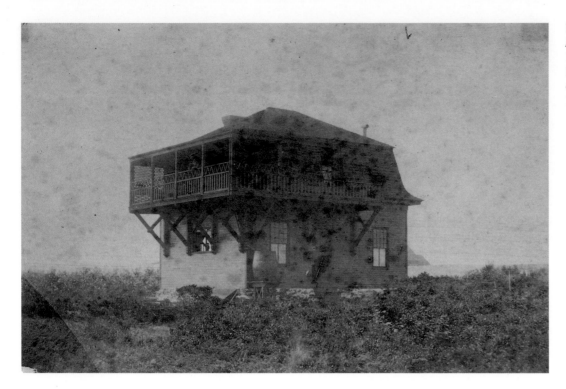

Figure 20. *Winslow Homer on the Gallery of His Prout's Neck, Maine, Studio Home*, circa 1884. Silver print by Simon Towle, Lowell, Massachusetts. Bowdoin College Museum of Art, Brunswick. Gift of the Homer family, 1964.*

on the south and southeast were Prout's most characteristic and alluring feature. There one looks directly out to sea from atop steep cliffs that rise from the water some fifty to eighty feet below at forty-five-degree angles (fig. 21). This promontory forms a grand, harsh rock wall against which otherwise unchecked sea rollers break with tremendous force.

In 1880 one popular travel guide amply described the unique features of Prout's Neck which might appeal to visitors, suggesting its destiny in terms that are significant to a consideration of Homer's motivation to settle there in 1883.

This is a promontory extending from the town of Scarborough three miles into the ocean, forming the eastern shore of Saco Bay. Nature has lavished her charms upon this place, and fitted it for a picturesque summer resort. There is a grandeur in its bold cliff-bound shore, beaten continually by boisterous breakers, and there is loveliness in the gentle breeze that fans its fields. Here the sun is seen to rise from the ocean, bathed in liquid gold; here his meridian rays are tempered by the mist-laden zephyrs; and from here he is seen to sink amid the fairy-tinted draperies of the golden west. Every hour of the passing day, at this place, bears with it a charm, and gives the mind the constant change which is rest and recreation. The varied facilities for enjoyment here presented make this one of the most desirable spots for a summer home.[2]

Vacationers in general discovered Prout's Neck at the same time as Homer. By 1873, when rail connections to Scarborough were completed, the once-remote farm community had become a burgeoning summer resort. To understand this development is to begin to fathom the complex social factors that underlay Homer's move there and that contributed to his personal happiness and his art in the Prout's Neck years.

It is tempting to equate remote Prout's Neck in the 1880s with the North Sea fishing village of Cullercoats, where Homer worked for twenty months from the spring of 1881 through the early winter of 1882.[3] It might seem reasonable to interpret his move to Maine almost immediately on his return from England as evidence of his desire to find an American Cullercoats in which to continue his studies of the physical and emotional struggles of men and women who lived by the sea. However, Prout's Neck bore little resemblance to Cullercoats even by the time Homer first visited it in 1875.[4] His enduring interest in Prout's is evidence of his predisposition toward rustic retreats, a predisposition that was typical of the late nineteenth century in general and characteristic of many genre and landscape painters in particular. Homer's move should be viewed in the context of this larger cultural pattern.

The artist's successive trips to Prout's Neck from 1875 on—and his excursions to upstate New York, the Massachusetts shore,

Figure 21. *Winslow Homer, His Dog Sam, His Father Charles Savage Homer, His Brother Charles Savage Homer, Jr., and Others Watching the Ocean from the Cliffs, Prout's Neck, Maine*, circa 1895. Silver print by unknown photographer. Bowdoin College Museum of Art, Brunswick. Gift of the Homer family, 1964.*

and Cullercoats—conform generally to the developing fascination with rural and sea-side summer retreats among America's growing urban class in the decades following the Civil War.[5] To a large segment of the urban population the concept of "country" became an essential counterpoint to lives increasingly circumscribed and regulated by the dictates of commerce and industry. As Henry Adams expressed it, to his generation "Town was . . . confinement, school, rule, discipline. . . . Town was restraint, law, unity." In contrast, "Country . . . was liberty, diversity, outlawry, the endless delight of mere sense impressions given by nature for nothing and breathed by boys without knowing it."[6] This ideal ultimately found tangible form in the resorts that sprang up along the New England coast and in the woodlands and mountains of the Northeast. Homer himself documented America's fascination with the rural and seaside retreat, first in illustrations in the 1860s for *Harper's Weekly* and other popular pictorial maga-

zines and subsequently in his Gloucester and Houghton Farm subjects of the 1870s. He clearly understood this social and cultural phenomenon well.

As a painter Homer was not unique in this period in retreating from the city to experience people and places unknown in urban culture. Many native artists who established themselves in country studios helped to advance, or at least reinforce, public interest in particular resort locales.[7] This trend had begun early in the century with Thomas Cole, who had established a well-known studio in Catskill, New York, in 1836, and with the summer sketching trips of America's nomadic first generation of landscapists. By the early 1880s most prominent landscape artists and many notable genre painters had established themselves in rural or seaside studios of varying character, with which they were associated in the popular imagination. In the pastoral Hudson River valley, for example, Frederic Edwin Church had built his magnificent

home and studio, Olana, near Hudson, New York, in the early 1870s; Jasper Cropsey was ensconced at his gentleman's farm and studio, Aladdin, near Warwick, in Orange County, by 1869; and Albert Bierstadt was settled in his grand Malkastan, in Irvington-on-Hudson, built in 1865–66 and destroyed by fire in 1882.[8] Also on the Hudson, in more rustic surroundings, George Inness had made a summer studio from an old barn in an apple orchard in Milton, New York, by 1885.[9] To the west, at Cragsmoor, in the Shawangunks, Edward Lamson Henry had established his studio in 1883 near the picturesque villages of southern Ulster County, which provided settings for his historical genre pictures; nearby, in the Neversink Valley of the Catskills, genre painters Seymour Joseph Guy and John George Brown had found rustic studios in Sullivan County.[10] Farther north Alexander Helwig Wyant had a summer studio in Keene Valley, New York, from 1875 through the late 1880s; and in Mountainville, New York,

Houghton Farm, with its "thousand acres of woodland and meadow" that had attracted Homer in 1878, was the regular summer haunt of Frederick Stuart Church.[11]

At the same time, along the New England seacoast, R. Swain Gifford and William Sartain were living year round in the village of Nonquitt, near New Bedford, and the lesser-known marine painter William Formby Halsall had a summer workplace on rugged Middle Brewster Island, in Massachusetts Bay.[12] Alfred Thompson Bricher, Henry Farrer, and James Nicoll were among a group of artists reported in 1885 to have had "summer sheds upon the rocks at Magnolia, Marblehead, Pigeon Cove, Cape Ann, and other points" on the Massachusetts coast.[13] Eastman Johnson kept a studio on Nantucket through the 1870s, chronicling, according to one observer, "a phase of our national life which is fast passing away, and which cannot be made up with old-fashion plates and the lay figure of the studio."[14] Even fashionable Newport, thought by this period to be too social and stultifying for the true artistic temperament, regularly attracted John La Farge and William Trost Richards as well as Samuel Colman, who, by 1885, had "dared to build a beautiful studio and home in the very center of the summer Vanity Fair."[15] Farther south, in rural Easthampton, Long Island, "the most popular of adjacent sketching grounds for New York artists," were the studios of painters Charles Yardley Turner, James Smillie, Hugh Bolton Jones, Bruce Crane, and Thomas and Mary Nimmo Moran.[16] According to a contemporaneous report, here, in particular, was scenery aplenty for the lover of nature and the painter of American country and seacoast life:

Nowhere on our coast can be found quainter houses and people, fishermen more available as models, or old salts with more marvelous stories of wreck and rescue, more foghorn keepers and light-house men, or men of more isolated lives and rugged individuality. . . . Here are rural nooks for the landscape-painter delightfully English in sentiment. Here are beach and sea panoramas, stormy cloud-battles, or shimmering calm for the marine-painter. Here are associations and legends . . . and here are salt sea-breezes and sunshine for all.[17]

In the 1880s and 1890s the firmly established trend toward summer migration and the resort movement were changing the look and character of rural America in ways that are worth noting, since they enhance our understanding of Prout's Neck life and society in Homer's day and contribute to our appreciation of his choice of locale. A definite pattern of development in America's popular vacation spots had emerged by the end of the nineteenth century. So widely perceived was this pattern that it could be satirized by William Dean Howells in his 1896 novel, *The Landlord at Lion's Head*, a moralizing story of the corrupting influence of a growing resort hotel on the rural landscape and people. Cultural historian Hans Huth has documented three distinct stages that characterized the growth of most nineteenth-century resorts, stages that are well illustrated by Howells's narrative.[18] The first phase depended largely on artists and writers, who typically were the first to explore picturesque outposts. Then, through their art, these sensitive observers drew others to a particular site. Howells, for example, makes the character of Westover, a romantic landscape painter, his vehicle for change in a small area of New England farm country. Westover's fascination with the region inspires one struggling farm family to establish a hostelry and attract other visitors, and his painted view of fictional Lion's Head Mountain serves to promote the place to art patrons in New York.[19]

As the numbers of visitors to a region increased, the natives—usually farmers—were compelled to accommodate and serve them. Humble homesteads became boarding houses. Eventually, these were transformed by enthusiastic owners into grand, if rustic, hotels, providing their proprietors with business far more lucrative than their traditional rural occupations. In this second stage of change, seasonal visitors brought "improvements" and their refined social order to the country. In return the country folk provided the means by which these casual observers could apprehend a place in detail. This phase, too, is illustrated in *The Landlord at Lion's Head*. Howells's character Whitwell is a naïve farmhand whose imagination is fired by the so-called improvements that come with the resort, and he marvels at the "'rennaysonce'-style" structure that is erected in place of the old-fashioned farmhouse.[20] He also congenially does his part to serve resort guests by running the livery, waiting tables, or leading "Tramps Home to Nature," walks and talks for city ladies unfamiliar with the great outdoors.[21] Whitwell embodies the change in rural landscape and values that accompanied the second phase of change.

Eventually, then, the hotels became seasonal homes to an ever-larger and more socially disparate clientele as the luxury of leisure time became available to the country's growing middle class. By this point the third stage of resort development had begun. The aristocratic old guard among the transients soon sought both refuge from the crowds and redefinition of the class lines that had become blurred in the popular resort hotels. These people bought parcels of adjacent land and built cottages. At the fashionable seaside resorts, such as Nahant, Newport, or Bar Harbor, the cottagers also tended to secure private owner-

ship of beaches and the picturesque shoreline, erecting an unsightly grid of property fences that disrupted the natural lay of the land and denied free access to the shore's natural beauty and delights.[22]

When Homer and his family acquired land at Prout's Neck in 1883, the resort was already well into its second phase of change. Sometime in the late 1860s, key landholders had realized the potential in developing the area for recreational purposes, and several natives had built and managed small hotels that were in full operation by the early 1870s. The younger members of Prout's old Libby family—the family that gradually had acquired all of the Neck in the late eighteenth and early nineteenth centuries—led the way: on the west side they built Cammock House and the West Point House, and on the east side they erected the popular Willows. Other natives joined in. Harry Kaler established the Southgate Inn, and the Foss family built the famous Checkley House (fig. 22), the "social center" of Prout's Neck.[23] Subsequently, several other hotels were established by locals, including the Atlantic House, Centennial House, Kirkwood House, Lee Cottage, and Prout's Neck House.[24] By 1880 John Staples Locke's guidebook to the area, *Shores of Saco Bay*, could describe the amenities of the resort for transients and would-be cottagers in this way:

> There are several hotels and boarding houses at this place. The Checkley House, under the management of Mr. Ira C. Foss, stands at the southeastern end of the Neck, near the ocean, in a charming spot; and the West Point House, on the west-point of the Neck, has accommodations for seventy-five guests, and is kept in the most thorough manner by Thomas J. Libby. The location of the house is most lovely. It overlooks the ocean, the islands, and the distant shores of Old Orchard and Pine Point. The proprietor is one of those jovial landlords who studies care-

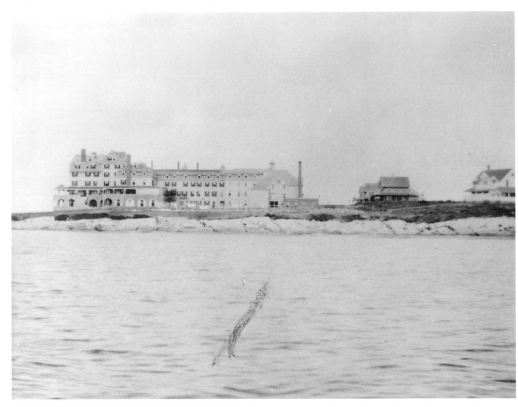

Figure 22. *The Checkley House, on the Southern Tip of Prout's Neck, Maine.* From *Album of Photographs of Prout's Neck—C. S. Homer's Cottages,* circa 1908, compiled and annotated by Winslow Homer. Silver print by unknown photographer. Bowdoin College Museum of Art, Brunswick. Gift of the Homer family, 1964. The Ark, the Charles Savage Homer house, is at the far right.

fully the wants of his patrons, and makes his house popular. He has a large tract of land on the Neck, which he offers on reasonable terms to those who wish to erect substantial summer cottages. Elegant cottages have been built this year; and as the place is one of great natural beauty, doubtless Mr. Libby will see a cottage settlement grow up around him in a few years.[25]

That Prout's Neck was on the verge of a resort boom by 1880 was not, of course, due solely to the initiative of the natives. Their efforts received necessary help from the railroads and steamship lines. In 1873 the Boston and Maine Railroad was opened through to Portland, bringing service to the seacoast towns of Wells, Kennebunk, Saco,

and Scarborough.[26] By 1880 four express trains passed daily between Portland and Boston, in addition to the frequent local trains between Portland and Kennebunk. For travelers, another pleasant way to make the journey to southern Maine was via the inexpensive overnight steamer of the Boston and Portland line; from Portland, steamer passengers could catch a local train and be at Prout's Neck or nearby Old Orchard "in time for early breakfast."[27] The accessibility of the region in summer was touted by travel promoters. Writing in 1895, one enthusiastic down-easter bragged that southern Maine's virtues—"its bracing air, its pure water, its varied scenery, and its exemption from those contagious diseases

of a fatal character"—were so readily available via rail or steamer "that even the most fastidious cannot fail of being suited if only he finds the right spot."[28] Thus, part of the attraction of Prout's for visitors was surely its convenient location at the edge of modern society. It was connected to cities throughout the Northeast by a major rail network and sea line, and, for the city folk who stayed there, civilization was never too far away.

The Homers were among the very first of the newcomers to build summer homes at Prout's Neck. This suggests something of the unique situation that presented itself to Winslow when he settled on the site of his studio-home. Prout's Neck provided him and his family with the opportunity to set the tone for future development, and they had the vision and financial resources to do this in an extraordinary way. Indeed, it was largely through the Homer family's efforts that Prout's Neck became the distinctive

resort it is today.[29] Homer himself played an active role in his family's real-estate dealings and building activity, a fact that emphasizes the appeal the area must have had for him as a painter. Here, simply put, he was allowed to shape his environment to suit his needs both personally and artistically.

The first deliberate and important action the Homers took to establish their family compound at Prout's Neck was to buy large contiguous parcels of land on the undeveloped oceanfront at the southeast tip of the Neck. At the time this was rather a bold move, as most settlers had deliberately avoided the cliff shore. Rupert Sargent Holland, an early resident historian, explained why:

> Most of the earlier of the summer cottages were located away from the shore, the land along the cliffs in particular being regarded as much too exposed to storms to be attractive for dwellings. The fields that bordered the rocks were also more or less bare of bushes

and trees. On the bay side and in the meadows in the central part of the Neck, where the woods afforded protection from gales, many of the first cottagers built.[30]

The Homer property, on the opposite side of the Checkley House from Saco Bay, was then considered "the wilderness" (fig. 23).[31] The shore there, Holland wrote, "was more exposed from the ocean and barren of trees or much vegetation, but there was a wide view of the open sea, and in the foreground were the ledges and cliffs against which the waves tossed their white crests in fine weather and thundered in gales."[32] Such a site, while unattractive to many cottagers, would have had obvious appeal for a marine painter, and Homer's interests must have been a factor in the family's purchase of this land.

The Homers acquired most of their oceanfront property in several transactions over an eight-year period, from 1883 to 1891.[33] Perhaps the most significant pur-

chases were those made in early 1883 and 1884, for they established the building program that would include Homer's studio-home and determined the direction in which he and his brothers, Charles and Arthur, would expand and develop their land holdings. The first acquisitions were two groups of lots near the popular Checkley House which were owned by Hannah Louise Libby Googins.[34] Googins had inherited most of the Neck from her two Libby siblings, and in 1882 she and her husband, Alonzo, were finalizing plans to open a boardinghouse on the undeveloped ocean-front tract of Libby land at the southeast end of the Neck. They already had commenced building a house and stable there when financial problems befell them, and they were obliged to abandon their plans. They sold these blocks of lots, with the partially constructed homestead attached, to Charles Homer, Sr., in two transactions in January and February 1883. In March of that year Charles Homer, Jr., took control of the property, entering into a gentleman's lease arrangement with his father, whereby the elder Homer paid his wealthy, generous, and supportive son a token annual rent for use of the property and the family home that was built there.[35] In November 1884, in the last of their major real-estate acquisitions, the Homers extended their holdings to include much of the Neck's Atlantic shoreline when the elder Homer purchased the eastern division of Libby land.

The Homers quickly took steps to create their own building plan, which would have ramifications for the architectural look of Prout's Neck and for Winslow's own interests. Unlike Arthur Homer, who in 1882 built his nearby cottage, El Rancho, from his own rather idiosyncratic scheme, Charles Homer, Sr.—possibly acting under guidance from Winslow—chose to build a distinctive architect-designed home, either al-

tering the existing Googins structure or beginning anew with his own program, which he formulated as early as 1882.[36] For this undertaking he and his sons commissioned the Portland architectural firm of Fassett and Stevens.[37] The project was significant, for it revealed that the Homers had from the outset a well-conceived notion of cottage design which would influence their subsequent building. For the firm's junior partner, John Calvin Stevens, the commission initiated what was to become a long, productive, and significant association with Prout's Neck, the Homer family, and Winslow Homer in particular.

The elevations (figs. 24, 25), probably drawn by Stevens, who was by then the firm's chief designer, give little evidence of the young man's future work in the burgeoning Shingle Style. Like most of Stevens's early domestic work, the Charles Homer house has Queen Anne characteristics: a nearly symmetrical facade, rationally articulated fenestration across the west side, and neo-Colonial architectural details, such as the prominent front pediment and balustrades and the classical fanlight in the gable. Still, in its generous use of natural shingles across the second story and its massing of units into one monumental silhouette, the design for the Ark—as Homer's father christened his cottage—suggests Stevens's emerging sensibility. That sensibility would be articulated in subsequent Homer family buildings at Prout's Neck, particularly the design for Winslow's studio.

Although Stevens's plans for the Charles Homer cottage (fig. 26) clearly show the family's intention to provide rooms and a studio for Winslow at the north end of the house on the second floor, the artist chose not to live in the Ark. Claiming the small carriage house that stood behind the house, he moved it farther north, to land he purchased from his brother Charles, and hired

Stevens to renovate it for use as a simple year-round studio-home.[38] Its design reveals much of what the painter valued in Stevens's architecture and much of what he found important to his own art.

That Stevens should have accepted Winslow Homer's relatively modest commission in late 1883 or early 1884 testifies to the architect's appreciation for the artist's basic outlook regarding his home and studio. Such a project would not easily have been completed without a common vision. Homer made an emphatic statement in choosing the carriage house for his use, and—as this was to be his sole living and working place—must have had preferences regarding how the limited space might be arranged for his maximum comfort and utility. By the same token, Stevens was an architect of strong convictions, a vocal idealist with deeply held beliefs on the socializing role of buildings and architects in modern society, the importance of high-quality domestic architecture in fostering humanity's regard for its environment, and the design principles that best served this larger social need. Stevens articulated his progressive social and aesthetic views in a treatise now considered to be one of the watersheds of late Victorian theory: *Examples of American Domestic Architecture*, published in 1889 in collaboration with his then partner, Albert Winslow Cobb. Their treatise established Stevens and Cobb as leading proponents of the Shingle Style in America.[39]

In the key elements of Stevens's design for Homer's studio, we see evidence of the vision these two men must have shared: an appreciation for simplicity, a concern for the relationship of building to site, and an understanding of the special studio needs of the outdoor painter. As the elevations show (fig. 27), Stevens did little to alter the basic characteristics of the original struc-

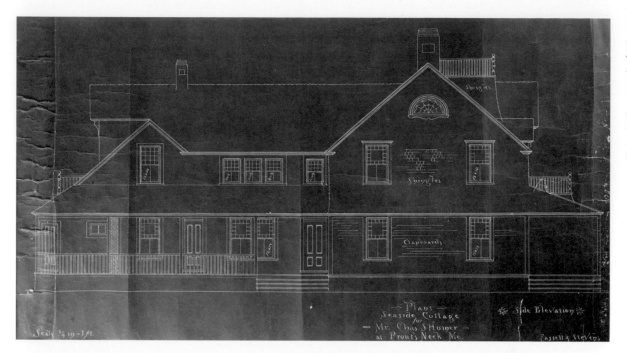

Figure 24. Francis Fassett and John Calvin Stevens, architects, *Seaside Cottage for Mr. Charles Homer at Prout's Neck, Maine: West Elevation*, 1882. Blueprint. Bowdoin College Museum of Art, Brunswick. Gift of Earle Shettleworth, Jr., for the Maine Historic Preservation Commission, 1989.

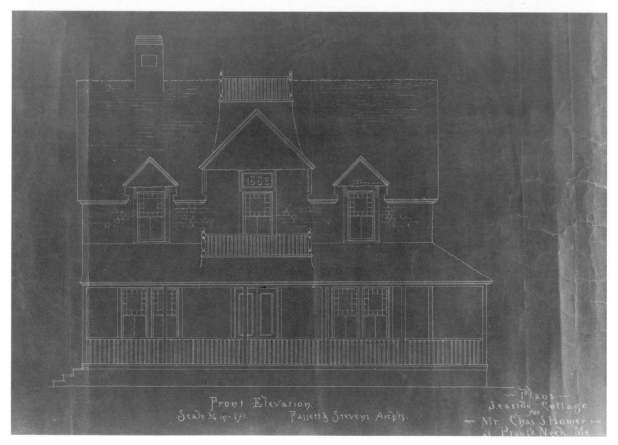

Figure 25. Francis Fassett and John Calvin Stevens, architects, *Seaside Cottage for Mr. Charles Homer at Prout's Neck, Maine: Front Elevation*, 1882. Blueprint. Bowdoin College Museum of Art, Brunswick. Gift of Earle Shettleworth, Jr., for the Maine Historic Preservation Commission, 1989.

ture, with its four plain walls and picturesque mansard roof enclosing one small, open space (fig. 28). His renovations almost glorified or heightened the dignity of the carriage house's innate simplicity, suggesting the value that both architect and client placed on that feature. Although Stevens added the piazza that projects from the original roof and wraps around the second story, he did not actually enlarge the living space. The lower floor essentially remained one room with small adjacent chambers, a large fireplace for heating, and a staircase leading to the second floor and balcony (fig. 29). Upstairs there was a bare sleeping space under the roof.

The small, spare studio-home was inexpensive to maintain, and the artist did not have to depend heavily on the sale of paintings to sustain such a modest lifestyle. By extension, then, the small space ensured a measure of artistic freedom, freedom from dependence on the taste of a large art-buying public. This concern may have influenced Homer's determination not to live at the Ark, since the large house would have been costly to staff and maintain year-round. But, perhaps more to the point for Homer's work, such primitive surroundings served to bring him closer to raw nature. Like Henry David Thoreau at Walden three decades earlier, a painter here might be allowed "to live deep and suck out all the marrow of life, to live so sturdily and Spartan-like as to put to rout all that was not life."[40] As Homer himself put it during bitterly cold December 1888, when writing to

Figure 26. Francis Fassett and John Calvin Stevens, architects, *Seaside Cottage for Mr. Charles Homer at Prout's Neck, Maine: Second Floor Plan*, 1882. Blueprint. Bowdoin College Museum of Art, Brunswick. Gift of Earle Shettleworth, Jr., for the Maine Historic Preservation Commission, 1989.

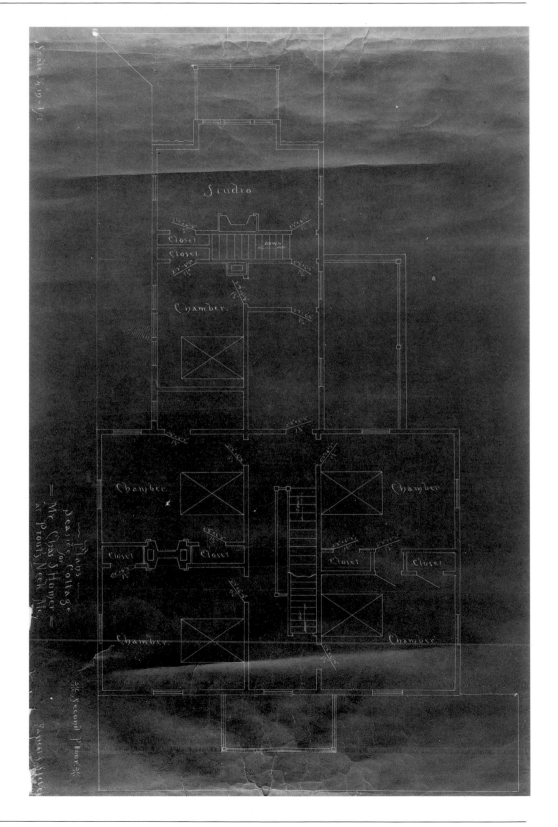

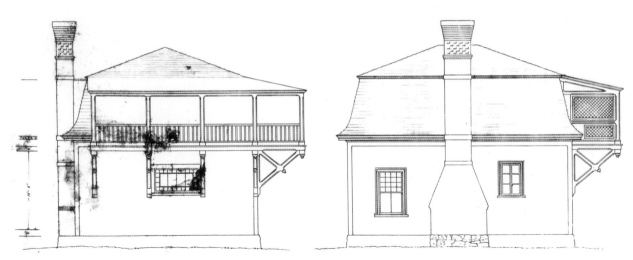

Figure 27. John Calvin Stevens, *Design for Conversion of Stable into Winslow Homer's Studio, Prout's Neck, Maine: East and South Elevations*, circa 1883. Ink on paper. Bowdoin College Museum of Art, Brunswick. Gift of the Homer family, 1964.

his father of the physical discomforts he endured due to an ineffective heating stove and frozen water, "I thank the Lord for this opportunity for reflection." Something of the philosophical component of his decision to live in such a rustic studio-home is revealed in this statement.[41]

Stevens also imbued the plain structure with special meaning. In *Examples of American Domestic Architecture* he and Cobb declare resolutely their taste for simplicity. "No apology will be offered for the manifest democratic plainness characterizing our work," they wrote. "We have, in setting forth our opinions, striven to declare unmistakably that we consider this characteristic most desirable."[42] Building modest structures like Homer's studio-home was, to Stevens's mind, highly important, "good" work in an ethical sense. He and Cobb stated:

> If it be even a mere shell of a wooden summer cottage that he is called upon to contrive, [the architect] need not despise the work; he may well give his best thought to making the house graceful, to grouping its rooms effectively and conveniently, and to inventing bits of pretty detail here and there; for though the structure be only ephemeral, while it does endure it is the home-shrine.[43]

Throughout their text Stevens and Cobb equate simplicity in domestic architecture with basic Christian values, and therein lies the basis of their design aesthetic. For Stevens these values were especially evident in the wholesome environment of Maine's coastal cottage communities, where, to his way of thinking, noble, contented, selfless people lived simply and spiritually, close to "the unperverted things of nature"; as he and Cobb elaborated:

> Here abound dwellings which express in a simple, primitive fashion, more or less graceful, the idea of home-comfort. Worthy of all reverence is the truly noble domestic life of which these dwellings are the scene. Within their walls men, women, and children, drawing their inspiration from the words of the Bible, cherish holy ideals and live reverent, brave lives; caring with all the heart and soul for each other.[44]

Stevens's avowed preference for Maine's rustic cottage architecture was clearly tied to his view of the moral estate of those who would inhabit such unpretentious abodes, and in his own work he aspired to create the embodiment of virtuous home life and self-sacrifice—to create, in his own words, "the harmonious co-operation between material arts and Christian ethics."[45]

That the character of the renovated carriage house should communicate something of the need and respect for simplicity that Homer and Stevens both felt is due to the cogent formal vocabulary the architect employed. The design is as exquisitely simple in its detail as in its overall concept. Believing that "broad spaces of plain wall render all the more effective the rare ornamentation which is here and there contrasted with them," Stevens allowed unadorned clapboard siding to carry the exterior design.[46] Against this he set an irregular pattern of a few small windows, suggestive of the informal arrangement of interior spaces; a large brick chimney; and the decorative, handcrafted brackets and balustrade of the balcony, elements derived from the simple, hand-hewn ornaments on American Colonial houses. All across the plain exterior, emphasis was placed on materials, craftsmanship, and the sheer beauty of wooden construction, an emphasis that was characteristic of late nineteenth-century American cottage architecture in general and that was a hallmark of Stevens's work in the Shingle Style.

The most obvious change Stevens made in the carriage house was to orient it toward the sea by means of the large piazza, a bold

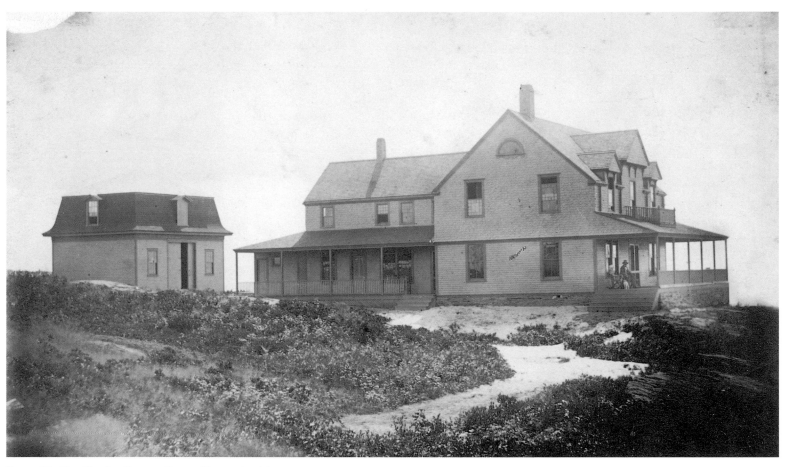

Figure 28. *The Charles Savage Homer House, the Ark, and Stable, Prout's Neck, Maine*, circa 1883. Silver print by unknown photographer. Bowdoin College Museum of Art, Brunswick. Gift of the Homer family, 1964.*

Figure 29. John Calvin Stevens, *Design for Conversion of Stable into Winslow Homer's Studio, Prout's Neck, Maine: First Floor Plan*, circa 1883. Ink on paper. Bowdoin College Museum of Art, Brunswick. Gift of the Homer family, 1964.

Scale ¼ in = one foot.

move in the context of existing building at Prout's Neck. In this way he exhibited his complete understanding of the site and of Homer's purpose in selecting it. The artist considered this particular point on the southeast headlands to be the "finest lot on this Neck" because of the panoramic view of the cliff-lined shore and open sea it afforded.[47] In his design Stevens took advantage of the studio-home's unique location principally through his use of the prominent second-story balcony. By this time the piazza was a standard feature of American resort architecture and had been recognized by cottage architects from Andrew Jackson Downing on as an effective means to extend domestic spaces into nature, a conceit deemed especially appropriate to buildings designed for summer pleasure.[48] In the case of Homer's studio-home, the singular importance of the piazza and Stevens's integration of it into the overall design suggest more than a conversance with the vocabulary of resort architecture; it underscores his sensitivity to the site as the inspiration for Homer's art and life. The covered piazza, which wraps around the tiny structure on the east and north, would allow Homer direct experience of the sea from a broad vantage, in all seasons and conditions and at any time of day. A vast expanse of nature would thus be brought inside, under an all-encompassing roof, and would be, as a consequence, ever-present in the studio. For reasons of practicality, Stevens also seems to have planned the wide balcony as a necessary extension of the roofline over the two exposed sides of the structure to provide some protection from the elements to the spaces below; in so doing he further demonstrated his skill in creating, through a remarkable economy of means, a happy union of building and environment.

Stevens's sensitivity to Homer's particu-lar studio needs is no doubt due in part to the architect's own interest and background in landscape painting outdoors. An accomplished, if amateur, landscape painter, he was a guiding force behind the Brushians, a group of plein air painters and followers of Portland landscape artist Charles Frederick Kimball who, in the 1880s and 1890s, regularly tramped Maine's southern coast with their painting kits, seeking out picturesque views, the invigorating experience of the outdoors, and the conviviality of an artistic brotherhood.[49] In his plan for Homer's studio Stevens eschewed the conventions: a commodious space with a vast source of steady northern light, expansive wall space for props and the display of finished pictures, a substantial, well-positioned fireplace for the comfort of the painter and models, and a congenial area for the repose of artist and visitors alike.[50] The architect must have known that such things were of little consequence to his client, who professed disdain for paintings done wholly within the contrived atmosphere of the studio, saying in a rare interview published in 1880:

> I prefer every time a picture composed and painted out-doors. The thing is done without your knowing it. Very much of the work now being done in studios should be done in the open air. This making studies and then taking them home to use them is only half right. You get composition, but you lose freshness; you miss the subtle, and to the artist, the finer characteristics of the scene itself.[51]

Stevens also understood that there was no need to provide Homer with the typical "show" studio, since he had a ready outlet for his paintings through dealers in Boston and New York and thus had no concern for accommodating patrons.[52]

Homer's satisfaction with his new work-place and home was immediate. He wrote to his beloved sister-in-law Mattie in June 1884, as construction was nearing completion: "The Studio will be quite wonderful. Will have it finished in about a week. It's very strong. The piazza is braced so as to hold a complete Sunday school picknick. Charlie will be very much pleased with it."[53]

Although only a few visitors to Homer's studio reported on its interior, some of the extant descriptions offer fascinating clues to his working methods. One of the first visitors in 1884 may have been the Boston newspaper columnist who asked,

> Where does he get his human impressions and emotions? . . . It is hard to tell, for the artist lets no one see him work, nor, unless you are an unwontedly favored person, will he let you in his door or even peep through his window, or perhaps upon his ground at all without some ostensible business. But should you enter, you would be apt to feel the place alive with sketches, chiefly in black and white, for which he became famous, even before mastering color—evidently caught from vivid life and motion. They are on the walls, nooks, crannies, everywhere.[54]

John Beatty, director of the Carnegie Institute in Pittsburgh, visited Homer in early September 1903, recording his impressions of the place and discussions with the artist. In 1923–24 he drafted a manuscript account of those days which was later published by Lloyd Goodrich. Beatty's recollection stands as the fullest firsthand report of the painter's daily life and work at Prout's. Of the studio and its contents he wrote:

> The interior of Homer's studio was as plain as the exterior. It was a mere workshop. At one side was a large table covered with tubes of paint, brushes, and other materials. In the center stood a small stove, to heat the room. On the walls were fishing rods and other articles for fishing and hunting. A few sketches, as I remember, hung on the walls.[55]

Figure 30. Winslow Homer, *Sketch for House at Kettle Cove, Prout's Neck, Maine*, circa 1901. Ink on paper. Location unknown.

In addition to confirming Homer's propensity for arraying drawings about his work space, Beatty documented another of the artist's unusual studio habits. Homer, it seems, used his balcony as a place to study paintings in progress from a distance, an impossible feat in the small first-floor workroom. He hung his canvases from the balustrade and apparently eyed them from the shoreline path, from which, he told Beatty, he "could see the least thing that was out."[56]

The studio as Stevens designed it served Homer for seven years during what was a period of discovery marked by close, exploratory studies of the cliffs, sea, weather, and atmosphere. In 1890 the artist's brother Charles made him a gift of a small painting room built onto the northwest side of the existing structure.[57] Though modest, this nearly doubled the area of the first floor, providing what must have been welcome work space. It is significant that the construction coincided with Homer's enthusiastic return to large-scale painting in oil following a two-year hiatus, when he chiefly made watercolors and drawings. The connection between the enlargement of the studio and Homer's renewed painting activity may, in fact, be the subject of an undated and rather tongue-in-cheek letter to Charles, in which the artist jokes: "Very bad pen but write to say that my Factory after being shut down for two years, is to be opened for the

month of June—every day, Superintendent engaged, & hands—pay noble $3 per day."[58]

Homer's painted view of his home, *The Artist's Studio in an Afternoon Fog*, was given to architect John Calvin Stevens in 1901 at the completion of his work that June on a second house for Homer at Prout's Neck, a large Shingle Style cottage at Kettle Cove, near Eastern Point, which Homer had built as a rental property. The two men collaborated closely, with Homer providing a preliminary plan for the structure (fig. 30) and tending to such tasks as clearing the land, installing drainpipes, planning the design of the windows and front door, and building a stone entrance wall (fig. 31). Although surviving correspondence documenting the project deals principally with mundane matters of construction, Homer and Stevens must have cemented their friendship in the course of their work on Kettle Cove, as the house was named, for the completion of the project saw an extraordinary exchange of tributes between them. Stevens's regard for Homer's art prompted him to request a painting in lieu of payment for his design services. Touched by Stevens's request, Homer said in his reply:

> I am very much surprised and pleased at your bill—This kind of thing occurs seldom in matters of business—The interest that you have shown in this cottage of mine and the

valuable time that you have given to it in your busy season and your success in producing it—shows [*sic*] me that I can Greet you as a brother Artist—& thanking you sincerely,—I send you this sketch of mine that I think is appropriate & will please you—.[59]

Homer's "sketch" was a fine painting in oil, the subject of which had obvious associations for both men. The painter himself must have been attached to this work, for it had hung in his studio for seven years. His gesture speaks eloquently of the high regard he had for Stevens's art.

The construction of the first Homer houses at the southeast tip of the Neck signaled a new phase of development in the area. Over the next twenty years, and due in large measure to the efforts of the three Homer brothers, a cottage community fanned out from the Ark and Winslow's studio across the headlands to the east and west shores (fig. 32). The Homers, eventually acquiring most of this property, developed a significant portion of it themselves, building rental cottages or designating parcels for public use. About 1887 Charles Homer, Sr., gave land fronting on Winslow's studio for Saint James Episcopal Church (fig. 33), an addition the artist considered "of great value to the property here."[60] The family's various rental cottages, which Winslow actively managed on behalf of his brothers, included Black Rock, built for

Figure 31. *Winslow Homer Standing in Front of the Stone Wall He Built at Kettle Cove, His Property near Eastern Point at Prout's Neck, Maine*, 1902. Silver print by unknown photographer. Bowdoin College Museum of Art, Brunswick. Gift of the Homer family, 1964.*

Charles Homer, Jr., in 1890 by a local builder, Francis Xavier Jannelle, and five houses constructed between 1891 and 1908 that can be traced or ascribed to John Calvin Stevens: Briarwood and the Walnuts, owned by Arthur; the Briary and the Coop, owned by Charles; and Winslow's Kettle Cove. In 1903 the painter gave or sold land to the bishop of Portland for the construction of a Roman Catholic church. Winslow also constructed bathhouses on Scarborough Beach for public use (fig. 34) and in September 1908 gave them to the Prout's Neck Association, the residents' oversight organization that had been established a decade earlier. In September 1909 Charles

made a parcel of land available to the Country Club in consideration of his desire "to promote the welfare of Prout's Neck"; just prior to the artist's death in 1910, he and Charles gave the Prout's Neck Association the large wooded parkland, known today as the Sanctuary, which now includes a dedicatory plaque acknowledging their generosity.[61]

His letters and other documents clearly show that Homer took an active interest in his family's properties at Prout's Neck. To Charles, for example, he wrote in March 1896 that he did not wish to visit New York because "I have things to do here that interest me more. I have just returned from burn-

ing brush over on the Eastern Point. I will take New York after I get through with this place."[62] The artist's greeting to his brother Arthur on January 1, 1901, consisted solely of his enthusiastic report on the building activity planned for the coming year: "There are several new things going on here. Thomas Merrick putting a wing on his house. Proctor building on D. Street opposite the head of I. Street facing Eastern Point—Charlie building corner of B. and C.—I am getting land cleared on which to build."[63] Similarly, in December 1907 Homer revealed how eagerly he awaited construction on a lot he had sold to a cottager from Rydal, Pennsylvania; as he wrote

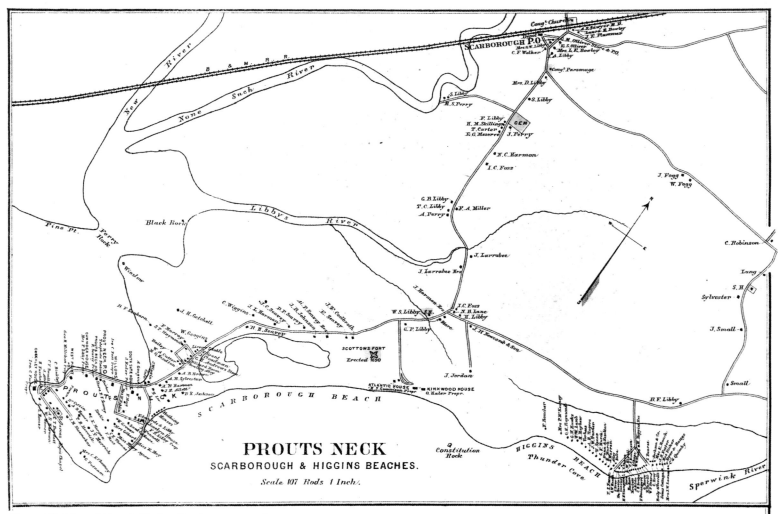

Figure 32. *Map of Prout's Neck—Scarborough and Higgins Beaches*, 1895. From *Stuart's Atlas of the State of Maine, 1894–95* (South Paris, Maine: J. H. Stuart and Co., 1895).

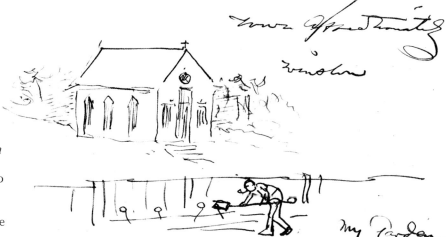

Figure 33. Winslow Homer, *Sketch of Saint James Episcopal Church, Prout's Neck, Maine*. From letter to Mattie Homer, June 19, 1887. Ink on paper. Bowdoin College Museum of Art, Brunswick. Gift of the Homer family, 1964.

Figure 34. *Bath Houses, Scarborough Beach, Prout's Neck, Maine, Built by Winslow Homer,* circa 1908. Silver print by unknown photographer. Bowdoin College Museum of Art, Brunswick. Gift of the Homer family, 1964.

to Charles, "I am enjoying every minute of my life here—busy outdoors and in. Curwen Stoddart, Jr. is expected down here soon—his house will be a grand affair. Very soon I will make you a sketch of it as soon as the first story is up."[64] Even more graphic evidence of Homer's concern is his annotated snapshot album compiled as a record of family properties, a visual survey of the Homer family's lasting mark on Prout's Neck (fig 35).[65]

The Homers helped to shape Prout's Neck in another way—through the sale of lots to other cottagers. Especially in the first decade of the twentieth century, Winslow was actively involved in developing the large parcel of land he had accumulated between 1884 and 1899, when, on settling their father's estate, Charles Homer had transferred to Winslow one-half of the large tract on the eastern shore that had been bequeathed to Charles himself as the eldest

son.[66] The implications of such growth were, for Homer, quite agreeable.[67] First, income from the rental and sale of properties permitted him to work unencumbered by a consideration of painting sales. This surely would have been a comfort to the man who wrote of his art sales in the early spring of 1897: "Other things, Big Things, are booming. I have made $100 cash. $120 of it will go for frames and that is my season's profit. All well by being very careful."[68] Also, Homer may have seen this income as a means of support in old age; he came to feel that his deteriorating health would cause him to give up painting. Perhaps more to the point is the fact that he knew he had a great deal of control over how development would affect his view of the Neck. Because he owned nearly the entire eastern stretch of shore property, he could sell lots selectively, with an eye toward balance, moderation, and harmony with the land-

scape. He enjoyed the benefit of a farsighted provision made in the legal division of the Neck in 1879 to maintain a broad, public marginal way around its perimeter, a way that had to be kept free of obstacles (fig. 36). Because of the marginal way, the cliffs would always be accessible to Homer for his walks and his painting, even though the land adjacent to the path might be privately held; thus, future building would not impede his freedom to come and go along the shore. Since the marginal way ensured a wide expanse of open shoreline, even with development the view from Homer's balcony remained broad and unobstructed.[69]

Homer's direct involvement in the development of his properties at Prout's Neck suggests a close connection with the society that evolved there as the summer cottage community was established. Although many writers have contributed to the now well-known myth of Homer's misanthropy, the truth is that the painter enjoyed, and even helped to foster, a social structure at Prout's Neck that was beneficial to him personally and artistically. In Homer's day the community conformed almost perfectly to what one popular social commentator described in 1899 as the ideal environment for the creative spirit, a place quite extraordinary in American culture

where men and women of the world [could] meet on an equal footing and under absolutely harmonious conditions for a free interchange of thought and stimulation, those who have attained eminence in the arts and sciences and professions . . . a few dozen men and women who have known the most that society could offer in every civilized country, and have that large practical wisdom, and knowledge of men and life, which such an experience gives, yet through the force of exceptional circumstances, or some richer well-spring in the nature, have kept a clear vision of the deeper meanings of things.[70]

Figure 35. *View of Winslow Homer's Studio.* From *Album of Photographs of Prout's Neck— C. S. Homer's Cottages*, circa 1908, compiled and annotated by Winslow Homer. Silver print by unknown photographer. Bowdoin College Museum of Art, Brunswick. Gift of the Homer family, 1964.

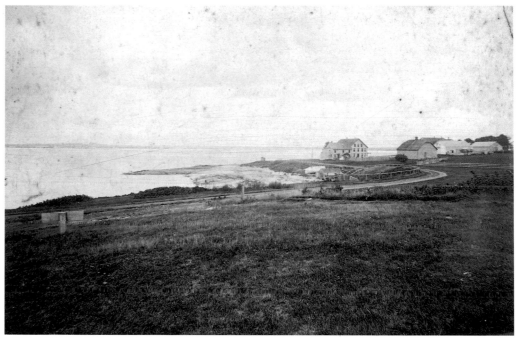

Figure 36. *View of West Point, Prout's Neck, Maine, with Arthur Homer's Boat, the* Mattie, *on the Marginal Way*, 1890. Silver print by Simon Towle, Lowell, Massachusetts. Bowdoin College Museum of Art, Brunswick. Gift of the Homer family, 1964.*

Figure 37. *Winslow Homer and Family and Friends at Corn Roast, Kettle Cove, Prout's Neck, Maine*, after 1895(?). Silver print by Simon Towle, Lowell, Massachusetts. Bowdoin College Museum of Art, Brunswick. Gift of the Homer family, 1964.*

The summer residents shared fundamental qualities of outlook and character compatible with Homer's own interests and temperament. Although the cottagers were all people of affluence, they were not, generally speaking, the sort who typically were drawn to the fashionable resorts in search of luxury and celebrity; there was little at Prout's Neck to attract such nomadic social climbers. Rather, most of those who built residences there were, like Homer himself, people who returned to Prout's Neck year after year, men and women of education, accomplishment, and enlightenment who found pleasure and satisfaction in the rugged beauty of this special stretch of Atlantic coastline. They were, too, individualists who valued independence, as Homer did, and who helped to keep Prout's Neck sparsely settled and private.

Homer's friends and neighbors included wealthy philanthropists such as Charles E. Morgan, whose brother bought the artist's

Right and Left (1909; National Gallery of Art, Washington, D.C.). Morgan was a prominent Philadelphia lawyer and a member of that city's board of education. Phineas Sprague of Boston, who acquired land from Arthur Homer, owned mines and coal companies throughout the Northeast and in West Virginia. J. Vaughan Merrick, who built the Briars about 1888, was a Philadelphia industrialist and founder of the Franklin Institute.[71] Homer's neighbors also included esteemed clerics and theologians, among them Bishop Charles E. Cheney of Chicago, who built the Barnacle sometime between 1888 and 1892 and who was the founder and senior ecclesiastic of the Reformed Episcopal Church. The Reverend Dr. and Mrs. Stanley White, who built Brushwood about 1902, devoted their lives to serving the foreign missions of the Presbyterian church. Dr. James McCullough Farr of Princeton, who was just a young man when he built Farhaven next door to

Homer's rental cottage in 1901, was to distinguish himself as pastor of New York's Christ Church and as a national leader in the campaign against tuberculosis.[72]

Also among Prout's summer residents were military leaders, lawmakers, and reformers. Judge John Wesley Warrington of Cincinnati, who settled there in 1902, was an eminent jurist and active in Republican politics on the national level. Mrs. Archibald Harmon, who with her husband built Twainways about 1893, was a suffragist and leader of the National Women's Party. General Henry Clay Merriam, who purchased Black Rock from Charles Homer, Jr., in 1904, was a Civil War hero, recipient of the Congressional Medal of Honor, and commander of the army's Department of Colorado, in the Western territory.[73] Prout's society also included respected men of science and medicine. Dr. James Holland of Philadelphia, who built East Cliff in 1908, and with whom, Goodrich tells us, Homer

took frequent nature walks, was a renowned surgeon and dean of the Jefferson Medical College. Dr. John Sailer, who settled at Daisy Sailer in 1906, was a noted heart and lung specialist. Having trained in his native Philadelphia and in Paris, Zurich, and Vienna, Sailer discovered the heart stimulant ouabain, a substance extracted from tropical trees.[74]

The company provided by this distinguished group of individuals must have been invigorating, indeed, and there is evidence to suggest that Homer took advantage of this fellowship when work allowed. Although he might travel to the Adirondacks in late spring or early summer or to warmer climes in midwinter, he was usually in Prout's Neck for most of "the season," from July through early September. And, as he wrote to Louis Prang in December 1893, "I deny that I am a recluse as is generally understood by that term. Neither am I an unsociable hog."[75] Several summer residents described to Lloyd Goodrich their visits to Homer's studio, at his invitation, to see paintings. Goodrich also reported that Homer sometimes held open houses on Saturdays during the summer, welcoming friends and neighbors who came to view his work.[76] To be sure, he looked forward to the thinning of the crowds in September, when most of the summer people left; he could then turn his full attention to painting and to Prout's Neck itself. As he wrote to Charles on September 1, 1884, "I commenced my winter's work today. I find that I am in fine order and I have every prospect of a successful season."[77] At times, at least, during the summer, Homer found a comfortable place in the social life the cottagers brought with them (fig. 37). Prout's Neck in season was, for the artist, the social equivalent of the Century Club in New York or the North Woods Club in the Adirondacks—a special place where he shared the stimulating com-

Figure 38. *Winslow Homer and His Brother Charles Savage Homer, Jr., on the Cliffs, Prout's Neck, Maine*, circa 1890–1900. Silver print by unknown photographer. Bowdoin College Museum of Art, Brunswick. Gift of the Homer family, 1964.*

panionship of many of the most prosperous and learned people to be found in late nineteenth-century America.

The artist wrote to Charles from Prout's Neck in February 1898: "My home here is very pleasant. I do not wish a better place."[78] This was, in fact, a sentiment he expressed time and again when commenting on his life there. As he saw it, his simple studio-home offered him, more than any other place, the social and artistic necessities (fig. 38). It was an uncomplicated place in an otherwise complicated culture, a culture of conflicting values and aspirations poised uncertainly on the brink of the twentieth century. Prout's Neck was the crucible in which Homer's mature vision of his life, world, and art was forged. The years he spent there were a time of personal satisfac-

tion and artistic achievement. Writing in 1911, William Howe Downes, the artist's first biographer, captured the essence of the lucky convergence between Homer and Prout's Neck: "The place, the time, and the man were well met."[79]

Prout's Neck Perceived: Artistic and Emotional Response

For all his expressions of feeling for his studio-home, Homer took it as the subject for a painting only once: in 1894, when he created *The Artist's Studio in an Afternoon Fog*. For inspiration he typically looked outward from his cliff-top home on the ever-changing environment. *The Artist's Studio* represents an unusual instance of Homer looking inward on his own life at Prout's Neck. Yet, his portrayal is not the traditional

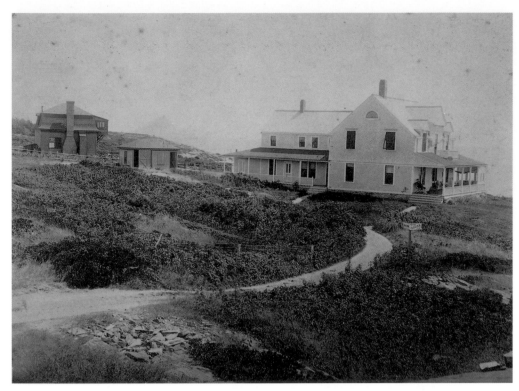

Figure 39. *The Charles Savage Homer House, the Ark, and Winslow Homer's Studio Home, Prout's Neck, Maine*, circa 1884. Silver print by unknown photographer. Bowdoin College Museum of Art, Brunswick. Gift of the Homer family, 1964.*

view of the studio interior as a workplace. Instead, Homer stepped back from his subject and considered it broadly, placing the studio in the landscape and a specific social context. The painting can be seen as a measure of the artist's response to two key elements of his life at Prout's Neck in the early 1890s: nature and family.

The subject of *The Artist's Studio* is the family compound on the southeast tip of the Neck (fig. 39). The Ark and the studio are shown as a unit in the flat middle ground between the cliffs and the sky, underscoring the connection Homer made between these two structures in his own mind. The original building program indicates that he had settled at Prout's Neck to be with his family, and while he chose to live outside the main house, he nevertheless stayed close by, and

his balcony afforded a clear and everpresent view of their home and activities. At the Ark, Homer believed, the spirit of his mother, Henrietta Maria Benson Homer, lived on, ministering to his creative energies after her death in April 1884; as he wrote to his sister-in-law early that May, "I went into the house at Prouts today. . . . Thought of Mother with a certain amount of pleasure. Thank the Lord I knew if possible she was with me."[80] From that point on, the Ark occupied much of Homer's time and thought as he tended to his eccentric widowed father (fig. 40). While he cherished his independence in the fall and winter, when Charles Homer, Sr., moved to Boston, the artist looked forward to the return of his father and brothers in the summer, when the large house took on even greater signifi-

cance. The Ark was also the summer home of Homer's elder brother, Charles, and his sister-in-law Mattie, who provided lifelong encouragement and support. The painter's letters show that he valued their companionship greatly. Writing to his brother Arthur in June 1891, for instance, Homer poured out his affection for Charles and Mattie, who had just set sail for Europe, leaving him uncomfortably alone: "I have never seen any one off before, that I cared anything about and I found it hard." He added, "I was glad when the steamer was off but New York seems empty to me."[81] Homer demonstrated the unqualified pleasure he felt in having Charles and Mattie nearby when he invited them to join him at Prout's Neck one July 4 holiday, offering them "the whole front of my house, Bath, & closet, large upper room, and piazza, lower room & front door"—in short, the whole of his small studio-home.[82] When they were not close by, Homer stayed in touch through short but thoughtful letters, which Mattie saved and which today are the principal source of our understanding of Homer's personality. Arthur Homer was also a valued companion at Prout's Neck, though he did not share Charles's central place in the artist's life. Although Arthur lived nearby at El Rancho in summer, his home was in Galveston, Texas. Thus, his summer presence at Prout's Neck was all the more special for Homer. As family photographs show (figs. 41, 42), the Ark was the center of family life at Prout's, and Homer looked to it continually as a source of solace and strength.

Although the Homer family compound is depicted in *The Artist's Studio in an Afternoon Fog*, the studio occupies the center of the composition. Seen from the east with its piazza in profile, the former carriage house looms unnaturally large in comparison with the house at the left and stands at the precise point where the radiant light of the

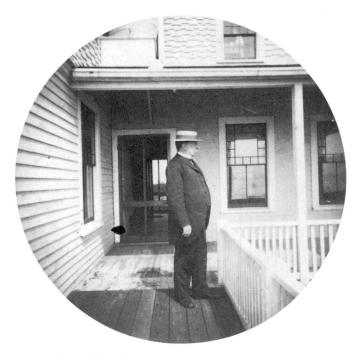

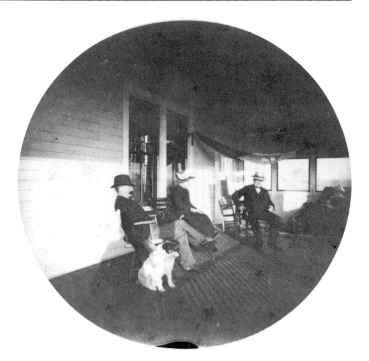

Figure 40. *Winslow Homer's Father, Charles Savage Homer, on the Porch of His House, the Ark, at Prout's Neck, Maine*, circa 1890–95. Silver print by Winslow Homer(?), taken with Eastman Kodak No. 1 camera, which produced a distinctive circular image. Bowdoin College Museum of Art, Brunswick. Gift of the Homer family, 1964.*

Figure 41. *Winslow Homer, His Dog Sam, His Sister-in-Law Martha Homer, and His Father, Charles Savage Homer, Sitting on the Front Porch of the Family Home, the Ark, at Prout's Neck, Maine*, circa 1890–95. Silver print by Charles Savage Homer, Jr.(?), taken with Eastman Kodak No. 1 camera. Bowdoin College Museum of Art, Brunswick. Gift of the Homer family, 1964.*

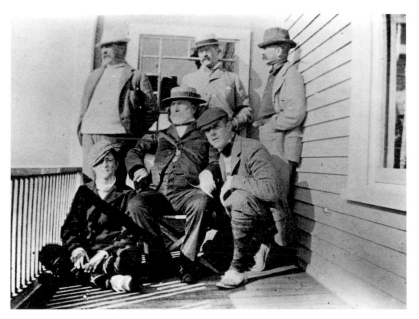

Figure 42. *The Male Members of the Homer Family on the Back Porch of the Ark, Prout's Neck, Maine*, circa 1895. Silver print by unknown photographer. Private collection. Front row, left to right: Charles Lowell Homer, the artist's nephew; Charles Savage Homer, Sr.; Arthur Patch Homer, the artist's nephew. Second row, left to right: Arthur Benson Homer, the artist's younger brother; Charles Savage Homer, Jr., the artist's elder brother; Winslow Homer.

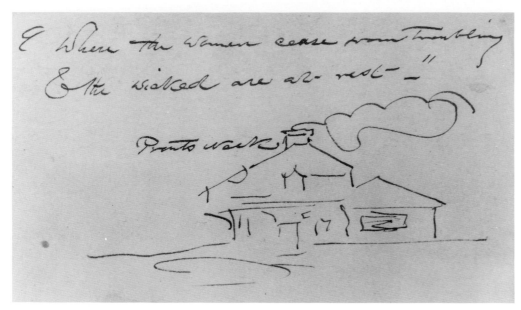

Figure 43. Winslow Homer, *Sketch of the Artist's Studio-Home, Prout's Neck, Maine*, circa 1898. Ink on paper. Inscribed: *Where the Women cease from troubling and the Wicked are at rest—*. Bowdoin College Museum of Art, Brunswick. Gift of the Homer family, 1964.

afternoon sun and the horizontal sweep of the barren shoreline intersect. Although it is bound to the Ark by its design, the studio is endowed with singular importance, thereby offering an indication of the value the artist placed on it and on his independence. This particular view of the studio is one Homer enjoyed often as he stood on the low rocks to the northeast, near Cannon Rock. From this vantage point he could see the sculptural shape of the building silhouetted against the setting sun in the western sky. By exaggerating its size and emphasizing its central position within his composition, Homer clearly was doing more than simply recording the look of the studio in afternoon light.

A shorthand sketch of his studio-home, dating from the late 1890s (fig. 43), provides a key to reading the larger meaning of the image as it appears in the earlier painting. The drawing bears a revealing inscription borrowed from the Old Testament Book of Job. In this short note Homer seemingly summed up what was to his mind the character and significance of the place: "Where the Women cease from troubling and the Wicked are at rest."[83] Homer implies that the studio was more than a workplace; it was a male sanctuary of sorts, a place unlike the Ark where he could indulge his bachelor instincts. Around Mattie, the matriarch of the Homer family, or with his cottager friends, the artist was always careful to consider his place within a rigid social order. In those situations he was ever the gentleman, as that term was defined by one female social commentator in 1899:

The gentleman of today . . . is the individual who best adapts himself to prevailing circumstances by not stopping the general flow of things with an intrusion, when not strictly necessary, of his own personality. He is the individual who puts no over-sensitive valuation on his personal standards, interferes little with others, has the silent courage of his own conduct, but no itch to explain it, or himself, or to impose either on a preoccupied world that has no time to attend and less patience.[84]

In an era that saw the rise of etiquette books and guides to home management—all designed to foster a feminine ideal of order and conduct—it is understandable that the painter, in viewing the family compound at Prout's Neck, would have seen it in terms of two distinct realms of behavior: male and female. A strong feminine influence emanated from the Ark. Mattie Homer was typical of her background and station, a woman who, in Philip C. Beam's words, "lived by a code, did all of the proper things, and . . . became a leader of New York society."[85] Although Homer looked to her for a degree of comfort and order in his own life, his studio offered him relief from the restrictive social code of the day, relief essential to his Victorian male psyche and artistic temperament. Although Mattie was hardly the "Iron Madonna" who "strangles the creative mind in her fond embrace," as one Victorian literary critic described the female social influence in 1894,[86] Homer nevertheless took steps to guard against the possibly stifling intrusion of feminine order and restraint into his life and work. The studio was Homer's symbol of freedom, artistic and otherwise, and he celebrated it as such.

Although the subject of *The Artist's Studio* is man-made, Homer created a view in which architectural elements are almost indistinguishable from the natural features of the landscape. The rocky cliff wall, scrub-dotted ledges, and buildings meld together into a solid band of unmodulated gray. Topography is indicated solely by the outline of buildings and brush set against the radiant sky. That Homer should have seen such a clear union between the architecture and its setting suggests, on one level

at least, the achievement of Stevens's architecture and the particular look of Prout's Neck as it developed under his guiding hand through the 1880s and 1890s. Visually, these Shingle Style buildings were integrated into their setting by their irregular, almost organic silhouettes, which Homer emphasized, and by their natural construction materials, wood and stone. From a distance Homer's moss-green studio would have appeared "the very color of the ledges out of which the building grows," as Stevens had expressed his design ideal.[87] Similarly, the Ark, with its weathered gray shingles, took on the character of the Neck's silvery rocks. In their general imitation of nature these buildings embodied the aspirations of Romantic architecture as they were developed and acclaimed in this country in the second half of the nineteenth century. Homer's response suggests his own Romantic vision of humanity's union with nature and his alignment with popular aesthetic and social ideals of the period.

While Homer's distillation of architectural and landscape elements into an organic whole in *The Artist's Studio in an Afternoon Fog* reveals the clarity of his view, it also suggests the conciseness of his expressive language by the 1890s. Further, it allows us to examine some of the means by which he moved from his focused narrative paintings of the 1860s and 1870s to the larger, more profound statements of his late years.

One means by which Homer conveyed a vision of unity in *The Artist's Studio* is through his minimal, coherent composition. The view has been reduced to three flat fields of tone: the dark triangular foreground cliffs, the middle band of buildings and brush, and the open expanse of sky. Each of these fields succinctly defines a spatial plane, and distance is implied solely by the size and texture of these planes and their tonal relationships. Homer's use of a simple aerial perspective makes the scene immediately apprehensible as a unified system of tiered shapes, a compositional system as spare as the Prout's Neck landscape itself.

Homer's ability to reduce his subject to its salient forms has always been recognized as one of his great and enduring strengths as a painter even as the specific sources of his design sense have defied precise identification. His predilection for dramatic formal and spatial balances has rightly been compared to Japanese art, but there is only superficial evidence for his reliance on Japanese sources. Although *The Artist's Studio* invites comparison with similar compositions in the woodcut views of Hiroshige and Hokusai, the composition remains original enough to suggest little more than a shared sensibility, what one critic described in 1903 as Homer's "Japanesque spirit of arrangement."[88]

There is evidence of an important influence on Homer's design sense at this time that may explain the abstract composition of *The Artist's Studio in an Afternoon Fog:* the influence of photography. Homer had demonstrated an active interest in the new medium by the early 1880s, acquiring a camera in England. His well-worn copy of Michel Chevreul's popular book on color theory carries, tipped in inside the front cover, an artful photograph of a Cullercoats fishing boat which may be one of Homer's own early prints.[89] By 1890 his brother Charles had given the painter the Eastman Kodak No. 1 box camera that became the artist's traveling companion on trips to the Adirondacks, Florida, and the tropics. Homer's interest in landscape photography at this time also may have been encouraged by the Portland picture dealer and photographer Robert H. Knight, whom the painter once called "my best friend."[90] Today al-

most nothing is known of Knight's work in taking or selling view photographs, but on his death in February 1910, his obituary made special mention of his pioneering efforts in that area in words that are intriguing in light of his relationship with Homer: "Mr. Knight was one of the first to realize the value of the now omnipresent view photograph as a valuable factor in the art world. He was one of the first to establish a photographic department in his business and the growth of that business has amply justified his experiment."[91]

From the few surviving examples of Homer's own photographic prints (fig. 44), it seems clear that the painter was attentive to the camera's ability to condense a view into a flat pattern of contrasting tones. He even exploited this phenomenon for artistic purposes in his photographic work. There is little evidence, however, that he used the camera much at Prout's Neck. Nevertheless, his ongoing photographic work at other locales and his close friendship with Knight certainly would have worked to inform his vision.

The other principal way in which Homer expressed the harmony he perceived in his surroundings in *The Artist's Studio* is through color, specifically, the harmony of contrasting colors as he understood it from Chevreul's treatise, which had been published in its original French edition in 1839. Chevreul's broad study of the interaction of color was an important influence on Homer's development from July 1860, when his brother gave him a condensed English translation. Its impact on his paintings of the 1860s is well documented. Homer's work of the 1890s shows that Chevreul's lessons endured and, through years of study, provided valuable insights into the artist's perception and representation of color at Prout's Neck and his employment of color as a purely expressive medium.[92]

Figure 44. Winslow Homer, *Palm Trees, Homosassa, Florida*, 1904. Silver print taken with Eastman Kodak No. 1 camera. Bowdoin College Museum of Art, Brunswick. Gift of the Homer family, 1964.

Homer brought his understanding of two fundamental color concepts to bear on *The Artist's Studio* and other paintings of the 1890s. The first was Chevreul's basic tenet that colors seen in nature are modified by the human eye in relation to other visual stimuli and are not true or constant. Thus, the somber colors of a Prout's Neck landscape on a foggy afternoon are the result of a unique set of chromatic effects, including the overall quality of light, the manner in which objects absorb and reflect that light, and the impact of that reflected light and color on neighboring objects. To understand this law of simultaneous contrast of color was, according to Chevreul, to approach painting with two important points in mind: first, that an artist had to recognize the dynamics of color and account for them in paintings if his or her intention was to be true to nature, and second, that it was essential in painting to consider color in nature as a complex whole rather than as a series of discrete phenomena.

The second color principle Homer invoked in *The Artist's Studio* was Chevreul's underlying notion of color as an expressive, as well as a descriptive, medium for the painter. In stressing chromatic unity Chevreul placed importance on an artist's ability to think abstractly and compose through color for visual effect and emotional impact. According to Chevreul's law of simultaneous contrast of colors, an artist was obliged to conceive of his subject in terms of dominant and subordinate hues and tones. The principal color elements were inherent in the object and true to nature, while the accessory hues and tones were open to interpretation and could be adjusted to create a harmonious whole. Although such adjustments might cause the artist to depart from nature in some areas, they were nevertheless true to science and were, according to Chevreul, the key to informed representation. This notion not only placed emphasis on observation but also forced the artist to consider his or her emo-

tional response to color as well as judge what did or did not constitute balance and harmony.

To encourage practical application of his scientific theories, Chevreul offered his readers numerous combinations of contrasting and analogous colors, pairs and triads he found pleasing or disagreeable. These proven formulas were, in fact, the primary attraction of his book for the nonscientist. Homer's personal copy reveals that he, like other painters, tested Chevreul's color groupings, and his marginal notes indicate which combinations he preferred. His inventiveness with color in the 1880s and 1890s indicates that he had a firm grasp of Chevreul's work and a sense of color harmony that came from years of studying Chevreul's principles.[93]

The Artist's Studio in an Afternoon Fog is a textbook example of Chevreul's concept of color harmony. Seemingly monochromatic, the picture actually resonates with color, demonstrating Homer's knowledge of the chromatic effects of diffuse light. Since the blanketed late-afternoon sun determined the dominant tone of the painting, Homer portrayed every other element in accord with this central yellow-gray light. Those features illumined by the sun—the house and the studio—are closer in range to its color and tone and thus appear warm gray, while those areas in shade—the foreground cliffs—appear as yellow's complement, violet. Chevreul explained the particular color quality of diffuse light and cited the triad of yellow, gray, and violet as producing a pleasing harmony of contrast.[94] Homer obviously agreed, for he marked this passage for reference.

Subtle harmonies of contrasting or analogous colors appear often in Homer's oils and watercolors of the 1890s. The color quality of *The Artist's Studio* is akin to the nearly monochromatic compositions of *The*

West Wind of 1891 (pl. 3), the Quebec sepia watercolors of 1895, and *The Wreck* of 1896 (pl. 4). All are virtuoso studies in luminous browns or grays that seem, like the studio view, to have been supreme tests of the artist's skill as a colorist. Such works must have represented a higher form of colorism to Homer, one born not of a full palette but of a thorough knowledge of nature's chromatic effects. As Chevreul wrote, "Color so powerfully influences the eyes, that frequently those who are strangers to painting can only conceive a colorist to be skillful whose tints are vivid, although his works may evince a want of observation."[95] Homer marked this paragraph in his volume for emphasis.

That the yellow-grays and violet-brown of *The Artist's Studio* are rich with color is due not only to the interaction of the three major color areas but also to the way in which Homer applied his pigment to the canvas. The light tonal areas are remarkably thin, having been laid down over a gray ground and thin brown *imprimatura* in much the same way that watercolor washes are overlapped to deepen their color value or intensity. Although the pigments Homer used are inherently opaque, their thinness allows the underlying brown wash to play an important part in the general building up of tone. The dark violet foreground takes its definition and texture from touches of red, blue, yellow, and white applied wet-on-wet, again in a manner reminiscent of the fluid medium of watercolor. The directness of paint application and translucency of the pigment bespeak Homer's achievements in watercolor at this time and point to the interdependence of watercolor and oil painting in his mature years.[96]

If one considers the subject and form of *The Artist's Studio in an Afternoon Fog* as expressions of Homer's life at Prout's Neck, one is compelled to believe that the painter saw his existence there in the 1890s in terms of simple order and complete balance. In picturing his studio-home within the rugged landscape, Homer chose symmetry and harmony as appropriate vehicles. How can we account for this overwhelming sense of order? How can we fathom the origins and significance of such a point of view?

Critics and biographers have long wrestled with the symbolic meaning of Homer's potent images, but they have been unable to define a religious or philosophical point of view at work in his art. Frank Fowler, writing in *Scribner's* in 1903, sensed the presence of some higher order in Homer's Prout's Neck paintings, but could not identify it. "Homer . . . stands as a man receiving strong emotions from the noble aspects of nature. . . . Nature, broad, spacious, elemental, seems to have sunk into his mind, fixed there in some shape or pattern," he wrote in an article lauding Homer's design sensibility.[97] Lloyd Goodrich argued that Homer at Prout's Neck was ever the objective realist, that he "was not trying to express directly his own emotions about nature but to create a living image of her."[98] Goodrich has been challenged, too, most recently by scholars who have made psychoanalytic inquiries into the emotional foundations of Homer's late work.[99]

With the discovery of the artist's personal library in 1974, a possible clue to his ideology was revealed in the form of a theological treatise, Dr. George Chaplin Child's *Great Architect: Benedicite; Illustrations of the Goodness of God, as Manifested in His Works*, first published in America in 1867.[100] Homer's copy of the 1871 edition was presented to him by John Gourlie, a friend and fellow member of the Century Club, in March 1872.[101] It is not surprising that both men should have had an interest in the book. *Benedicite* was so widely read in those years that it was reissued in thirteen editions through 1899. Today, however, it has slipped into obscurity, and its impact on American society and culture has not been examined.

Child's thesis surely would have appealed to a man of Homer's interests in science and nature. Child assumed that spirituality was not a matter of blind faith but was, instead, a product of close observation of nature's miraculous phenomena. He also exalted modern science as a basis for man's ever-expanding knowledge of divine order. It was not Child's aim to prove the existence of God in nature. Rather, he sought to extol order in nature as evidence of a beneficent divine plan. He took as his organizing theme the Benedicite, the biblical song of the Three Holy Children, an apocryphal addition to the Book of Daniel that glorifies those areas of nature in which God's benevolence and redemption can be found. Following the scriptural text, Child identified twenty-one natural realms that made up a divinely ordered system of reciprocity, including "The Sun and the Moon," "Seas and Floods," "Nights and Days," "Light and Darkness," "Winter and Summer," and "Waters above the Firmament."[102] He drew on scientific thought as diverse and far-reaching as that of Charles Darwin, in biology; of Matthew Fontaine Maury, in oceanography; and of Sir William Herschel, in astronomy. As the enthusiastic reviewer for *The Nation* said of the book in 1867, "It includes in its ascriptions almost every form of organized life . . . together with the forces of the inanimate world, and furnishes a glorious text for a discourse on the perfection of the world."[103]

There is some indication that Homer read *Benedicite* with care and maintained an abiding interest in Child's philosophy. For one thing, Homer may have been the one who, for emphasis, underlined his copy's opening paragraph, which reads:

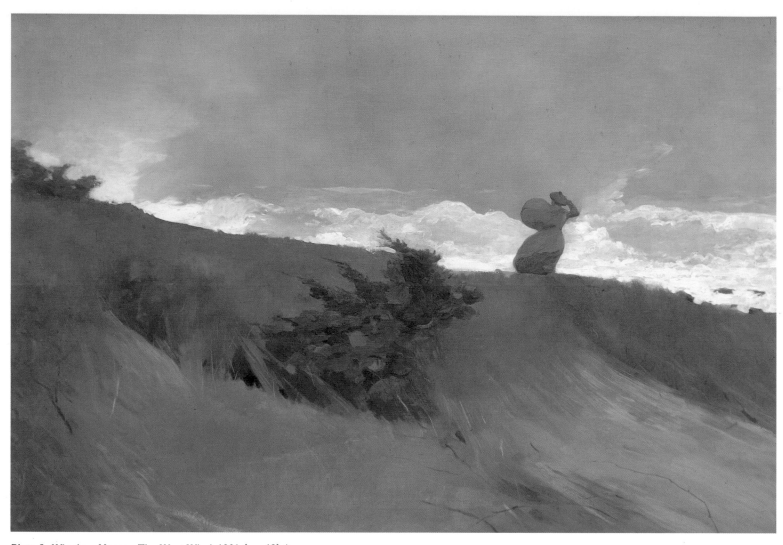

Plate 3. Winslow Homer, *The West Wind*, 1891 (no. 12).*

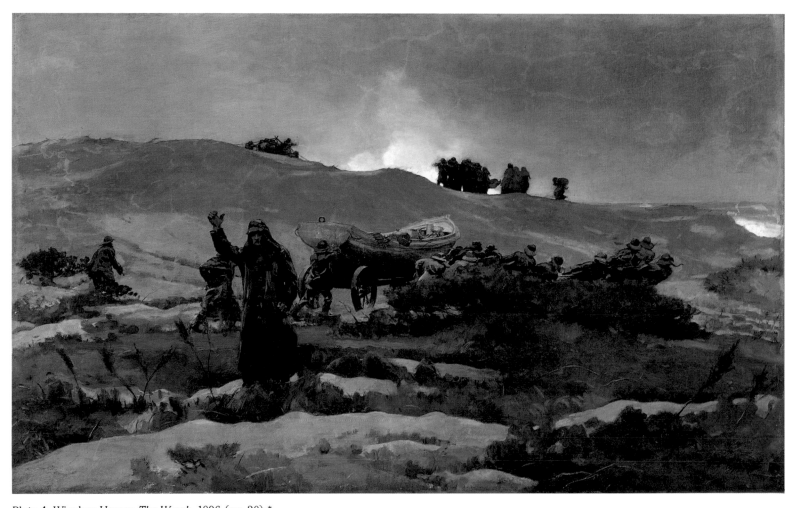

Plate 4. Winslow Homer, *The Wreck*, 1896 (no. 30).*

There are not a few in this world who habitually receive God's blessings so much as a matter of course that they are scarcely conscious of any active feeling of gratitude in regard to them. The very regularity and profusion with which these blessings are showered on all alike seems *[sic]* to have the effect of deadening the sense of individual obligation. A general admission of thankfulness may occasionally be made at church or in the closet, but there is a want of that abiding consciousness of it with which we ought to be imbued.[104]

Homer seems to have taken Child's exhortation to heart, for he expressed his satisfaction with life at Prout's Neck in terms that seem to be a direct response to the author's call for thanksgiving; as the artist wrote to his brother Charles in 1895, "The Life that I have chosen gives me full hours of enjoyment for the balance of my life. The sun will not rise or set without my notice and thanks."[105]

Another sign of what may have been Homer's enduring interest in Child's work is the fact that *Benedicite* was among the few books he kept until the end of his life. Moreover, inside the front cover he pasted an engraved portrait of oceanographer Maury, whose writings on the Gulf Stream had special interest for Homer in the 1890s.

How might Homer have brought his understanding of Child's *Benedicite* to bear on his art? On one level the artist's clear vision may reflect the author's clear definition of nature's mysteries and his rational system of universal order. The refined space and forms of *The Artist's Studio in an Afternoon Fog* certainly conform to Child's view of an organized world in which all aspects of nature and human endeavor are interrelated. On another level the very content of Homer's paintings may stem in part from his understanding of Child. In *The Artist's Studio* Homer focused on the kind of specific natural phenomenon—an afternoon fog—that Child explained in symbolic terms. Our comprehension of Homer's subject is certainly expanded when we apply Child's writing to it. For instance, the author placed singular importance on the atmosphere at the seaside, writing, "On the open shore the air takes hold of us more bracingly than elsewhere; we realize more thoroughly the healthful consciousness of its presence."[106] What is more, Child defined atmosphere as the source by which humanity receives the blessing of the sun as it diffuses light over objects and makes vision possible. Without it, he wrote, "The varied beauty of scenery would have vanished, and every landscape would have been disfigured with seams and patches of inky blackness."[107] Finally, Child gave meaning to fog itself, calling it an extension of the life-giving blessing of water. "In every form and stage God has chosen water as His servant to scatter good gifts among His creatures," he stated. "Ocean, clouds, rain, and rivers are the elements of a gigantic circulation on which the life of the world depends. The ocean is the mighty heart—the clouds and vapors driven by the wind are the conducting arteries."[108] In the form of vapor, water was a benign force, "cooling and refreshing the air at one time, warming and moderating the rigors of climate at another."[109]

In certain ways Homer's veiled image, *The Artist's Studio*, parallels Child's descriptions of atmosphere. The enveloping fog creates an artful scene by diffusing the sunlight and rendering the landscape a striking, unified, flat pattern of shapes and colors. With the compositional elements thus reduced to their essential characteristics, all is beauty and harmony, for the fog obscures disruptive detail. Moreover, in its yellow-gray tone the fog warmly embraces the artist's studio-home, as if bestowing its blessing on this special place. Although it would be simplistic to assume that Homer was attempting to pictorialize Child's symbolic view of atmosphere, it is plausible to think that the writer may have provided the artist with some idea of the essence and meaning of that element.

Significantly, Child's *Benedicite* offered Homer an optimistic view of the world and of humanity's place in it. "We may rest assured that nothing in Nature has been established without benevolent design," Child wrote, "and even the difficulties arising from the proverbial uncertainties of climate are not without their use."[110] Humanity, he believed, was tested and made stronger by experience with nature; that was God's grace. As Child put it,

Everything shows that we are here as in a training school and surrounded by circumstances which, by demanding the energetic exercise of our faculties, tend to preserve and strengthen them. In man's contests with the so-called faults of climate, he is, for the most part, reasonably victorious. His prudent foresight, his ingenious contrivances, his dextrous wielding of science to avert evils and improve opportunities, are continually showing how abundantly the Creator has supplied him with all means needful for his welfare, in whatever quarter of the world his lot may happen to be cast.[111]

If indeed this concept helped to shape the artist's vision through his last years, the implications for our understanding of *The Artist's Studio* and his other late works are great. According to Child's theory, Prout's Neck would have revealed to the painter ample evidence of divine order and good will, even in its darkest, coldest, and most foreboding aspects. By extension, then, even Homer's most somber and brooding images of that landscape and of the sea likewise might carry a message of hope and salvation.

NOTES

1. The painting was purchased by the Memorial Art Gallery of the University of Rochester in 1941 from the estate of John Calvin Stevens, who had acquired the work directly from the artist in 1901.

2. John Staples Locke, *Shores of Saco Bay: A Historical Guide to Biddeford Pool, Old Orchard Beach, Pine Point, Prout's Neck* (Boston: J. S. Locke, 1880), pp. 88–89.

3. For the most part, contemporaneous writers who knew the artist and his situation at Prout's Neck reported it accurately. Others unfamiliar with the area who judged it only through Homer's paintings seem to have misunderstood the circumstances of the artist's life there. For instance, the comparison to rugged and remote Cullercoats seems implicit in discussions of Homer's move to Maine in the biographical introduction to *Catalogue of a Loan Exhibition of Paintings by Winslow Homer*, exh. cat. (New York: Metropolitan Museum of Art, 1911), p. xix, and in Arthur Hoeber, "Winslow Homer, A Painter of the Sea," *World's Work* (February 1911), p. 14016. In modern literature Prout's Neck is characterized as a "Cullercoats-like spot" in Gordon Hendricks, *The Life and Work of Winslow Homer* (New York: Harry N. Abrams, Inc., 1979), p. 165.

4. Although there was an offshore fishing fleet and a small colony of fishermen centered around Pine Point and Stratton's Island, both opposite the Neck, the latter was settled primarily by farmers. The fishermen attracted Homer for a while, but the fleet died out in the early 1880s; see Philip C. Beam, *Winslow Homer at Prout's Neck*, exh. cat. (Boston and Toronto: Little, Brown and Company, 1966), p. 67.

5. Recognition that Cullercoats was an emerging artist's colony that may have brought Homer into contact with British practitioners of a distinct brand of popular peasant genre is due to the recent scholarship of Kenneth McKonkey, in Tony Knipe et al., *Winslow Homer: All the Cullercoats Pictures* (Sunderland, England: Northern Centre for Contemporary Art, 1988), p. 69. It may be argued that the Cullercoats experience grew in part out of Homer's general interest in the 1870s in exploring rural themes—a typical interest for the time.

6. Henry Adams, *The Education of Henry Adams: An Autobiography* (1907; reprint, Dunwoody, Georgia: Norman S. Berg, 1975), pp. 7–8.

7. Popular interest in the studios and summer haunts of American artists is documented in Hans Huth, *Nature and the American: Three Centuries of Changing Attitudes* (Berkeley and Los Angeles: University of California Press, 1957), pp. 105–29.

8. For a thorough discussion of the studio-homes of Church, Cropsey, and Bierstadt, see William B. Rhoads, "The Artist's House and Studio in the Nineteenth-Century Hudson Valley and Catskills," in Sandra S. Phillips et al., *Charmed Places: Hudson River Artists and Their Houses, Studios, and Vistas* (New York: Harry N. Abrams, Inc., in association with the Edith C. Blum Institute, Bard College, and the Vassar College Art Gallery, 1988), pp. 82–87.

9. Described in Lizzie W. Champney, "The Summer Haunts of American Artists," *Century* 30 (1885), p. 846.

10. Ibid., p. 847.

11. Wyant's studio is described in Rhoads (note 8), p. 95. Frederick S. Church at Houghton Farm is discussed in Champney (note 9), p. 851.

12. Champney (note 9), pp. 853, 855.

13. Ibid., p. 855.

14. Ibid., p. 854.

15. Ibid., pp. 852–53.

16. Ibid., pp. 849–50.

17. Ibid., p. 850.

18. This thesis is well developed by Huth (note 7), pp. 118–24.

19. The character of Westover the painter is introduced on p. 3 of the original edition (New York: Harper and Brothers, 1896).

20. Ibid., p. 395.

21. Ibid., p. 66.

22. The restrictive privatization of beach resorts is documented in Huth (note 7), p. 124; Beam (note 4), p. 29; and "The Sporting Resorts," in Kit and Frederica Konolige, *The Power of Their Glory—America's Ruling Class: The Episcopalians* (New York: Wyden Books, 1978), pp. 237–50.

23. Described in Rupert Sargent Holland, *The Story of Prout's Neck* (Prout's Neck: Prout's Neck Association [circa 1924]), p. 48.

24. These hotels are among the list of eight published in *Stuart's Atlas of the State of Maine, 1894–95* (South Paris, Maine: J. H. Stuart and Co., 1895), p. 83.

25. Locke (note 2), p. 105.

26. Ibid., p. 90.

27. Ibid.

28. William B. Lapham, "Maine Summer Resorts," in *Stuart's Atlas . . .* (note 24), p. 21. The nearest railroad station to Prout's Neck was four miles away and accessible only by horse-drawn carriage. Although the trip was relatively easy in good weather, it was more difficult in winter.

29. That the three Homer brothers systematically worked to develop Prout's Neck as a summer resort was recognized by Winslow's first biographer as early as 1911, but the fact has been overlooked by many modern scholars. See William Howe Downes, *The Life and Works of Winslow Homer* (Boston and New York: Houghton Mifflin Company, 1911), pp. 109–19, as well as Lloyd Goodrich, *Winslow Homer* (New York: Macmillan Co. for the Whitney Museum of American Art, 1944), p. 103, and Beam (note 4), pp. 28–30.

30. Holland (note 23), p. 48.

31. Ibid., p. 52.

32. Ibid.

33. See Cumberland County, Maine, Record of Deeds, 1883–1910, Cumberland County Courthouse, Portland. The Homers made numerous purchases and sales of property on the Neck, all of which are described in detail in these records.

34. Cumberland County, Maine, Record of Deeds, Book 494, p. 168, January 23, 1883; Book 495, p. 118, February 5, 1883: Charles Savage Homer, Sr., of Brooklyn, New York, buys fifty-nine lots with buildings attached from Hannah Louise Googins; Book 514, p. 241, November 26, 1884: Charles Homer, Sr., buys all of "Eastern Division" allotted to Minerva Libby; Book 578, p. 331, September 23, 1891: Charles Homer, Sr., purchases all remaining Libby property. In addition to their important acquisitions of these large tracts of

Libby land, the Homers made many other purchases of small groups of lots throughout the 1880s and 1890s. All property in the deeds is referred to by the numerical designation given in the S. L. Stephenson plan of the Neck, prepared in 1879 for the Libby family; the plan is on file at the Cumberland County, Maine, Records Office, Cumberland County Courthouse.

35. Cumberland County, Maine, Record of Deeds, Book 494, p. 309, March 10. 1883: Charles Savage Homer, Jr., buys lots 29–37 with buildings attached for five thousand dollars; Book 494, p. 312, March 10, 1883: Charles Homer, Jr., leases this property to Charles Homer, Sr., for one dollar a year. The actual terms of the lease are unknown, since the parties involved were not required to specify them for the public record. Only rarely do the terms of any of the Homers' many real-estate transactions appear in these records.

36. John Calvin Stevens recalled to Lloyd Goodrich that Homer was frequently in the Fassett and Stevens offices in connection with work on his father's house at Prout's Neck and thus may have taken an active interest in both the design and construction of the dwelling; see Stevens to Goodrich, January 6, 1937, Graduate Center, City University of New York/Lloyd Goodrich and Edith Havens Goodrich/Whitney Museum of American Art Record of Works by Winslow Homer. I am grateful to Philip C. Beam for providing me with a photocopy of Stevens's letter.

37. Francis H. Fassett, one of Portland's leading architects in the second half of the nineteenth century, first employed John Calvin Stevens as an office boy and, subsequently, as a draftsman. In 1880 Stevens became the junior partner, for a brief period running the firm's Boston office. In 1884 he formed his own firm, which is still in operation in Portland under the direction of the fourth generation of Stevens family architects. The most thorough studies of Stevens and his architecture are Earle G. Shettleworth, Jr., and William David Barry, eds., *American Domestic Architecture: A Late Victorian Stylebook*, a facsimile edition of John Calvin Stevens and Albert Winslow Cobb, *Examples of American Domestic Architecture* (Watkins Glen, New York: American Life Foundation and Study Institute, 1978), n.p.; Earle G. Shettleworth, Jr., and William David Barry, "'Brother Artists': John Calvin Stevens and Winslow Homer," *Bowdoin* 61, no. 4 (Fall 1988), pp. 16–19; Vincent J. Scully, Jr., *The Shingle Style and the Stick Style: Architectural Theory and Design from Richardson to the Origins of Wright* (New Haven and London: Yale University Press, 1971), pp. 113–21; and Roger Hale Newton, "Our Summer Resort Architecture—An American Phenomenon and Social Document," *Art Quarterly* (Autumn 1941), pp. 310–11. Stevens scholar Earle Shettleworth, Jr., Director, Maine Historic Preservation Commission, has kindly shared with me many of the fruits of his extensive research. Laura Fecych Sprague, who has completed a survey of Stevens's work at the Neck for the commission, has generously shared with me her survey document sheets on all of the Stevens projects there. The records of the "Maine Historic Preservation Association, Historic Properties Survey: Prout's Neck" are on file at the association's office in Augusta, Maine. Ms. Sprague recently located the Fassett and Stevens plans and

elevations for the Ark; those plans are now in the Bowdoin College Museum of Art, Brunswick (acc. 1989.1.1–3).

38. Cumberland County, Maine, Record of Deeds, Book 509, p. 140, May 9, 1883: Winslow Homer pays twelve hundred dollars for four lots purchased from Charles Homer, Jr.

39. Shettleworth and Barry, *American Domestic Architecture* (note 37), n.p.

40. Henry David Thoreau, *Walden; or, Life in the Woods* (1854), quoted in Philip Van Doren Stern, ed., *The Annotated Walden* (New York: Clarkson N. Potter, Inc., 1970), p. 222.

41. Homer to Charles Savage Homer, Sr., December 5, 1988, Bowdoin College Museum of Art, Brunswick, acc. 1964.69.28.

42. Stevens and Cobb, in Shettleworth and Barry, *American Domestic Architecture* (note 37), p. 30.

43. Ibid., p. 25.

44. Ibid., pp. 27–28.

45. "Preface," in ibid., n.p.

46. Stevens and Cobb, in Shettleworth and Barry, *American Domestic Architecture* (note 37), p. 30. The earliest photographs of the studio, such as that reproduced as figure 20, taken before the addition of a painting room in 1890, show that the structure was originally clapboard. Today the siding is a mixture of natural shingles and painted clapboard. These changes could have been made in the 1930s, when other additions and alterations were made to the structure under the direction of the artist's nephew, Charles Lowell Homer, who inherited the studio and the Ark from his uncle, Charles Homer, Jr. (Philip C. Beam to author, February 2, 1988). See a 1936 photograph of the studio taken by Charles Lowell Homer, which shows many of the late renovations, in Beam (note 4), p. 31.

47. Homer to unknown recipient, January 15, 1890, Bowdoin College Museum of Art, Brunswick, acc. 1964.69.61.

48. See Scully (note 37), pp. xxiii–lix.

49. John Calvin Stevens's work as a landscape painter and member of the Brushians is described in L.L.H., "The Brushians: A Sketch of Genial Sketchers," *Pine Tree Magazine* 5 (April 1906), pp. 213–23, and in John Calvin Stevens, "Charles Frederick Kimball: An Appreciation of Maine's Greatest Landscape Painter," *Pine Tree Magazine* 5 (April 1906), pp. I–VII. Stevens also reported on the Brushians' work at Prout's Neck, and on the encouragement Homer gave the group, in a reminiscence that appeared shortly after the painter's death in the *Portland Evening Express and Advertiser* (November 12, 1910, clipping in scrapbook, Portland Museum of Art). I am grateful to Earle Shettleworth, Jr., for providing me with a copy of this article. In 1910 Stevens wrote a poetic tribute to the Brushians, a manuscript copy of which is now in the possession of the architect's grandson. I am grateful to Mr. and Mrs. John Calvin Stevens II for sharing with me biographical material concerning the elder Stevens and for allowing me to look at his paintings in their possession.

50. The standard studio plan is described in several nineteenth-century articles and modern studies, but one of the most detailed discussions from an architectural point of view is the two-part article that appeared in 1880–81 in the English publication *The Art Journal*, expressly for the benefit of American readers who might wish to build studios modeled on those of contemporary British landscape painters. See Edward J. Tarver, "Artists' Studios," *Art Journal*, n. s. 19 (1880), pp. 249–52; n. s. 20 (1881), pp. 109–12.

51. Quoted in George W. Sheldon, *Hours with Art and Artists* (1882; facsimile, New York and London: Garland Publishing, Inc., 1978), p. 38. Sheldon's interview with Homer first appeared in "Sketches and Studies," *Art Journal*, n. s. 6 (1880), pp. 107–8.

52. Homer's dealers in the 1880s and 1890s were Doll and Richards, in Boston, and Reichard and Company, Knoedler and Company, Albert Milch, and William Macbeth, in New York.

53. Homer to Mrs. Charles Homer, Jr., June 24, 1884, Bowdoin College Museum of Art, Brunswick, acc. 1964.69.24.

54. "The Strange Hermitage of Winslow Homer on the Maine Coast," *Boston Herald*, 1884, clipping, Homer scrapbook, Bowdoin College Museum of Art, Brunswick, acc. 1963.69.185, p. 55. There is much in this article, a review of an exhibition of drawings, to indicate the author's familiarity with Prout's Neck. However, he may not actually have been inside the studio.

55. John W. Beatty, "Recollections of an Intimate Friendship," in Goodrich (note 29), p. 209.

56. Ibid., p. 222.

57. Beam (note 4), p. 88.

58. Homer to Charles Homer, Jr., May 28, [no year], Bowdoin College Museum of Art, Brunswick, acc. 1964.69.89.

59. Homer to Stevens, June 26, 1901, Bowdoin College Museum of Art, Brunswick, acc. 1988.38.12. The Homer–Stevens correspondence regarding Kettle Cove consists of fourteen letters from Homer to his architect dating from February 20 to July 12, 1901; all are now in the collection of the Bowdoin College Museum of Art, a gift of John Calvin Stevens II. The large and impressive house, constructed of wood frame and cedar shingles, is illustrated and described in *Scientific American Building Monthly* (July 1904), pp. 6, 17. The history of the Homer–Stevens collaboration on this project is detailed in Shettleworth and Barry, "'Brother Artists'" (note 37), pp. 16–19, and in [Susan Ransom], "Stevens Gift of Winslow Homer Letters," *Between the Lions: The Newsletter of the Bowdoin College Museum of Art* 9 (Spring 1989), pp. 1–2. I am grateful to John Calvin Stevens II for sharing these letters with me, and to Professor Philip C. Beam and Susan Ransom for providing me with photocopies and transcriptions of them after they were received by the Bowdoin College Museum of Art in 1988. John Calvin Stevens elaborated on his request for a work from Homer in a letter to Lloyd Goodrich dated December 23, 1938 (Graduate Center, City University of New York/Lloyd Goodrich and Edith Havens Goodrich/ Whitney Museum of American Art Record of Works by Winslow Homer); Professor Beam kindly provided me with a photocopy of this letter.

60. Homer to Mattie Homer, June 19, 1885, Bowdoin College Museum of Art, Brunswick, acc. 1964.69.30. Despite its nearness to Homer's studio, the artist took delight in this addition to the property: "A church is being built with much hammering as it must be finished by July 1st. . . . The Church is of great value to the property here. It is very pretty—it is quite near my house."

61. Information on these transactions is documented in "Maine Historic Preservation Association, Historic Properties Survey: Prout's Neck" (note 37), and in the Cumberland County, Maine, Record of Deeds as follows: Book 733, p. 333, June 30, 1903: for one dollar Winslow Homer sells four lots to the Roman Catholic Bishop of Portland; Book 845, p. 330, September 22, 1909: Charles Homer, Jr., acting "in consideration of $1 and my desire to promote the welfare of Prout's Neck," sells forty-eight lots to the Prout's Neck Country Club. Winslow Homer's bathhouses and his gift of them to the Prout's Neck Association are described in Homer to John Sailer, September 12, 1908, Bowdoin College Museum of Art, Brunswick, acc. 1968.139. The gift of the Sanctuary to the Prout's Neck Association shortly before Homer's death in 1910 is recorded in the report of Mrs. George P. Putnam presented at the annual meeting of the Prout's Neck Association, August 3, 1951, quoted in *Prouts Then and Now, 1888–1970* (Portland, Maine: Prouts Neck Association, 1971), p. 52. The Prout's Neck Association was established in 1888 as a volunteer organization dedicated to maintaining the community; see ibid., p. 3. The building of the Episcopal church on Homer property in 1887 is documented in Homer to Mattie Homer, June 19, 1885, Bowdoin College Museum of Art, Brunswick, acc. 1964.69.30, and in "Maine Historic Preservation Association, Historic Properties Survey: Prout's Neck."

62. Homer to Charles Homer, Jr., March 21, 1896, Bowdoin College Museum of Art, Brunswick, acc. 1964.69.60.

63. Homer to Arthur Homer, January 1, [1901], Bowdoin College Museum of Art, Brunswick, acc. 1964.69.85.

64. Homer to Charles Homer, Jr., December 7, 1907, Bowdoin College Museum of Art, Brunswick, acc. 1964.69.126.

65. The photograph album, which Winslow labeled "C. S. Homer's Cottages," actually surveys the properties owned by all of the Homers. In addition to showing the various houses, it includes snapshots of the Episcopal church and the Sanctuary. All annotations are in Winslow's hand. The small, square prints seem to have been made from a single roll of film and were probably taken sometime after 1908, when Arthur Homer's house, the Walnuts, was built. The album is in the collection of the Bowdoin College Museum of Art, Brunswick (acc. 1964.69.177).

66. Cumberland County, Maine, Record of Deeds, Book 676, pp. 130, 133, 138, 495, May 3 and May 6, 1899: Charles Homer, Jr., transfers his father's bequest of land to Winslow and Arthur. Winslow and Arthur essentially split the lots evenly between them.

67. The 1890s saw Homer acquiring land, and the first decade of the twentieth century found him selling selected lots. His first recorded sales occurred in 1903, and the rest between 1906 and his death in September 1910. These transactions are recorded in Cumberland County, Maine, Record of Deeds as follows: Book 733, p. 333, June 30, 1903: four lots sold to the Roman Catholic bishop of Portland; Book 798, p. 213, December 21, 1906: eight lots sold to Curwen Stoddart, Jr., of

Rydal, Pennsylvania; Book 828, p. 129, August 24, 1908: lot sold to Annie Robinson of Washington, D.C.; Book 845, p. 331, September 22, 1909: nine lots sold to Hester Gouveneur Bartol of New York; Book 845, p. 426, October 4, 1909: eights lots sold to William B. Goodwin of New York; Book 845, p. 450, October 5, 1909: nine lots sold to Cyrus L. Merriam of Washington, D.C.; Book 863, p. 207, August 22, 1910: land sold to Augustus Moulton of Prout's Neck.

68. Homer to Charles Homer, Jr., March 17, 1897, Bowdoin College Museum of Art, Brunswick, acc. 1964.69.78.

69. See Augustus F. Moulton's legal definition of "Ownership of Streets, Marginal Way and Shores on Prouts Neck," September 3, 1896, in Prout's Neck Association Archives. I am grateful to Laura Fecych Sprague for providing me with a photocopy of this document. See an excellent discussion of the marginal way and its ramifications in Beam (note 4), p. 29.

70. Aline Gorren, "American Society and the Artist," *Scribner's* 26 (November 1899), p. 630.

71. Morgan obituary, *New York Times*, March 6, 1917, p. 11, col. 6; Sprague biography, *The National Cyclopaedia of American Biography*, 2d ed., vol. 40 (New York: J. T. White and Co., 1955), p. 552; Merrick biography, ibid., vol. 13 (1906), p. 344.

72. Cheney biography, *The National Cyclopaedia of American Biography* (note 71), vol. 33 (1947), p. 2; Mrs. Stanley White obituary, *New York Times*, February 2, 1950, p. 27, col. 5; Farr obituary, ibid., August 7, 1953, p. 19, col. 2.

73. Warrington biography, *The National Cyclopaedia of American Biography* (note 71), vol. 30 (1943), pp. 376–77; Harmon obituary, *New York Times*, April 13, 1923, p. 17, col. 3; Merriam obituary, ibid., November 19, 1912, p. 15, col. 4.

74. Holland obituary, *The [Philadelphia] Evening Bulletin*, February 11, 1922, p. 3, col. 2; see also Goodrich (note 29), p. 112, regarding Holland's friendship with Homer; Sailer obituary, *New York Times*, January 2, 1929, p. 27, col. 5. Interestingly, Dr. Holland was painted by Thomas Eakins in 1899 (*The Dean's Roll Call*, Museum of Fine Arts, Boston). The doctor's connection with Eakins no doubt would have served to bring Homer word of the other painter's work.

75. Homer to Prang, December 1893, quoted in Goodrich (note 29), p. 113.

76. Goodrich (note 29), p. 107.

77. Homer to Charles Homer, Jr., September 1, 1884, Bowdoin College Museum of Art, Brunswick, acc. 1964.69.25.

78. Homer to Charles Homer, Jr., February 28, 1898, Bowdoin College Museum of Art, Brunswick, acc. 1964.69.73.

79. Downes (note 29), p. 119.

80. Homer to Mattie Homer, May 6, 1884, Bowdoin College Museum of Art, Brunswick, acc. 1964.69.23.

81. Homer to Arthur Benson Homer, June 17, 1891, Bowdoin College Museum of Art, Brunswick, acc. 1964.69.40.

82. Homer to Charles Homer, Jr., May 28, [no year], Bowdoin College Museum of Art, Brunswick, acc. 1964.69.89.

83. Frontispiece to Homer's memorandum and sketchbook, circa 1898, Bowdoin College Museum of Art, Brunswick, acc. 1964.69.1. The inscription is based on Job 3:17: "There the wicked cease *from* troubling; and there the weary be at rest."

84. Gorren (note 70), p. 630.

85. Beam (note 4), p. 52.

86. Hjalmar Hjorth Boyesen, in "The American Novelist and His Public," *Literary and Social Silhouettes* (New York: Harper and Brothers, 1894), p. 46.

87. Stevens and Cobb, in Shettleworth and Barry, *American Domestic Architecture* (note 37), n.p.

88. Frank Fowler, "An Exponent of Design in Painting," *Scribner's* 33 (May 1903), p. 639.

89. Homer's copy of John Spanton's 1859 English edition, *Chevreul on Colours, or The Laws of Contrast of Colour; And Their Applications to the Arts . . . By M. E. Chevreul* . . . (London: Routledge, Waines, and Routledge, 1859), is in the collection of the Strong Museum, Rochester, New York, which owns twenty-two books from Homer's collection. David Tatham has catalogued the twenty-six volumes that remain from Homer's personal library; see "Winslow Homer's Library," *American Art Journal* 9 (May 1977), pp. 92–98. The Spanton/Chevreul volume, which obviously served Homer as a kind of scrapbook, includes other clippings and notes of a personal nature. The Cullercoats photograph is glued onto the front flyleaf. The image was transcribed in a subsequent watercolor, *The Breakwater, Cullercoats* (1882; Portland Museum of Art).

90. Homer's relationship with Robert H. Knight is thus reported in a reminiscence that appeared in the *Portland Evening Express and Advertiser* on Saturday, November 12, 1910: "Speaking to a Portland newspaperman who met him in company with the late R. H. Knight, of whom he said with the familiarity born of long acquaintance, 'Bob is my best friend. . . .'" (clipping, scrapbook, Portland Museum of Art).

91. *[Portland] Daily Eastern Argus*, February 15, 1910, p. 8, col. 2.

92. For a detailed discussion of Chevreul's principles and the application of his theories by artists of the late nineteenth century, see Faber Birren, in *The Principles of Harmony and Contrast of Colors and Their Applications to the Arts, by M. E. Chevreul. With a Special Introduction and Explanatory Notes by Faber Birren* (1839; reprint, New York, London, and Amsterdam: Reinhold Publishing Corporation, 1967). For a thorough analysis of Chevreul's theories at work in Homer's Civil War paintings of the 1860s, see Kristin Hoermann, "A Hand Formed to Use the Brush," in Marc Simpson et al., *Winslow Homer: Paintings of the Civil War* (San Francisco: Bedford Arts Publishers for the Fine Arts Museums of San Francisco, 1988), pp. 103–19.

93. Helen Cooper has pointed out that Homer's interest in pure color effects, first evinced in his watercolors of 1880, corresponded to the publication that year of Ogden Rood's *Modern Chromatics*, an extension of Chevreul's theories on the interaction of color. Homer, in fact, may have known Rood and his experimental watercolors; see Helen Cooper, *Winslow Homer Watercolors* (New Haven and London: Yale University Press for the National Gallery of Art, 1986), p. 72. Nevertheless, Homer credited only Chevreul as the source of his color sense and as late as 1903 referred to Chevreul's study as "my bible" (Beatty, in Goodrich [note 29], p. 223).

94. The chromatic effects of diffuse light are described in Spanton (note 89), pp. 74–80. The ternary arrangement of yellow, gray, and violet is outlined in ibid., p. 60, para. 223.

95. Ibid., p. 86.

96. A detailed description of the construction of the painting is contained in "Report on Condition," Intermuseum Conservation Association, 1960, in document file 41.32, Memorial Art Gallery. The painting was lined twice, in 1960 and 1970, and these procedures may have diminished the tonal effect of the ground color. Nevertheless, the fine weave of the original canvas and lining and the thinness of the paint layers are such that the canvas is rendered translucent when illuminated from behind. This method of examination revealed Homer's cursory underdrawing of the studio and horizon line. I am grateful to conservators Dan Kushel and James Hamm, State University of New York College at Buffalo, for their thorough examination of the painting's construction and for sharing their observations on the effect of the ground layer.

97. Fowler (note 88), pp. 639–40.

98. Goodrich (note 29), p. 126.

99. These studies are Henry Adams, "Mortal Themes: Winslow Homer," *Art in America* 71 (February 1983), pp. 112–26, and Jules Prown, "Winslow Homer in His Art," *Smithsonian Studies in American Art* 1 (Spring 1987), pp. 31–45.

100. The full citation is George Chaplin Child, M.D., *The Great Architect: Benedicite; Illustrations of the Power, Wisdom, and Goodness of God, as Manifested in His Works*, 2 vols. in 1 (New York: G. P. Putnam and Sons, 1871). Homer's copy is in the collection of the Strong Museum, Rochester, New York.

101. John Hamilton Gourlie, one of the founders of the Century Club, was a fascinating character. Painter John Ferguson Weir described him as a witty, charming fellow. "Gourlie was what Thackeray would have termed 'a clubbable man,'" Weir wrote, a characterization that reveals something of what Homer would have valued in Gourlie's friendship. See *The Recollections of John Ferguson Weir*, ed. Theodore Sizer (New York and New Haven: New-York Historical Society and the Associates in Fine Arts at Yale University, 1957), p. 51. I am indebted to David Tatham for this reference.

102. These are chapter headings from Child's table of contents.

103. *Nation* 4 (May 23, 1867), p. 413.

104. Child (note 100), p. 27.

105. Homer to Charles Homer, Jr., February 21, 1895, Bowdoin College Museum of Art, Brunswick, acc. 1964.69.5.

106. Child ((note 100), p. 134.

107. Ibid., pp. 90–91.

108. Ibid., pp. 156–57.

109. Ibid., p. 156.

110. Ibid., pp. 80–81.

111. Ibid.

Winslow Homer and the Sea

David Tatham

Well before his death at Prout's Neck in 1910, Winslow Homer's popular reputation as an artist assumed a form that survived into the middle of the twentieth century. It held that he was one of the truly great painters in the history of American art and that his stature derived especially from his late oil paintings of the sea.[1] From this point of view, his earlier work seemed to have been a long, diverse prologue to the transcendent achievements of his late-arriving maturity on the coast of Maine. Charles Caffin expressed this widely held opinion in 1907 in his *Story of American Painting*, where he wrote about Homer that "the turning point in his career was reached when he transferred his studies to the characteristics of the Maine coast. . . . [There he produced oils that were] without any rival in American art for originality and impressiveness."[2] Homer's earlier paintings, Caffin said, lacked "any considerable artistic merit."[3]

This thumbnail assessment was, of course, altogether too simple, particularly concerning the pre-Maine paintings. Those of Caffin's contemporaries who knew Homer's work well were keenly aware that masterpieces had come from his brush in every decade since he had begun to paint. Nor had oil been Homer's only important medium. He was a master of watercolor, an able lithographer, and a powerful etcher. He was one of the great draftsmen of nineteenth-century American art. In fact, Homer's art varied so much in medium, subject, and aim that comparisons of one segment of it with another always have been difficult. Still, for many years critics and the public alike considered the late sea paintings as first among equals.

This was so until the 1960s. Then, almost as if to redress a historical imbalance of attention, Homer exhibitions and monographs began to focus intently and selectively on his earlier accomplishments and his works in media other than oil paint. Scholars examined Homer as a graphic artist (1968), an illustrator of poetry (1979), a delineator of croquet scenes (1984), a master of watercolor (1986), a painter of the Civil War (1987), a portrayer of blacks (1988), and an artist in England (1988).[4] These studies of important aspects of his career have gone far to broaden and deepen an understanding of the artist and his times, but they also have tended to segregate the late marines as a special case, not quite taken for granted, but somehow separated from what preceded them.[5] Since it now is clear that Homer's earlier work possesses considerable merit indeed, the time is right to reassess the late sea paintings, great works of art for more reasons, perhaps, than has been realized.

Two things must be observed about these paintings at the outset. First, though human figures and activity occupy much of the canvas in some of them, the commanding presence of the sea controls nearly everything. This is true even in such cases as *The Lookout—"All's Well"* (fig. 45), in which only a sliver of ocean can be seen. Second, for those paintings that include no figures, a long and honorable literary tradition offers verbal analogues for Homer's representations of the sea. Here is Samuel Isham in 1905: "When Winslow Homer's

great swells roll in out of the fog, and slowly heap themselves up against the granite coast without foam, without effort, until with the ebb the thousands of tons of clear green water grind crashing down through the crevices of the rocks, we feel the awful, elemental force."[6] The verbs *roll*, *heap*, *grind*, and *feel* evoke not only the action of the sea but also something of the act of painting which is preserved on these canvases.

Homer's first biographer, William Howe Downes, combined this kind of description with analytical insights about the genesis, method, and character of the marines when he wrote in 1911:

> The weight and thrust of an Atlantic billow, the rush and turmoil of the surf, the dynamic force of the pounding seas in a winter gale, are realized in his paintings with an invigorating vividness, it is true, but the synthetic method by which his art conveys such impressions is the result of a life-long course of patient observation and experimentation; the instantaneous vision of a huge toppling breaker, the affair of a fraction of a second, may have cost the close study of years. It is natural to be carried away by the sheer strength and swiftness of the movements of these ocean symphonies, but the wonderful things about them, after all, are their delicacy and reserve.[7]

The words denoting action—*thrust*, *rush*, *turmoil*, *pounding*, *toppling*, and *swiftness*—describe, like Isham's verbs, the movement of the sea as it confronts the rocky shore at Prout's Neck. It is no small credit to Homer's illusionism that for fully a century his paintings of the subject (which are, after all, unmoving pieces of canvas) have provoked so many able writers to search for words that fit the motions of the sea at work.[8]

One reason writers have tried to approximate in language some of the dynamic forces seen in these paintings is that the

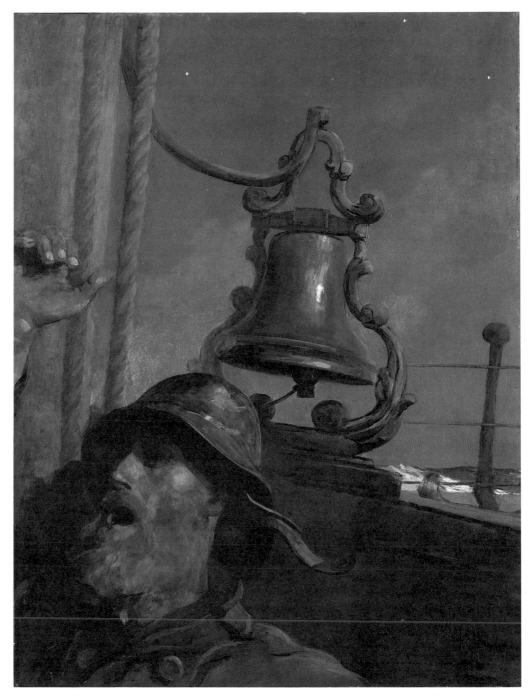

Figure 45. Winslow Homer. *The Lookout—"All's Well,"* 1896. Oil on canvas, 40 × 30¼ in. (101.6 × 76.8 cm). Museum of Fine Arts, Boston. William Wilkins Warren Fund.

more conventional art-historical ways of discussing them do not work very well. The late marines have little in common with earlier American or European approaches to painting the sea. The names of Courbet, Kensett, Heade, and Richards are summoned up only to be dismissed as having no real pertinence to Homer's work. He does not fit very comfortably into traditions of marine art. Nor have writers been able to turn to Homer himself for illumination, since he said virtually nothing to reveal what ideas he meant to convey in these paintings. We need to look beyond the world of art to comprehend his great pictures of the sea and the circumstances of their making. The first place to look is Prout's Neck.

What unites Homer's Prout's Neck paintings more than anything else is a strong sense of place. This sense, evident in his work from the beginning, developed steadily. We find it as early as the 1850s in the many depictions of Boston street life he contributed to popular weekly magazines. By the 1880s he was differentiating the places he painted by endowing them with distinguishing consistencies of spirit. This makes it possible to know in a flash, for example, whether a summer-season watercolor comes from Houghton Farm in New York State, from Gloucester harbor in Massachusetts, or from Cullercoats in England, places in which he painted between 1879 and 1882.[9] Subjects and techniques differ within these three groups, but each has its own distinct feeling of locale.

Part of Homer's sense of place was purely visual. His remarkable powers of observation repeatedly found pictorial value in things others overlooked. More than any other American artist of his time, perhaps, he trusted his eyes and mistrusted the vogues of art making.[10] He saw forms, planes, colors, conditions of light, and moods that struck him as characteristic of a place. He invoked them in work after work, employing a distinctive, economical style with roots in his early illustrations. The reportorial instincts that served him so well in drawing for such journals as *Harper's Weekly* never left him. One of the first things Homer did after deciding to settle at Prout's Neck was to embark on a series of drawings of the ledges and scrub that were now part of his daily experience (pl. 5). He continued to record them, increasingly in paint and in more ambitious compositions, until his death a quarter of a century later, and in doing this he never repeated himself. The microworld of Prout's Neck constantly revealed new things to his eyes.

If part of Homer's sense of place was visual, another part was social. There has been an unfortunate tendency in the years since his death to describe him as reclusive and unsocial. This image developed from the brusqueness of his correspondence with his dealers, his late-life impatience with interviewers, autograph seekers, and other strangers, and his move from metropolitan life in New York to what seemed (in the eyes of New Yorkers) isolation at Prout's Neck.[11] But ample contrary evidence exists, not the least in his art. Far from being reclusive, he was as dependent on close, trusting social bonds as any of us. His best work came consistently from places where he had supportive, familiar faces around him. These places varied greatly in character, from the Civil War camps he shared with his cousin and other friends to the fishing community at Cullercoats, where every face was new but open and friendly in a typical north-of-England way.[12] The milieus Homer chose tended to be small; after the 1870s they rarely included anyone from the world of art.

Homer's natural reserve kept him from wearing his heart on his sleeve, and he seldom painted the people emotionally closest to him.[13] Yet their presence sometimes can be felt in his work. This is certainly true of *A Summer Night* (pl. 6), in which the familial closeness of the silhouetted figures and the dancing women convey a feeling of easy well-being which surely has its source in Homer family gatherings at the Ark and neighboring hotels.[14] Homer bonded with Prout's Neck as much for its social contentments as for its visual satisfactions.

Beyond the visual and social components of Homer's sense of place was the introspective one. In the last three decades of his career, he consistently arranged to live in places that allowed him to look deeply into them, to move beyond surfaces into essences. This required him not only to select the right places but also to simplify his life and build barriers against distraction. In return he gained a more profound knowledge of his subjects and his relation to them. He lived this way—studying intensely some aspect of his surroundings—for a summer (1880) in Gloucester harbor, where his primary subject was atmospheric light. He then moved for a year and a half (1881–82) to Cullercoats on the North Sea and examined more completely than ever before human beings in relation to their natural surroundings, gradually shifting his balance of interest toward nature. He spent the next twenty-five years (1884–1909) exploring the same subject not only at Prout's Neck but also at the North Woods Club in the Adirondacks, at camps in the Quebec wilderness, and at locations in the Caribbean.

Like Thoreau, Homer examined the minute particulars of nature to gain a vision of larger things. And like Thoreau, his attempts to simplify his life for this purpose were regarded by some as verging on the antisocial. Yet it is clear that he sloughed off the frenetic pace and conflicting demands

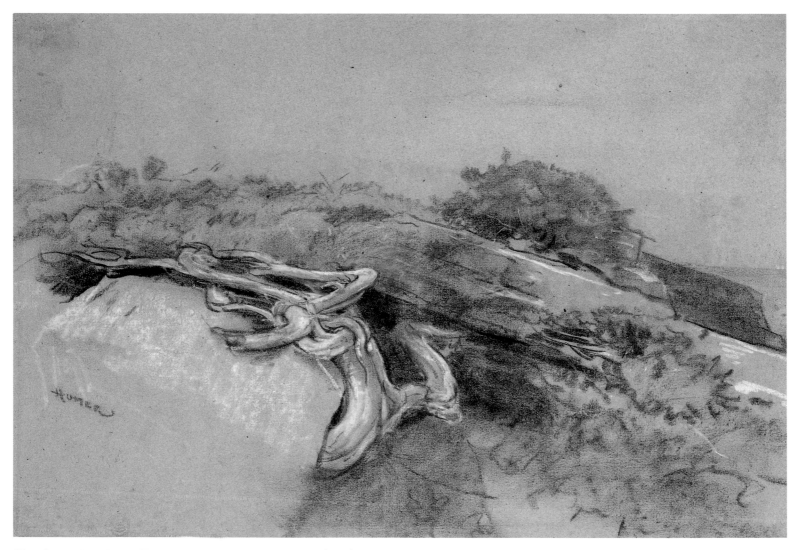

Plate 5. Winslow Homer, *Tree Roots, Prout's Neck*, circa 1884 (no. 4).*

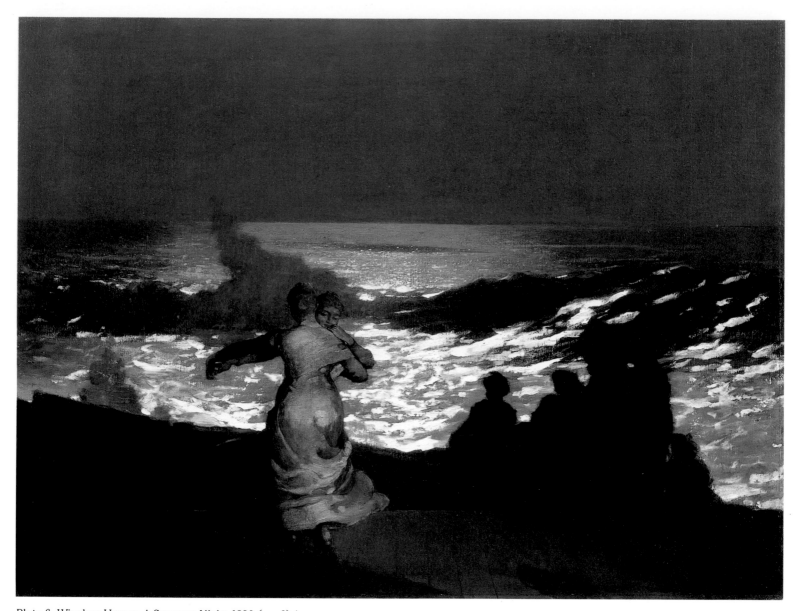

Plate 6. Winslow Homer, *A Summer Night*, 1890 (no. 8).*

of New York not to escape from anything in particular but to gain something he could not find in any city: the right circumstances for his work. But there was nothing hermetic about his life or his subjects in Maine. He no more isolated himself at Prout's Neck than Thoreau did at Walden.

While there is no evidence that Homer read *Walden* or anything else by Thoreau (though as a product of Cambridge culture Homer almost certainly knew of him), the parallels between the two have long made them seem kindred spirits. Each was a great stylist, and each in maturity looked closely at nature and beyond it to humanity. The work of each always has had a powerful presence in American culture independent of critics and scholars and always has rebuffed attempts at easy categorization. Whether he read *Walden* or not, it seems likely that Homer would have found a sympathetic note in such passages as:

> The millions are awake enough for physical labor; but only one in a million is awake enough for effective intellectual exertion, only one in a hundred millions to a poetic or divine life. To be awake is to be alive. I have never yet met a man who is quite awake.[15]

> I went to the woods because I wanted to live deliberately, to front only the essential facts of life, and see if I could not learn what it had to teach, and not, when I came to die, discover that I had not lived. I did not wish to live what was not life, living is so dear; nor did I wish to practice resignation, unless it was quite necessary. I wanted to live deep and suck all the marrow out of life, to live so sturdily and Spartan-like as to put to rout all that was not life, to cut a broad swath and shave close, to drive life into a corner, and reduce it to its lowest terms, and, if it proved to be mean, why then to get the whole and genuine meanness out of it, and publish its meanness to the world; or, if it were sublime, to know it by experience, and be able to give a true account of it on my next excursion.[16]

> I do not wish to be any more busy with my hands than is necessary. My head is hands and feet. I feel all my best faculties concentrated in it. My instinct tells me that my head is an organ for burrowing, as some creatures use their snout and fore-paws, and with it I would mine and burrow my way through these hills. I think that the richest vein is somewhere hereabouts; so by the divining rod and thin rising vapors I judge; and here I will begin to mine.[17]

But it would be wrong to seek many parallels between Thoreau and Homer. Their creative aims had little in common. As a writer, Thoreau was a rebel "against the world's cowardly habits of living" and a preacher of reform.[18] Homer had no such purposes. Still, both used a sense of place as a point of departure to reach something altogether beyond place. Walden Pond is allegorical as well as real and so, too, in its own fashion, is the meeting of cliffs and sea at Prout's Neck.

Homer found at Prout's Neck a place of exceptional visual interest where both the summer residents (including his own family) and the Yankee locals were people to his liking. He found in the sea a subject that he could study ceaselessly and that held his attention longer than any other. He was close to Portland and no stranger to it. He traveled regularly to Boston and New York for business and pleasure and to Chicago, Pittsburgh, Philadelphia, and other cities for important occasions. Part of each summer he spent in the Adirondacks or Quebec in the company of other sportsmen and, often, their families. Most winters he fished and painted in the Caribbean. He was deeply involved for many years in the development of Prout's Neck as a property. He was more a man of the world on the coast of Maine than he ever had been during the years he maintained a studio in New York. But little of this shows in his work. His marines speak of something else, something apart from the daily round.

The question of meaning in Homer's late marines is a thorny one. He was mostly silent on this matter (as he was on all matters relating to art). Critics and historians have gladly described these paintings, for the most part venturing cautious interpretations when faced with the need to discuss their meanings—if they have ventured interpretations at all. The most cautious approach has been to deny that such paintings of the sea as *Coast in Winter* (pl. 7) have any meaning other than what greets the eye. This approach celebrates Homer as an elemental realist, a master of selecting, simplifying, and rearranging what he saw, identifying his aim as little more than the transcription of nature. Such a view underlies Stuart Davis's comment, made in 1930, that "Homer's style is no style at all, but the natural method of a man who has seen a lot of photographic illustration and likes it."[19] Davis, in the manner of most American modernists of his generation, had little taste for American realism of any kind and was skeptical about the usefulness of discussing meaning in art.

A less cautious interpretation finds in the late marines a culmination not only of the dynamism present in Homer's work from the beginning but also of American dynamism in general. Homer achieved a bracing tension in all his work through many means but especially through the subtle, often quiet, opposition of color, form, and line. This tension made for good design, and it also aided narrative. With regard to narrative and the late marines, Lloyd Goodrich observed in 1944 that Homer "had always been a storyteller. Dramatic action was what interested him, and this the sea supplied to take the place of human action."[20] One can move a step further to say that Homer supplanted human action with something grander in scale and that his late paintings of the sea signify the burgeoning,

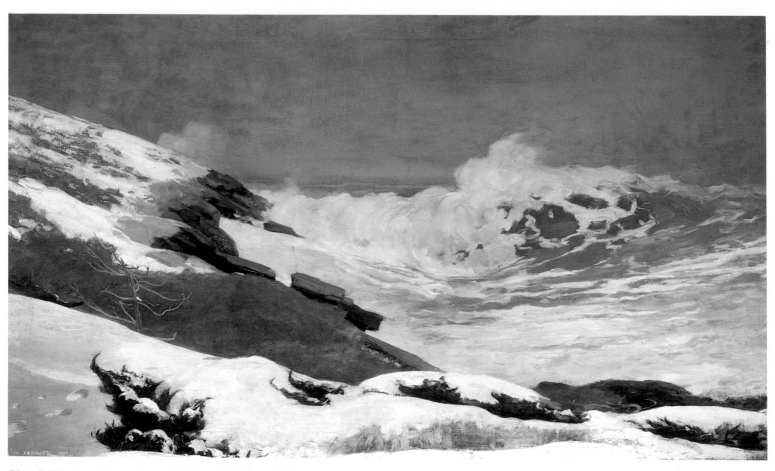

Plate 7. Winslow Homer, *Coast in Winter*, 1892 (no. 13).*

dynamic society of which he was a part. According to this interpretation, he painted nature as emblematic of the confident but restless energy of his era, energy he heard in the marches of John Philip Sousa and felt in the electrified grandeur of the World's Columbian Exposition. In the irresistible force of the ocean meeting an immovable object (Prout's Neck) we can find, if we wish, a figure of American culture optimistically attempting to subdue its restraints. This kind of conjectural interpretation leaves untouched the central question of what Homer thought about the sea, however. It bypasses the intellectual foundations of his paintings.

There is no way of knowing for certain, or in any detail, what ideas Homer associated with the sea. He left no record of such things. But one written remark of his, coupled with a picture pasted into a book he owned, suggests that his ideas were in harmony with those espoused in the writings and lectures of the naval officer-scientist Matthew Fontaine Maury. A key piece of evidence in support of this is Homer's oil painting, *The Gulf Stream* (pl. 8), a product of his Prout's Neck studio that took as its subject Caribbean waters rather than those of the Maine coast.

In 1902, two years after Homer had completed it, *The Gulf Stream* was still in the hands of his dealer Knoedler in New York. The painting shows a disabled small boat in subtropical waters, with a dazed figure on its deck and frenzied sharks swimming near it. A common inference is that one or more members of the boat's crew have just perished. A waterspout whirls in the middle distance, while a large sailing ship passes on the distant horizon. This painting had a greater narrative content than any that had come from Homer's brush in several years, and, more than in his other work, he left the drama of the narrative unresolved.

Knoedler, who had been asked to explain the subject, inquired of Homer about it and received an acerbic reply that reads in part: "I regret very much that I have painted a picture that requires any description. The subject of the picture is comprised in *its title* [Homer's emphasis] and I will refer these inquisitive schoolmam'ms to Lieut. Maury. I have crossed the Gulf Stream *ten* times and I should know something about it."[21]

The artist's reference to Maury, who had died in 1873, was in fact to Maury's book, *The Physical Geography of the Sea*, and especially to its chapters entitled "The Gulf Stream" and "The Influence of the Gulf Stream." First published in 1855, the book became a best seller, went through many revisions, and sold steadily in the United States and Great Britain for twenty years.[22] Homer had some interest in Maury as a person, or so we may conclude from the fact that within his copy of G. Chaplin Child's popular book, *Benedicite*, is pasted a clipped printed portrait of Maury.[23] Although Homer received his copy of *Benedicite* in 1872, the portrait (whose published source has not been identified) almost certainly postdates Maury's death in 1873 and was probably added to the book by Homer himself.

What association might Homer have had with Maury that would have called for this kind of memorialization? Answers to this question must necessarily be speculative, but two possibilities stand out. The first arises from Maury's presence in Boston in December 1856, when Homer was apprenticed to a Boston lithographer. Then at the height of his popular fame, Maury had received the signal honor of an invitation to give the annual Lowell Lectures.[24] For many years these lectures had brought eminent figures to Boston to address the general public on diverse subjects. Maury gave six

lectures in three weeks in a series entitled "The Winds and Currents of the Sea." He drew capacity audiences,[25] being a charismatic speaker who managed to reconcile science, religion, and commerce in ways that appealed to the educated public (but were dismissed by many of his fellow scientists).[26] His lecturing style seems to have included a good deal of pictorial description. The Boston *Transcript* gives an inkling of it in a report on his fourth lecture:

The Lieut. described, with the ardor and graphic power of a true lover and student of nature, his sensations on board ship when lying off Valparaiso at night, just after the sea breeze had lulled. The contrast of the turmoil and fury of the wind with the deep stillness that succeeded; the blackness like a pall followed by the dazzling brilliancy of the sky lighted up as it were instantaneously by myriads of stars; the magnificent appearance of the firmament, the moon and planets seeming to stand out from the azure, and the various constellations shining with unwonted splendor, all formed a picture which the Professor touched with the pencil of the artist.[27]

At the time, Homer's older brother, Charles, who was a student at Harvard University's Lawrence Scientific School, would have had every reason to attend the Lowell Lectures and may well have met Maury. Homer also may have been at the lectures and, tagging along with Charles, also may have met the celebrated oceanographer. His recollections of Maury might have been intensified by the notoriety that surrounded him a few years later, when as a Virginian he cast his lot with the South, becoming an important representative of the Confederacy in England and elsewhere. Maury returned to the United States in 1868, only learning on arrival in New York that he had been pardoned. This would have provided a second occasion for Homer to have associated with him, perhaps through the

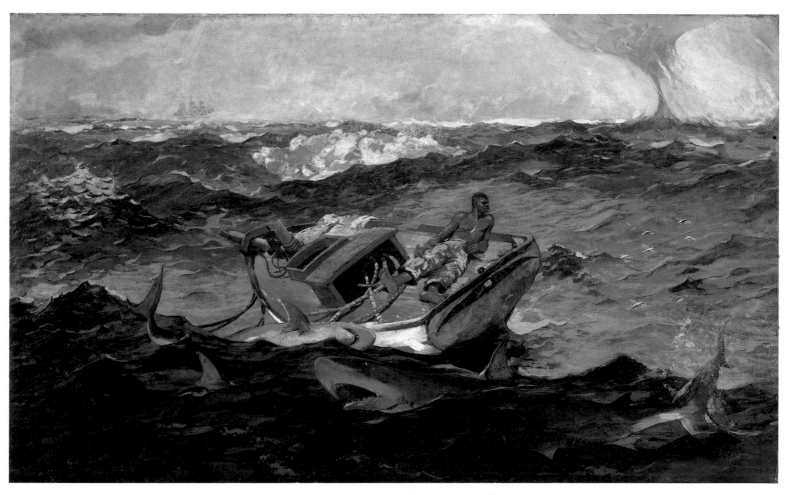

Plate 8. Winslow Homer, *The Gulf Stream*, 1899. Oil on canvas, 28⅛ × 49⅛ in. (71.4 × 124.8 cm).
The Metropolitan Museum of Art, New York. Wolfe Fund, Catherine Lorillard Wolfe Collection, 1906.

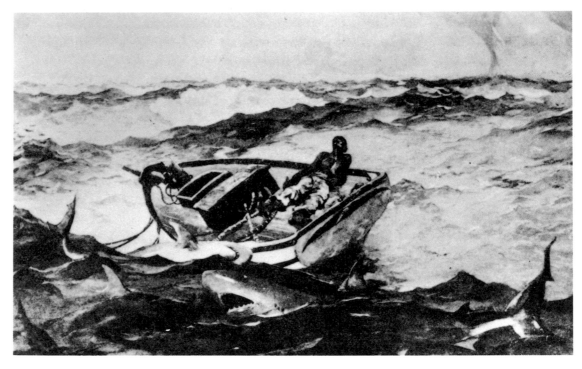

Figure 46. Photograph of *The Gulf Stream* in 1900, before the artist's changes. Reproduced from *Pennsylvania Academy of the Fine Arts, Catalogue of the Sixty-ninth Annual Exhibition, January 15 to February 24, 1900*, second edn.

Century Club, since Maury was warmly welcomed back into the world of authors. Lacking evidence, however, we can only say that nearly fifty years after the Lowell Lectures, Homer in his letter to Knoedler cited Maury as a prime authority on the sea.[28]

What did Maury say about the sea that impressed Homer so deeply? Anyone who turns to the *Physical Geography of the Sea* will wonder. The book is a hodgepodge of passages from Maury's earlier publications interspersed with borrowings from the writings of other scientists and supplemented with newly written chapter introductions and connective text.[29] Although Maury's new material tends to be out of harmony with the old, it undoubtedly was responsible for much of his book's popularity. Consider the Romantic sweep and biblical cadences of the opening paragraph of the first chapter, "The Gulf Stream": "There is a river in the ocean. In the severest droughts it never fails, and in the mightiest floods it never overflows. Its banks and bottoms are of cold water, while its current is of warm. The Gulf of Mexico is its fountain, and its mouth is in the Arctic Seas. It is the Gulf Stream. There is in the world no other such majestic flow of waters."[30] This grand manner flags before the page is done, however, and is succeeded by a workmanlike, pedantic prose style relieved by only a few other chapter openings and occasional passages of lively description.

It would be interesting to find a passage about sharks and demasted boats that might have served as a basis for Homer's *Gulf Stream*, but none exists. Homer's reference to Maury in his letter to Knoedler pertained to something other than the dramatic incident in the foreground of his painting, but his inadequate specification of what he intended the main subject to be apparently failed to register on Knoedler and has been left inadequately examined by virtually everyone who has written about the painting since.

Nonetheless, the reader who takes the trouble to examine *Physical Geography*'s two chapters on the Gulf Stream will discover what Homer had in mind and will have grounds to alter the standard readings of this well-known painting, at least in part. In his description of the Gulf Stream, Maury emphasizes two qualities that have relevance to Homer's painting. The first of these is color:

> Its waters, as far out from the Gulf as the Carolina coasts, are of an indigo blue. They are so distinctly marked that their line of junction with common sea water may be traced with the eye. . . . [There is] a want of affinity between those [two] waters . . . a reluctance, so to speak, on the part of those of the Gulf Stream to mingle with the littoral waters of the sea.[31]

Elsewhere Maury describes the color of the seawater as "greenish" and "dirty green."[32]

The second quality of the Gulf Stream described by Maury and pertinent to Homer's painting is its capacity to attract

and breed storms. Having established the stream as full of "atmospheric disturbance," Maury writes that "we might expect storms of the most violent kind to accompany it in its course." For this reason "Sailors dread storms in the Gulf Stream more than they do in any other part of the ocean. It is not the fury of the storm alone that they dread, but it is the 'ugly sea' which these storms raise. The current of the stream running in one direction and the wind blowing in another, creates a sea that is often frightful."[33] Further along he observes that "These storms, for which the Gulf Stream has such attraction, and over which it seems to exercise such control, are said to be, for the most part, whirlwinds."[34]

In light of Maury's descriptions of the Gulf Stream, certain details in Homer's painting take on new significance. The ship on the horizon moving ahead under full sail is untouched and presumably unthreatened by the waterspout because it is outside the stream's troubled indigo waters. Homer set it in a ribbon of gray paint representing Maury's "common sea water." His choice of gray over Maury's dirty green was probably a function of his own observations and of the requirements of his color scheme. When the picture was first exhibited, at the Pennsylvania Academy of the Fine Arts in January 1900, neither the ship nor the gray paint on the horizon was part of it. Homer added these details later in the year to heighten the distinctive characteristics of the Gulf Stream—its color and its storminess—by contrasting it with the ocean beyond its edge.[35] He noted at the time that in making these changes he had added "more of the Deep Sea water."[36] A photograph of the painting taken at its original showing in Philadelphia documents the changes Homer made to establish this contrast (fig. 46).[37]

The meaning of the contrast Homer was so careful to reinforce has gone uncomprehended by most viewers. Indeed, only those acquainted with the Gulf Stream at its Caribbean beginnings would have perceived Homer's differentiation of the two waters: one near-indigo, one near-white; one agitated, the other, by comparison, calm. Nor would many viewers have understood that he meant his painting's primary subject to be not the dramatic incident dominating the foreground but the surging, often "ugly" character of the great Atlantic current on which the incident takes place. He apparently wanted the stunned man, crippled boat, and crazed sharks to be seen as an emblematic group representing the ruthless energy of the Gulf Stream, but their naturalism makes them less than satisfactory for this role. It fixes the viewer's attention on the drama of the moment rather than on the timeless truths Homer and Maury attributed to the ever-flowing stream.[38]

Throughout his book Maury creates the impression that oceans are living things obedient to natural laws. He occasionally describes them anthropomorphically. He also makes it clear that the sea is a source of aesthetic pleasure, especially in its constant motion. Homer knew these things from direct experience: his two transatlantic journeys (1866–67 and 1881–82), an excursion to the Grand Banks in the North Atlantic with a fishing fleet, and annual voyages in the Caribbean (1885 on). By his Prout's Neck years he hardly needed Maury to instruct him in the ways of the ocean. Maury nonetheless reinforced his concept of the grandeur of the sea and lent it credibility.

To extend Homer's thinking in the case of *The Gulf Stream* to his Prout's Neck marines of the 1890s requires a modification of long-held assumptions about his subjects. These subjects have been understood as dealing primarily with humanity's struggle for survival in an often hostile natural world (*The Wreck*; see pl. 4) or with the never-ending contest between the sea and the shore (*High Cliff, Coast of Maine*; pl. 9), in which humans play no role. We might better see them as two parts of a single subject, one that is at once elemental in its simplicity and incomprehensible in its complexity: the power of the sea. Everything in these paintings—people, weather, rocky headlands—is an accessory whose significance derives from the ocean. The human activity in *The Wreck*, so deeply moving in human terms (and so impressively rendered), is of no import whatever in terms of the sea. Homer shows only a bit of the ocean, but everything in his canvas has been shaped by it—the land, the behavior of the people, their gear, the stormy sky. A momentary tower of spray hints at the colossal power that is the painting's underlying subject. In *High Cliff* the apparent contest between sea and shore is no contest at all in geological terms. The sea will win; time is in its favor. It will wear down the rock, await its resurrection, and wear it down again. In this conjunction of elements at Prout's Neck, Homer glimpsed eternity (as Thoreau said anyone might). Is it any wonder that he ceased painting Yankee urchins and pie-nurtured maidens?[39]

Few American artists have been as self-knowing as Homer. He recognized the distinctiveness of his talents at the outset of his career and developed them steadily by instinct and trial and error. He took pains not to learn much from others, out of concern that it would rob him of himself. While this independence preserved his artistic individuality, it also meant that he never learned some things that artists much his inferior knew well, such as how to paint a hand naturalistically gripping an object. A thread of naïveté runs through his life's work, paradoxically giving it strength. It conveys a

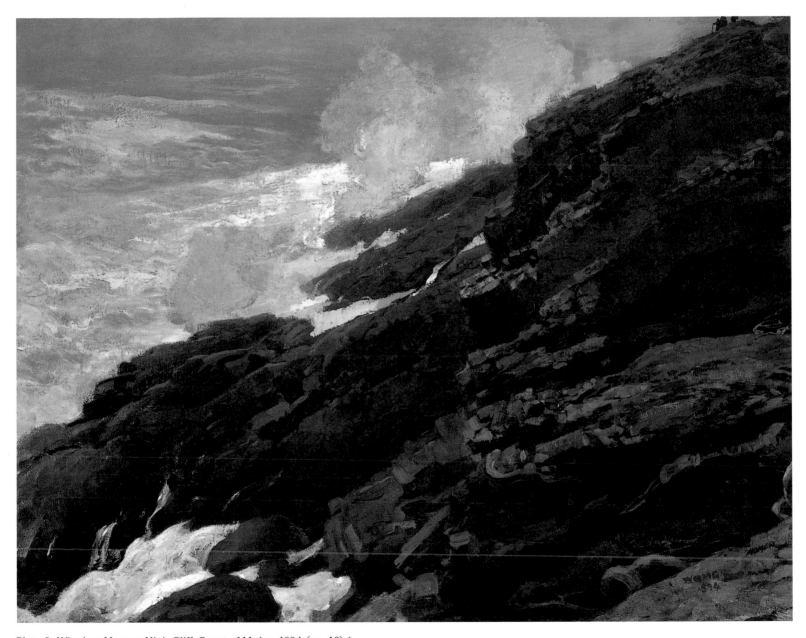

Plate 9. Winslow Homer, *High Cliff, Coast of Maine*, 1894 (no. 16).*

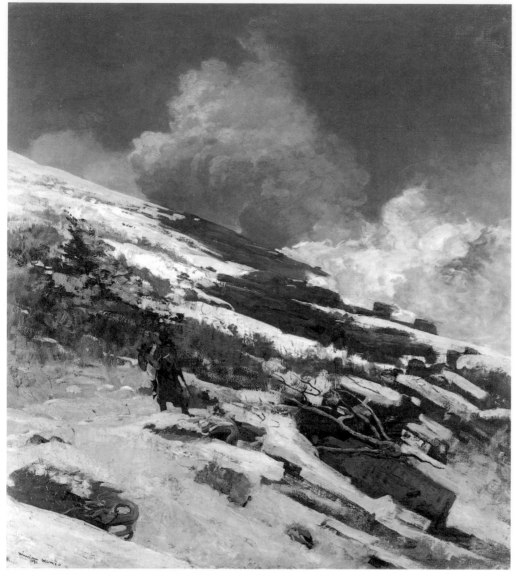

Figure 47. Winslow Homer, *Winter Coast*, 1890. Oil on canvas, 36 × 31⅝ in. (91.5 × 80.4 cm). Philadelphia Museum of Art. John G. Johnson Collection of Philadelphia.

at Prout's Neck. The astonishing freedom of his work in watercolor in the late 1880s carried over into his work in oils, modulated to suit not only the medium but also his subjects. The watercolors capture a moment; the oils reach for the eternal. With *Winter Coast* of 1890 (fig. 47), everything fell into place: the vigorous brushwork, a grasp of form, and a profound sense of the power of the sea, undiminished by narrative. A single figure, a hunter with a goose slung over his back, stands transfixed by the pounding breakers. He gives scale to the ledges. In its naturalism and economy of means, this is one of Homer's most remarkable figures.

It has become commonplace to say that after 1890, figures gradually disappeared from Homer's Prout's Neck subjects and from his work generally. This is curious, since figures in fact appear in many of his marines from these years, including his last works. It would be more accurate to say that the figures in the marines of his Prout's Neck years differ in important ways from those he had painted earlier. Most of the late figures, like the hunter, are subsidiary to the sea rather than subjects in their own right. The woman in *The West Wind* (pl. 3), one of Homer's most impressive essays in Tonalist color, and the group in *Watching the Breakers* (pl. 10) are important compositional components; their rapt attention to the sea emphasizes its power, but they have no presence as individuals, as did many of Homer's earlier figures. Other late figures, such as that depicted in *The Fisher Girl* (pl. 11), were adapted from sketches and paintings begun in Cullercoats in the early 1880s, and while admirable in some ways, they often lack freshness. They are more studied than most of Homer's figures. This may represent his answer to the recurrent criticism that his figures were harshly painted.

forthrightness—a special truthfulness—that set his work apart from that of his academically sophisticated colleagues and seemed perfectly in tune with American taste. Comparing him to his great contemporary Thomas Eakins, Fairfield Porter observed that "Homer had the advantage over Eakins of not having received any artistic ideas from his education that were inappropriate to the audience."[40] This may well have had something to do with Eakins's remark at the end of his own career that Homer had been the greatest American artist of their era.[41]

Homer's self-developed style reached maturity within a few years after he settled

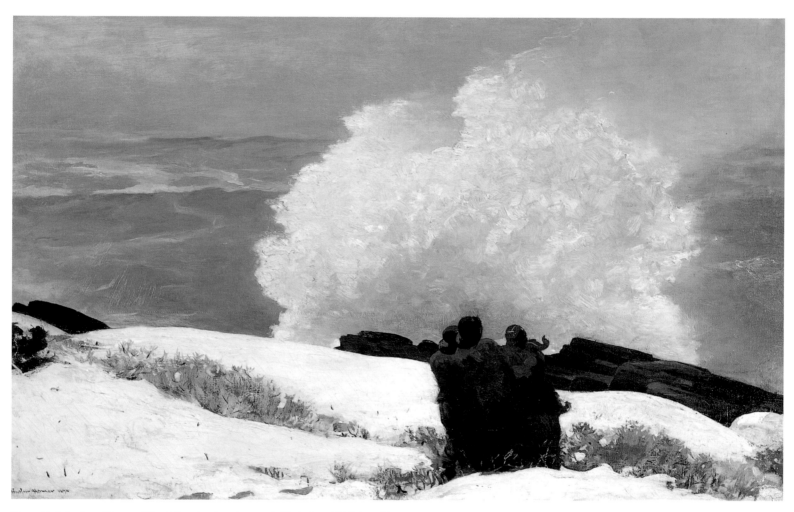

Plate 10. Winslow Homer, *Watching the Breakers—A High Sea*, 1896 (no. 31).*

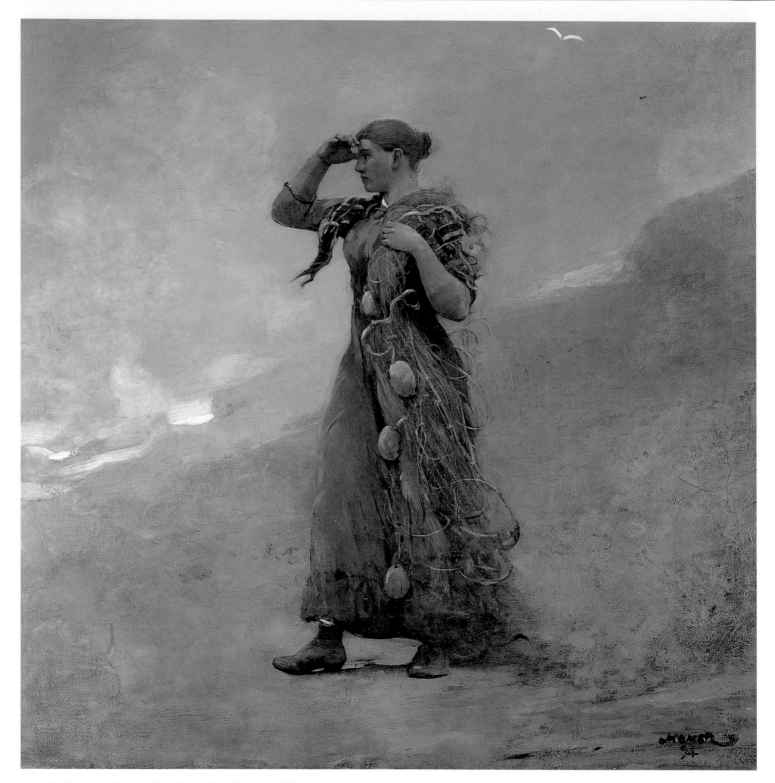

Plate 11. Winslow Homer, *The Fisher Girl*, 1894 (no. 19).*

Homer did not eliminate figures from his late work so much as he added a new subject to it: pure seascape. This subject required no human accessories. To ennoble those who live on the coast, as he did in *The Wreck,* or to generalize them, as he did in *Watching the Breakers,* contributed little to what he had to say about the sea. In such figureless marines as *Sunlight on the Coast* (pl. 12), *Eastern Point* (pl 13), and *West Point, Prout's Neck* (pl. 14), Homer moved beyond human concerns but not away from them.

Every serious artist must contend with the ever-present conflict between tradition and personal vision in art. Homer staked his chances on personal vision and constantly, quietly, surprised his peers. "He paints his own thoughts, not other people's," observed the critic George Sheldon in 1878.[42] But while Homer's singularity as an artist became legendary during his years at Prout's Neck, it also cried out for explanation. How was it that a self-trained artist who had removed himself from the center of the American art world could produce works year after year that made the efforts of nearly all of his academically trained colleagues seem weak and derivative?

There have been no satisfactory answers to this question, and perhaps it is, as Homer would likely have thought, merely a makework for critics, biographers, and historians. It is the kind of consideration, only tangentially related to art, that Homer resisted when Knoedler asked him for information about *The Gulf Stream.* More, perhaps, than any other American artist of his time, Homer wanted nothing to intervene between the viewer and the painting. When he said, "I regret very much that I have painted a picture that needs description," he meant it. He trusted us to know what we see, in art as well as life.

NOTES

1. Homer's primacy among American artists and the special significance of his Prout's Neck work are eloquently described by Mariana (Mrs. Schuyler) Van Rensselaer in *Six Portraits* (Boston and New York: Houghton Mifflin, 1889), pp. 237–74. Her chapter on Homer is a much-revised and enlarged version of "An American Artist in England," *Century* (November 1883), pp. 13–21.

2. Charles Caffin, *The Story of American Painting* (New York: Frederick A. Stokes, 1907), p. 234.

3. Ibid.

4. Lloyd Goodrich, *The Graphic Art of Winslow Homer* (New York: Museum of Graphic Art, 1968); David Tatham, *Winslow Homer and the New England Poets* (Worcester: American Antiquarian Society, 1979); David Park Curry, *Winslow Homer: The Croquet Game,* exh. cat. (New Haven: Yale University Art Gallery, 1984); Helen Cooper, *Winslow Homer Watercolors* (New Haven and London: Yale University Press for the National Gallery of Art, 1986); Marc Simpson, et al., *Winslow Homer: Paintings of the Civil War* (San Francisco: Bedford Arts Publishers for the Fine Arts Museums of San Francisco, 1988); Peter H. Wood and Karen C. C. Dalton, *Winslow Homer's Images of Blacks* (Austin: University of Texas Press, 1988); Tony Knipe et al., *Winslow Homer: All the Cullercoats Pictures* (Sunderland, England: Northern Centre for Contemporary Art, 1988). This is a representative, but hardly exhaustive, list of important contributions to the Homer literature from the past twenty years that examine his pre–Prout's Neck work.

5. Individual works have received close attention, however, especially in terms of collection documentation. For a notable example, see Natalie Spassky, *American Paintings in the Metropolitan Museum of Art, Volume II* (Princeton: Princeton University Press, 1985), pp. 468–90. Several interpretive essays on individual works have appeared in recent years, including those by Theodore Stebbins, Jr., and Carol Troyen in *A New World: Masterpieces of American Painting, 1760–1910,* exh. cat. (Boston: Museum of Fine Arts, 1983), pp. 332–40.

6. Samuel Isham, *History of American Painting* (New York: Macmillan, 1905), p. 355.

7. William Howe Downes, *The Life and Works of Winslow Homer* (Boston: Houghton Mifflin Company, 1911), p. 10.

8. Lloyd Goodrich's publications on Homer, including his essay for the centennial exhibition catalogue, *Winslow Homer Centenary Exhibition* (New York: Whitney Museum of American Art, 1936), and especially his monograph *Winslow Homer* (New York: Macmillan Co. for the Whitney Museum of American Art, 1944), still the essential study of the artist, marked a move to a more objective style of description, but the older style survives, particularly in nonacademic writing.

9. Examples of watercolors from these three places are reproduced in Cooper (note 3), pp. 53–63, 67–77, 87–117.

10. Descriptions of Homer as trusting his eyes rather than art occur frequently in the literature from the 1860s onward. They constitute the foundation of Van Rensselaer's chapter in *Six Portraits* (note 1).

11. The popularization of the notion that Homer was a recluse can be traced to Clarence Cook's mild and qualified statement in 1888 that "for some years Homer has lived a rather recluse life on the coast of Maine" (*Art and Artists of Our Time* [New York: Selmar Hess, 1888], vol. 3, p. 258). This impression was strengthened in William Howe Downes and Frank Torrey Robinson, "Later American Masters," *New England Magazine* (April 1896), p. 140, by the more romantic statement that "like Thoreau, Homer is a recluse, for the reason that the art of the sort he lives for is incompatible with the amenities of society. He lives in a lonesome spot on the coast of Maine. His sole companions are natural and uncomplicated beings, outdoor folk, hunters, fishermen, sailors, farmers." These inaccuracies were taken up and given wider circulation in 1908 in a much-quoted article by Leila Mechlin, in which she describes Homer as "withdrawn from the world of men and living the life of a recluse" ("Winslow Homer," *International Studio* 34 [June 1908], p. 129). Mechlin's view of the matter was perhaps influenced by Homer's graceless refusal in 1907 to grant her an interview (Goodrich, *Winslow Homer* [1944] [note 8], p. 188). The artist was, in any event, in declining health and spirits at this late point in his life.

12. His cousin was Francis Channing Barlow, a Union officer who quickly reached high rank and distinguished himself on more than one battlefield. For Homer in Civil War camps, see Simpson et al. (note 3) and David Tatham, "Winslow Homer at the Front," *American Art Journal* 11, no. 3 (Summer 1979), pp. 86–87.

13. He seems not to have painted his parents, for example, or his sister-in-law Martha French Homer, to whom he was devoted.

14. This painting has provoked comments over the years about its "phantasmagorical light," its "unheard music," and the alleged oddity of two women dancing together, but these observations seem strained. Women often danced as partners quite properly at all social levels from the mid-nineteenth through the mid-twentieth century. The music presumably comes from a piano within the building on whose veranda the women dance, though they also could be singing. It is of necessity "unheard" in a painting, but not more so here than in dance subjects of the same era by, say, Renoir or Toulouse-Lautrec.

15. Henry David Thoreau, *Walden* (1854; reprint, Princeton: Princeton University Press, 1971), p. 90.

16. Ibid., pp. 90–91.

17. Ibid., p. 98.

18. Brooks Atkinson, Introduction, in Henry David Thoreau, *Walden and Other Writings* (New York: Random House, 1937), p. xv.

19. Stuart Davis, "Is There an American Art?" *Creative Art* 6 (February 1930), pp. 34–35. Davis's remark comes in the course of a discussion of European influences on the styles of American master painters.

20. Goodrich, *Homer* (1944) (note 8), p. 135.

21. Homer to Roland Knoedler, February 17, 1907, published in ibid., p. 162.

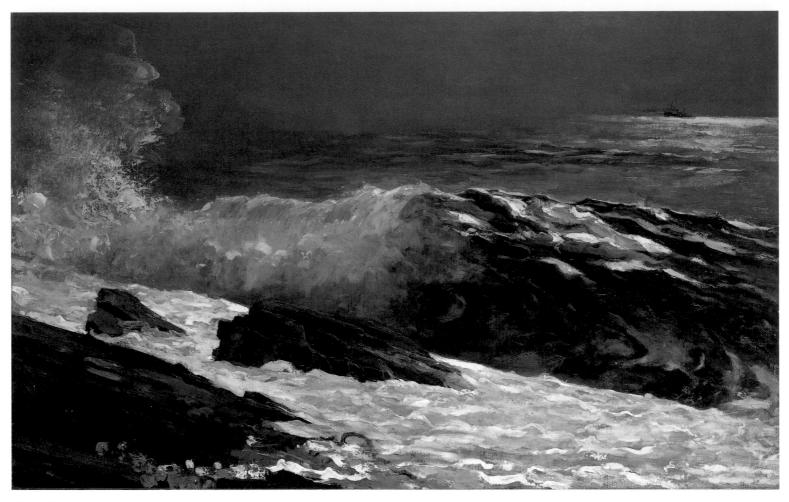

Plate 12. Winslow Homer, *Sunlight on the Coast*, 1890 (no. 9).*

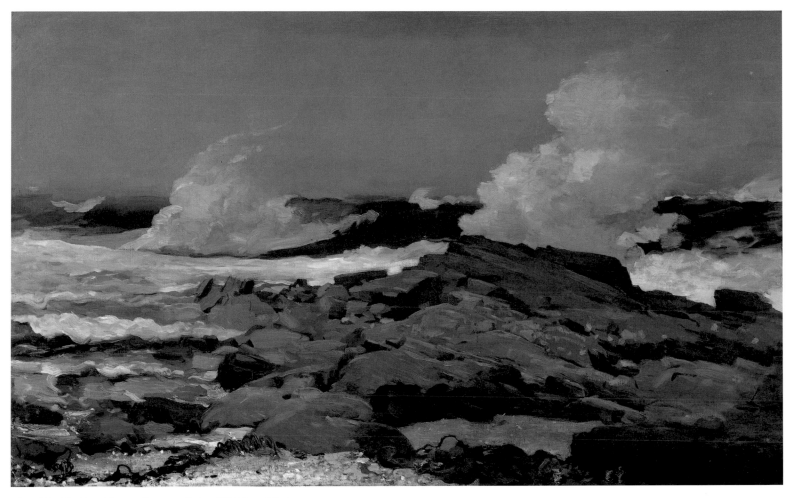

Plate 13. Winslow Homer, *Eastern Point*, 1900 (no. 33).*

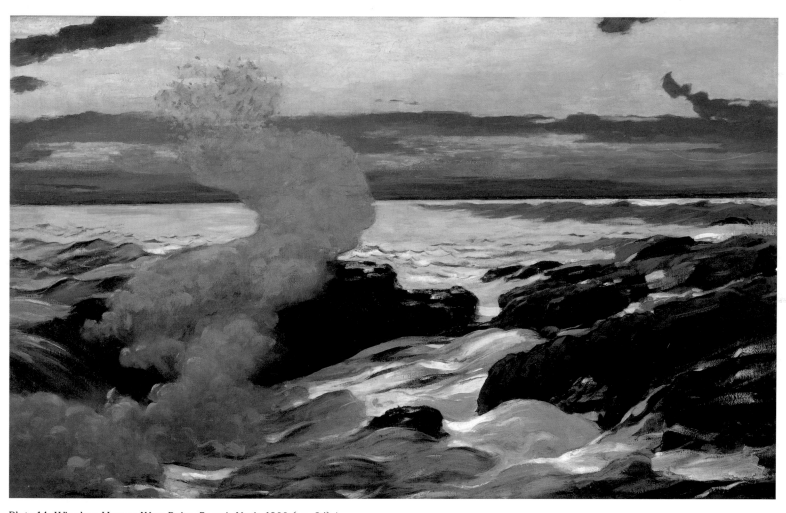

Plate 14. Winslow Homer, *West Point, Prout's Neck*, 1900 (no. 34).*

22. Matthew Fontaine Maury, *The Physical Geography of the Sea* (New York: Harper and Brothers, 1855).

23. George Chaplin Child, M.D., *The Great Architect: Benedicite; Illustrations of the Power, Wisdom, and Goodness of God, as Manifested in His Works*, 2 vols. in 1 (New York: G. P. Putnam and Sons, 1871). First published in England in 1866, Child's discourse on the divine natural order of the physical world enjoyed several years of popularity on both sides of the Atlantic. Homer's copy is described in David Tatham, *Winslow Homer's Books: A Descriptive List of Books Once Owned by Winslow Homer and Now the Property of the Margaret Woodbury Strong Museum, Rochester, New York* (Syracuse: Syracuse University Department of Fine Arts, 1976), pp. 10–11.

24. Charles Lee Lewis, *Matthew Fontaine Maury: The Pathfinder of the Seas* (1927; reprint, New York: AMS Press, 1969), pp. 102–3.

25. Ibid.; *Boston Transcript*, December 6, 1856, p. 2.

26. For Maury's relations with other scientists and a considered estimate of his historical significance, see Robert V. Bruce, *The Launching of Modern American Science* (New York: Alfred Knopf, 1987), pp. 171–86.

27. Boston *Transcript*, December 13, 1856, p. 2.

28. Homer may have heard Maury lecture on his last tour, which took the oceanographer to Boston and New York in September 1872, though his subject then was meteorology and agriculture rather than the sea. See Lewis (note 24), p. 234.

29. Maury revised his *Physical Geography of the Sea* from time to time, so that various editions and printings differ in numerous ways. I have cited the sixth edition of 1857, so-called in Maury's introduction to the volume, and the eighth edition of 1861, which contains his final revisions and reorganizes the material.

30. Maury, *Physical Geography*, 6th edn., p. 25.

31. Ibid.

32. Maury, *Physical Geography*, 8th edn. (reprint, Harvard University Press, 1963), p. 47.

33. Maury, *Physical Geography*, 6th edn., pp. 60–61.

34. Ibid., p. 62.

35. Spassky (note 5), vol. 2, p. 484.

36. Homer to John W. Beatty, September 1900, cited in ibid., p. 483.

37. Ibid., p. 484.

38. The foreground group has been criticized perhaps more than any other detail in Homer's late paintings, though nearly always within a context of praise for the work's great strengths. The criticisms have ranged from doubts about the correctness of Homer's marine architecture to assertions that his figure drawing is faulty. For a summary of such criticisms, see ibid., pp. 483–90. A number of critics find allusions in the picture to both Copley's *Watson and the Shark* (Museum of Fine Arts, Boston) and Géricault's *Raft of the Medusa* (Musée du Louvre, Paris), but since Homer virtually never referred to other artists' works in his own, and would have had no likely motive for doing so here, this line of conjecture seems unpromising. In the narrower realm of the history of fish painting, it is fair to observe that Homer's sharks, developed from watercolor sketches made in the Caribbean in 1885 (Cooper [note 3], pp. 141–43), are far more naturalistic than Copley's single shark, which was not painted from a living specimen. Homer undoubtedly was acquainted with *Watson*, but it seems improbable that he meant his *Gulf Stream* to be a gloss on it.

39. "Yankee urchins" and "pie-nurtured maidens" are Henry James's descriptions of Homer's subjects of the mid-1870s. See Henry James, Jr., "On Some Pictures Lately Exhibited," *Galaxy* (July 1875), pp. 90–94.

40. Fairfield Porter, "Portraits of Americans: Homer," in Rackstraw Downes, ed., *Fairfield Porter: Art on Its Own Terms. Selected Criticism, 1939–1975* (New York: Taplinger, 1979), p. 195.

41. Interview reported in *Philadelphia Free Press*, February 22, 1914; quoted in Lloyd Goodrich, *Thomas Eakins* (Cambridge, Mass.: Harvard University Press, 1982), vol. 2, p. 270.

42. George Sheldon, "American Painter—Winslow Homer and F. A. Bridgman," *Art Journal* 4 (August 1878), p. 227.

Winslow Homer's Maine

John Wilmerding

I t may be the central paradox of Winslow Homer's later career that in concentrating his vision on a few acres of Maine rock, he was able to convey a universal sense of nature's forces. From introspection came philosophical breadth, from a finite physical world an expansive cosmos of ideas and feelings. As the last decade of a century, the 1890s were for many Americans redolent of finality and dissolution. Arguably for Homer the decade saw the culmination, even liberation, of his style. Within his realism at this time he found a power of abstraction in both form and meaning.

At the center of this period and of Homer's vision is *The Artist's Studio in an Afternoon Fog* (see pl. 2), for it is emblematic of the history, process, and future of Homer's art. Through the subconscious tradition of art history, its suffusive sunlight refers back to Claude and Turner. At the same time its bold brushwork and contrived design remind us of Homer's attention to purely formal elements of his art, while the studio stands literally in the middle of the composition, not just as the principal sub-

ject of the painting but as a metaphor for his making of art.

Although Prout's Neck has its high cliffs and views of Cannon Rock and Wood Island Light, Homer did not come to Maine, as most of his predecessors had, for such views. American artists first began to venture down the Maine coast during the late 1830s and 1840s, among them Alvan Fisher, Thomas Birch, Thomas Doughty, and Thomas Cole, primarily in search of the kind of sublime wilderness they were discovering in the Catskills and at Niagara Falls. This romantic generation approached the newly discovered American nature largely by means of inherited European conventions, yet its members were committed to interpreting that nature as one with the national character. Traveling by boat, the major and almost only means of transportation in this difficult and inaccessible landscape, they reached some of the more dramatic outposts such as the Camden Hills and Mount Desert Rock. By and large their depictions were exaggerated and imaginative due to the license they took with details,

vantage points, and arrangement of elements, as effects of grandeur took precedence over accuracy of record.

With the next generation of painters, led by the Gloucester artist Fitz Hugh Lane, sailing the coast during most of the 1850s, artistic interest turned toward capturing actual views with precision, especially the enveloping effects of light and atmosphere. By midcentury coastal Maine had become increasingly accessible by steamer and, thereafter, by railroad. Artists still sought quiet, isolated scenery for contemplation of nature's uplifting beauty. Lane was aware of the growing commerce along the New England coast and faithfully recorded within his luminous pictures the quotidian details of shipping, quarrying, and lumbering. The Maine wilderness afforded him and his colleagues an imagery of physical serenity and spiritual sustenance, a confirmation of natural bounty and promise believed to express a sense of the nation's high noon in the decade before the outbreak of civil war.

Frederic Edwin Church overlapped Lane

in his several visits to Mount Desert in the 1850s and early 1860s, but Church found in his own language of increasingly intense, explosive sunsets a vision of conflict, anxiety, and change correlating with the physical and emotional turbulence of the war years. Church's technical refinement, his command of draftsmanship in pen, pencil, and brushwork, reflected the new consciousness in America of John Ruskin's principles of accuracy in recording nature's aspects. Immediately following Church to Maine was William Stanley Haseltine, another Ruskinian, who drew and painted close-up studies of coastal rocks and ledges with the scrutiny of a natural scientist.

Following the Civil War, with America returning to domestic routines, citizens and artists could take up the growing pursuit of leisure. Recently returned from Paris, Homer painted seaside sketches at the resort area of Long Branch, New Jersey, and, during the early 1870s, along the Gloucester waterfront. At the same moment other painters still working in the Luminist manner of Lane were making excursions to the Maine coast, now—like many sections of the Rhode Island and Massachusetts shorelines—the setting for burgeoning summer communities. The building of vacation cottages and resort hotels that flourished most notably at Newport, Rhode Island, occurred up and down the seashore from Tom's River, New Jersey, to Bar Harbor, Maine. Painters like Bricher, Gifford, Shattuck, and Richards traveled as far as Mount Desert, and some went even farther, to Grand Manan in the Bay of Fundy, celebrating the new era of recreation as well as the visual beauty of this still largely pristine landscape.

Just as Homer was settling at Prout's Neck in the mid-1880s, a number of his colleagues were devoting themselves to stylistic variations of Impressionism following their French counterparts. Among those who came to paint the islands and bays of the Maine coast in the Impressionist vocabulary were Frank Benson, who began to summer at North Haven toward the end of the century; John Singer Sargent, who briefly visited friends on Ironbound Island in Frenchman's Bay; and Childe Hassam, who executed a number of works at both ends of the Maine coast, from the Isles of Shoals to Winter Harbor.[1] Their bright canvases convey the pleasures of summer vacation life even as they acknowledge the timeless presence of Maine's rugged geology and sharp northern light.

It is all the more remarkable that Homer's art in the same period and region examined themes of life and death. His canvases were charged with the energies of life at the same time that they were deadly serious. As we have seen, during the late nineteenth century Prout's Neck was developing as a vacation resort, yet in Maine Homer seldom painted genre pictures, reserving his depictions of both lighthearted and more dramatic human activities for renderings of the Adirondacks and Caribbean. Once settled at Prout's Neck, moreover, he saw no need to explore or paint the more spectacular or alluring portions of the coast farther east. In contrast to virtually all of his predecessors and contemporaries, he was neither adventurer, tourist, geologist, historian, nor nationalist. Perhaps a moralist and philosopher, he required only the circumferences of self, eye, and studio. His near ground was filled with the sloping ledges of the peninsula's cliffs, his horizon, with the sun or moonlight on the sea, and in between, the perpetual contest of the elements was symbolized by the breakers often occupying his view. His piece of Maine was sufficient for commonplace observation and for the articulation of profound natural truths.

When Homer moved to Prout's Neck after his return from Cullercoats in 1882, it became his residence for the rest of his life.[2] The rhythms of his existence developed primarily in conjunction with the seasons. By the 1890s Homer was going regularly to the Adirondacks in the fall on fishing trips with his brother Charles and to Florida or the Caribbean in the dead of winter. During this decade his subjects shifted between intimate figural vignettes and bleak landscapes with little or no human presence. One senses that from mid-life onward he continually sought to express the tensions he felt between closeness to, and separation from, others, between shared experience and loneliness or isolation. Although most of his major landscapes done at Prout's Neck during the 1890s include no figures or include them anonymously, he painted views there at all times of the year.[3] He had become interested in capturing the protean effects of light and moisture, and he was moving toward compositions of bolder design and greater formality.

Both impulses explain something of the abstract power in *The Artist's Studio in an Afternoon Fog*. Two elements of the painting are especially evocative: Homer's isolated studio and the enveloping shroud of glowing fog. The cantilevered balcony that afforded Homer a panoramic view of the cliffs and ocean[4] is visible in the centrally isolated silhouette of his studio. From its similarity of tone and roofline we read this building as part of the family compound; at the same time its placement in the composition and sharper contour emphasize its significant separateness. Thus, Homer held in equilibrium his axial needs for connectedness and independence. The fog enshrouds the whole, creating privacy and eerie detachment. Anyone who has read a suspense novel set on the Maine coast knows how fog can embody mystery, and anyone who has

sailed the coast knows how fog can be sur-real and disorienting. As sight is blurred and confused, the other senses of sound and smell, even touch and taste, are height-ened. In this painting Homer has orches-trated noise and silence in a tone poem of muted colors, themselves amazing in their contrast and internal harmony. On one level the painting is an observation of palpable facts, on another, a meditation on acts of imagination.

We know that the last three decades of Homer's life are considered his most cre-ative and productive. What might be argued is that the central decade of this span, the 1890s, saw the greatest concentration of his masterpieces. By any account it was a com-plicated period of achievement and growth. Where we might recognize many of his grand allegorical pictures (*The Life Line* [see fig. 3], *The Fog Warning*, *Eight Bells*) as belonging to the 1880s, and what might be described as his summary symbolic ab-stractions (*Kissing the Moon* [Addison Gallery of American Art, Phillips Academy, Andover]; *Right and Left* [National Gallery of Art, Washington, D.C.]) as coming in the 1900s, the 1890s began with the mysterious *A Summer Night* (see pl. 6) and concluded with the iconic *Gulf Stream* (see pl. 8). In almost every year of the decade Homer pro-duced a cluster of memorable works, a large majority of them inspired by his Prout's Neck surroundings.

Just as the seasons played off against one another, so too did Homer's images deriving from his sequential trips to the northern woods and southern waters com-plement the Maine landscapes. Arguably, these non-Maine subjects are all of a piece with his Prout's Neck output, but they also may be seen as foil and backdrop. Among the several developments in Homer's art of the 1890s, and clearly evident in the Maine work, is his heightened concern with formal means. Both his technical powers and the seriousness of his ideas advanced in this period, resulting in works marking the sum-mit of his career. Having begun to paint in watercolor during the early 1870s, Homer thereafter took up related, and in some in-stances identical, subjects concurrently on paper and on canvas. But during the 1890s he achieved a new sophistication in exploit-ing the expressive possibilities of water-color and oil, due in part to the stimulus of his trips to the Adirondacks and the Bahamas. These environments, so different from each other and from Prout's Neck, prompted him to paint some of the most free, lush, intimate, and subtle works of his maturity.[5]

Early in the 1890s, Homer carried over two major images from watercolor to oil: *Guide Carrying Deer* (Portland Museum of Art) and its canvas version, *Huntsman and Dogs*, and two versions of *Hound and Hunter* (both National Gallery of Art, Washington, D.C.). As other historians have observed, in moving from one technique to the other Homer was able to develop an idea from a particular incident to a general con-cept, to shift from an expression of sponta-neity to one of permanence, from descrip-tion and definition to allusion and suggestiveness.[6] There are no such direct correlations between his Maine seascapes in watercolor and oil for a couple of rea-sons. Though some have argued that he was better able to match his livelier brushwork and colors to landward scenes of local gar-dens and woodland interiors,[7] Homer had begun his scrutiny and analysis of rolling waves and breakers soon after settling at Prout's Neck a decade earlier. Fluid, trans-parent watercolors like *Prout's Neck, Rocky Shore* of 1883 and *Prout's Neck, Breaking Wave* of 1887 (Art Institute of Chicago) led to such corporeal oils as *High Cliff, Coast of Maine* (see pl. 9) and *Sunlight on the Coast* (see pl. 12) in the 1890s. In the watercolors he caught the spontaneity and immediacy of the water's action, the refraction and spar-kling reflections of light dancing on its sur-faces: nature in vibrant motion and pulsing with life. When he turned to painting on canvas, he seems to have been more inter-ested in revealing nature's permanence, her physical—even molecular—structure, the dynamics of weight, mass, and volume.[8]

Following his literal investigation of the properties of oil and watercolor, Homer con-sidered their relationship to meaning as he formulated compositions of opposing forces. Even when nature was calm and gentle, as in *A Summer Night* (see pl. 6) or *Moonlight, Wood Island Light* (pl. 15), an awareness of molecular energy and rhyth-mic forces was present, as subtle yet as strong as the tides. More frequently, Homer favored depictions of the drama of the sea, and the plastic density of oils perfectly suited the collisions of solid and liquid he wished to depict. Some pictures address humanity's contest with nature: in *Winter Coast* (see fig. 47) and *The West Wind* (see pl. 3) the viewer joins a figure who faces the wind and surf. Compositions such as *Cannon Rock* (pl. 16) and *Northeaster* (pl. 17) distill the conflict of opposites by setting water and rock, wind and tide, against one another. Pairs and opposites held in balance or tension, long a part of Homer's pictorial strategies, acquired their boldest form at this time.[9] Closely related to these reduc-tions is his stress in numerous works of this period on simplified tonal contrasts. His early training in graphic art contributed to his consciousness of line, silhouette, and chiaroscuro. But in these great dramas of nature's basic elements, Homer found a symbolic and fateful language in tonal ex-tremes. It is relevant that in the same years he began to use photographs extensively and to paint a remarkable series of water-

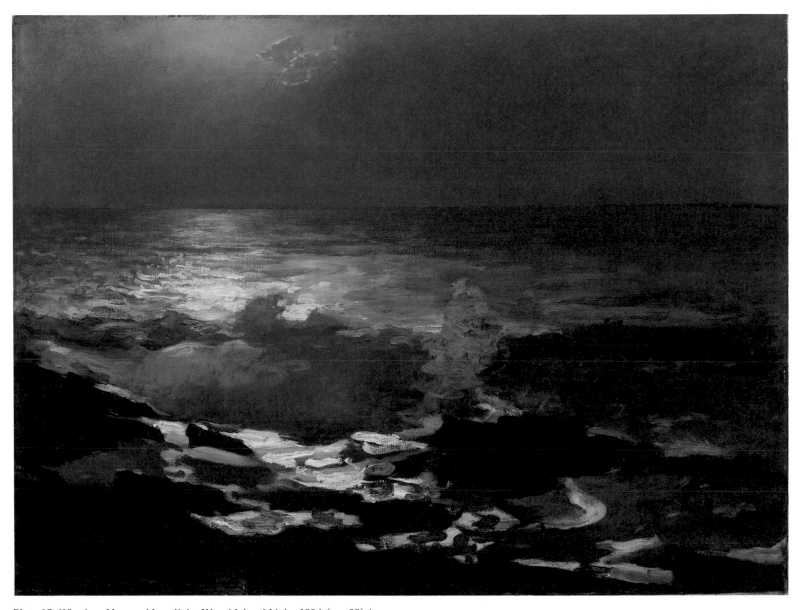

Plate 15. Winslow Homer, *Moonlight, Wood Island Light*, 1894 (no. 23).*

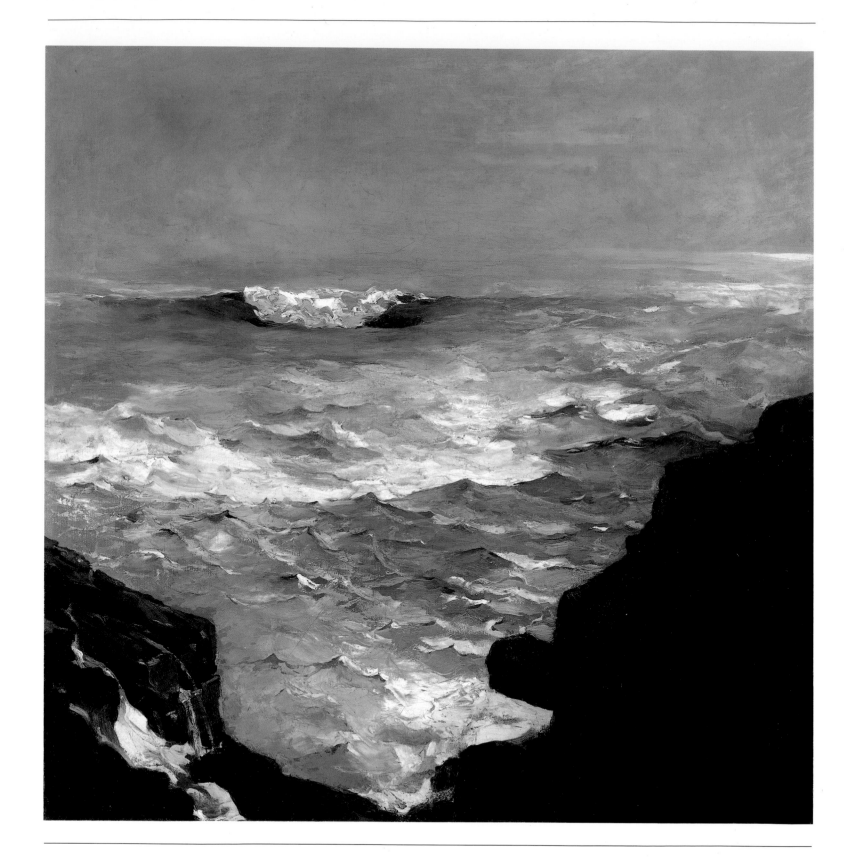

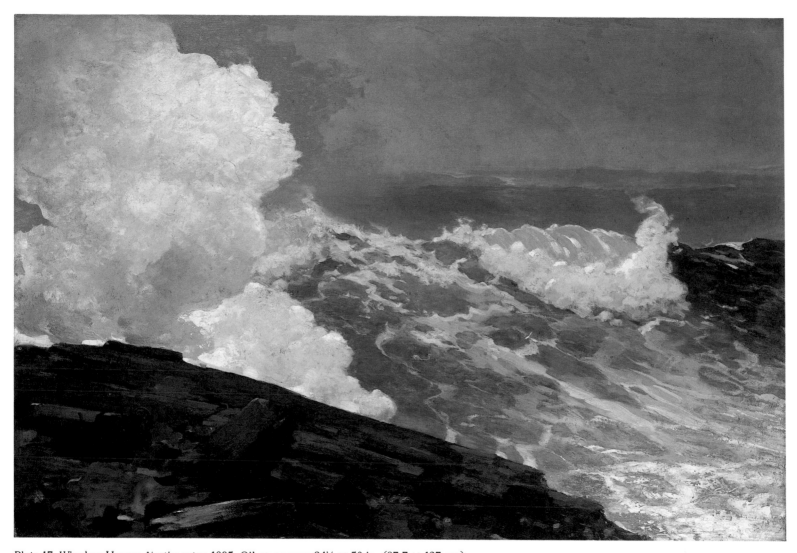

Plate 17. Winslow Homer, *Northeaster*, 1895. Oil on canvas, 34½ × 50 in. (87.7 × 127 cm).
The Metropolitan Museum of Art, New York. Gift of George A. Hearn, 1910.

opposite:
Plate 16. Winslow Homer, *Cannon Rock*, 1895 (no. 27).*

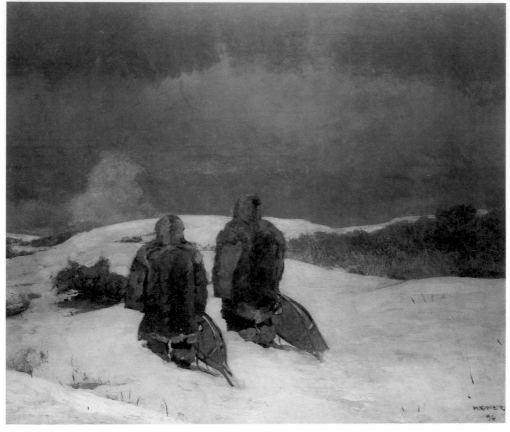

Figure 48. Winslow Homer, *Below Zero*, 1894. Oil on canvas, 23³⁄₁₆ × 27 in. (60.2 × 71 cm). Yale University Art Gallery, New Haven. Bequest of George Roberts.

colors in gray, black, and white gouache.[10] Like other artists late in their careers—Rembrandt and Goya, for example—Homer discovered the intense emotional resonance of near-black pigments, brooding, mysterious, and universal.

What we see in Homer's art from this time is his increasing use of formal elements for their symbolic, rather than their descriptive, capacities. During the early 1890s he also handled his colors in limited but intense ranges. For example, besides *The Artist's Studio*, *The West Wind*, *Below Zero* (fig. 48), and *The Wreck* (see pl. 4) are studies in almost Whistlerian tans and browns, while grays and blues dominate the

ghostly *Sleigh Ride* (fig. 49).[11] If we add to this group the striking, if disturbing, *Fox Hunt* of 1893 (see fig. 5), we can understand why more than one observer has pointed to the Oriental simplicity of these works.[12] Aside from being one of Homer's most famous achievements of the decade, this last image dramatizes two further aspects of his late style: a new emphasis on flatness of surface and compression of space, and elevated, generalized subjects of life and death. The process of simplification, whereby an essential piece stands for the whole, is evident in *The Lookout—"All's Well"* (fig. 45), whose title signifies humanity's secure place in the universe. By con-

trast, the threatened mortality of human and animal was a constant in Homer's work from the beginning to the end of the decade, whether away or at home, in summer or in winter. Just consider *Hound and Hunter*, *The Fox Hunt*, *Signal of Distress* (Thyssen Collection, Lugano), and *The Gulf Stream* (see pl. 8).

Two final compositional devices of this period are worth mentioning. In at least two major oils, *Cannon Rock* of 1895 (pl. 16) and *On a Lee Shore* of 1900 (pl. 18), Homer employed a square format, one artificial for the conventional landscape view and therefore emphatic in its formal purity and attention to composed shapes. Elsewhere, primarily in his virtuoso fishing watercolors done in the Adirondacks and Canada, he began to experiment with startling juxtapositions of foreground and background forms, surprising shifts in scale and vantage points, and almost unnerving asymmetries of design. What began as fish leaping in the distance or at the end of a line, scaled in traditional perspective, gradually became looming foreground forms that almost overwhelm the design and place the viewer in the position of mortal victim.[13] Although more intimate in mood and size than the oils, these watercolors demonstrate a comparable intensity of feeling and metaphor, a comparable transformation of illusion into allusion.

In 1890 Homer was fifty-four years old, and at the end of the decade and turn of the century, sixty-four. Historians have noted his pictorial response to his mother's death in 1884 with works like *The Life Line* (see fig. 3) and *Undertow* (see fig. 4), with their powerful suggestions of sexual repression.[14] His father's death in 1898 appears to have been a factor in Homer's profound consciousness of impending death and loss depicted in the summary work of the period, *The Gulf Stream*.[15] Bearing the date

1899, this picture is also an emblem of century's end and, subconsciously as well as intentionally, an embodiment of the fin-de-siècle mood of anxiety, if not despair, felt by many Americans and Europeans in these years. Certainly, it was an age in transition, as Homer's near contemporary Henry Adams was to articulate in *The Education*, published in 1905, and Albert Einstein was to confirm with his theory of relativity, announced the same year. Both art and science, by means of Picasso's cubism, the technology of the X ray, and the practice of psychoanalysis, were about to dissect and penetrate the surface of the visible world. Homer's mature art did not predict these events, but his sense of abstraction and anxiety was surely modern in its expression.

Significantly, Homer painted one of his first reductive visions at the 1893 World's Columbian Exposition in Chicago, an occasion that marked a major anniversary of American history but also concluded the progress of the nineteenth century. This black-and-white oil, *The Fountains at Night, World's Columbian Exhibition, Chicago* (fig. 50), is an almost private meditation on the artificial light and electrical energy of a new age.[16] Equally significant is the photograph taken of Homer in his studio at the end of the decade, standing next to his canvas *The Gulf Stream* (fig. 51). While three other works, including the 1892 oil *Hound and Hunter*, are partially visible behind him, it is the tragic Caribbean drama with which the artist chose, or allowed himself, to be identified near the end of his own life. We are not sure to what extent Homer empathized with the victimization of blacks in America at the close of the nineteenth century or, more generally, with figures isolated by society.[17] But we can see for ourselves that this intense image of the South was both painted and centered in his north-

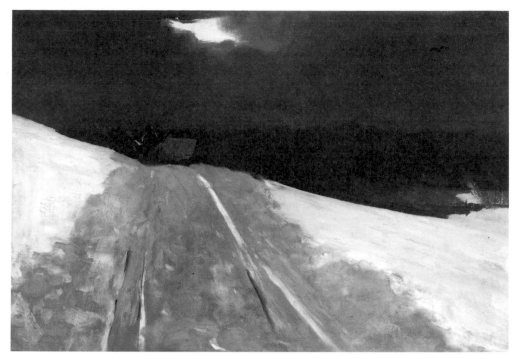

Figure 49. Winslow Homer, *Sleigh Ride*, circa 1893. Oil on canvas, 14⅛ × 20¹⁄₁₆ in. (35.9 × 51 cm). Sterling and Francine Clark Art Institute, Williamstown, Massachusetts.

Figure 50. Winslow Homer, *The Fountains at Night, World's Columbian Exposition, Chicago*, 1893. Oil on canvas, 16 × 25 in. (40.6 × 63.5 cm). Bowdoin College Museum of Art, Brunswick. Bequest of Mrs. Charles S. Homer, Jr.

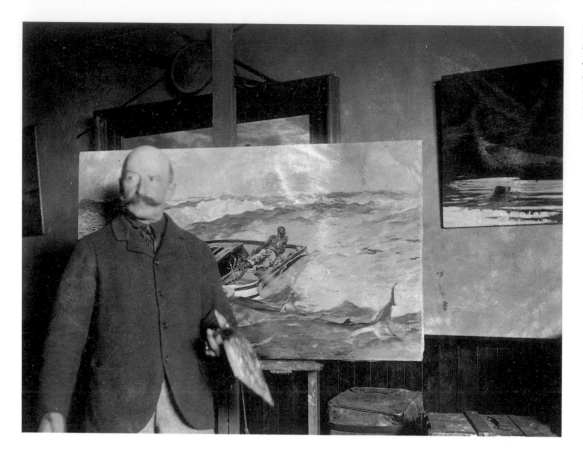

Figure 51. *Winslow Homer at His Easel, with* The Gulf Stream, *in His Painting Room at Prout's Neck, Maine*, 1898. Silver print by unknown photographer. Bowdoin College Museum of Art, Brunswick. Gift of the Homer family, 1964.*

ern Maine studio. While its nominal subject has nothing to do with his observations of Prout's Neck, it clarifies Homer's overriding confrontation in these years with irony, uncertainty, and fate.

All of which brings us back to *The Artist's Studio*, both the painting and the actual location. Even without the topicality of the world's fair image or the foreboding of *The Gulf Stream*, this introspective view of Prout's Neck displays tonal modulation recalling the former and brooding somberness forecasting the latter. Most of the formal advances Homer made in the 1890s are present: the flat surface, reductive palette, and rich, varied textures of brushwork, suggesting mood as much as veiling physical facts. Despite its identifiability, the painting shows evidence of a created design, as is

clear when it is compared with photographs of the site.[18] Homer both turned and flattened the buildings, manipulated their silhouettes, and contrived a vantage point that looks up and directly at the ghostly structures all at once. He designated one architectural detail of his house, the overhanging piazza, as the central place from which he could look out to sea. That presumed direction of vision to the left is matched by the incoming narrow wedge of water, as it were bringing his subject in toward the studio. No such slice of water is visible in the actual ledges seen from this angle, another reminder that this painting is about more than what the eye sees.

Fog as an obscurer of the seen world, sometimes shrouding impending peril, already had been Homer's subject in *The Fog*

Warning of 1885. In *The Artist's Studio* it transforms all it touches into differing densities of liquid, from the wet rocks in the foreground to the radiant particles of light suspended in the moist air. Although Homer recorded on the painting's stretcher that this was an afternoon fog, it has the effect, like an eclipse, of suspending time or, like the midnight sun in polar latitudes, of inverting day and night. The ultimate inversion of the picture is that Homer has turned his studio inside out. On the one hand he has brought the exterior, observed world into his painting room; on the other he has turned the most private act of imagination into a physical image on his canvas. Of all his Maine landscapes this one is significant for its double insight, that is, for truly looking inward, first from the water's edge in-

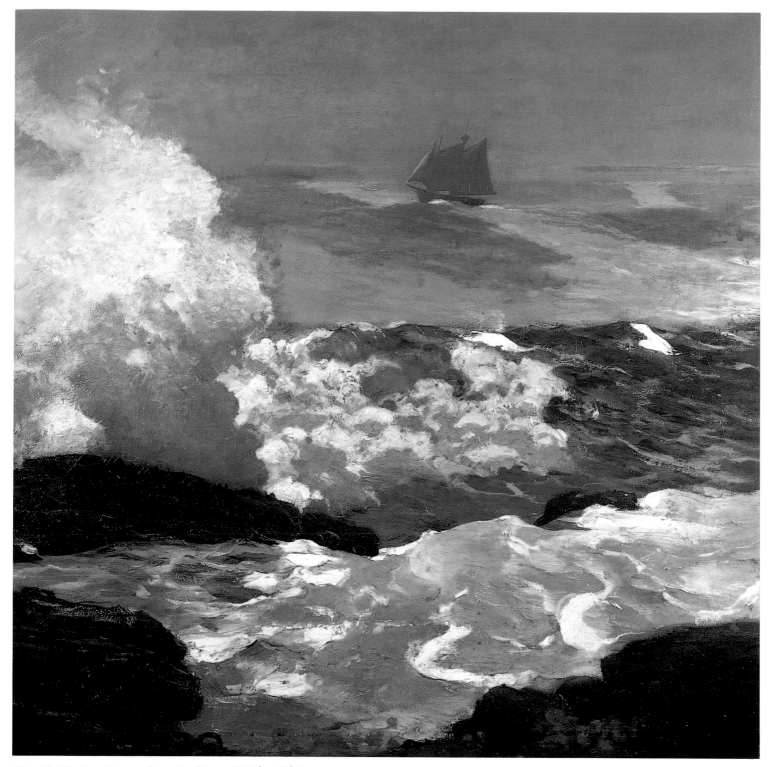

Plate 18. Winslow Homer, *On a Lee Shore*, 1900 (no. 32).*

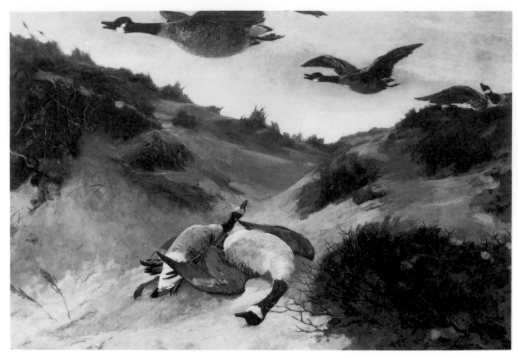

Figure 52. Winslow Homer, *Wild Geese in Flight*, 1897. Oil on canvas, 34¹⁄₁₆ × 50⅛ in. (86.7 × 127.3 cm). Portland Museum of Art, Maine. Bequest of Charles Shipman Payson, 1988.

NOTES

1. For a fuller discussion of this subject, see John Wilmerding, "The Lure of Mount Desert and the Maine Coast," in *Paintings by Fitz Hugh Lane*, exh. cat. (Washington, D.C.: National Gallery of Art, 1988), pp. 106–27, and "Benson and Maine," in *Frank W. Benson: The Impressionist Years*, exh. cat. (New York: Spanierman Gallery, 1988), pp. 10–15.

2. The details are fully given in Philip C. Beam, *Winslow Homer at Prout's Neck* (Boston and Toronto: Little, Brown and Company, 1966).

3. Beam (ibid., p. 93) suggests that the pure land scapes were painted in the autumn after the departure of the summer visitors.

4. See ibid., pp. 30–31, 88–89.

5. Among the most notable are *Mink Pond* (1891), *Hunter in the Adirondacks* (1892; both Fogg Art Museum, Harvard University, Cambridge), *Adirondack Guide* (1894; Museum of Fine Arts, Boston), *Rum Cay* (1898; Worcester Art Museum), and *Turtle Pound* (1898; Brooklyn Museum). See Helen Cooper, *Winslow Homer Watercolors* (New Haven and London: Yale University Press for the National Gallery of Art, 1986), pp. 162–217.

6. See Cooper (note 5), pp. 168, 176; also Nicolai Cikovsky, Jr., "Homer around 1900," in *Studies in the History of Art* 26 (Washington, D.C.: National Gallery of Art, 1989), and Beam (note 2), p. 92.

7. For example, *Woods at Prout's Neck* (private collection) and *Among the Vegetables* (Murjani Collection), both 1887 (Cooper [note 5], pp. 158–59).

8. For additional discussion of this group, see John Wilmerding, *Winslow Homer* (New York, Washington, and London: Praeger, 1972), pp. 141, 167, and Beam (note 2), pp. 61–62, 92, 125.

9. Fuller analysis of this theme is given in John Wilmerding, "Winslow Homer's *Right and Left*," *Studies in the History of Art* 9 (Washington, D.C.: National Gallery of Art, 1980), pp. 59–85.

10. Cooper (note 5), pp. 200–1; Beam (note 2), pp. 104–5, 118, 126–30.

11. See Gordon Hendricks, *The Life and Works of Winslow Homer* (New York: Harry N. Abrams, Inc., 1979), pp. 227–35.

12. Beam (note 2), p. 110; Cooper (note 5), p. 161.

13. See Wilmerding (note 9).

14. See especially Henry Adams, "Mortal Themes: Winslow Homer," *Art in America* 71, no. 2 (February 1983), pp. 112–26.

15. Cikovsky (note 6); Adams (note 14).

16. Beam (note 2), pp. 114–16; Cikovsky (note 6).

17. See Albert Boime, "Blacks in Shark-Infested Waters: Visual Encodings of Racism in Copley and Homer," *Smithsonian Studies in American Art* 3, no. 1 (Winter 1989), pp. 18–47.

18. For example, see those reproduced in Hendricks (note 11), pp. 170–73, and Beam (note 2), pp. 122–23.

19. See Beam (note 2), pp. 143–45, and Wilmerding (note 9).

land (instead of the reverse) and then from outside the studio (metaphorically) to what happens within. More than any other work this one explains why Homer's representations of Maine are original.

By the end of the 1890s Homer had been moved to undertake some of his purest compositions as well as his most somber narratives of our universal condition. In the watercolor *Blown Away* (Brooklyn Museum) a lone gale-driven sailboat scuds toward an unknown destiny, a theme more amply realized in a larger oil, *A Summer Squall* of 1904. Similarly, *Wild Geese in Flight* (fig. 52) led to his penultimate masterpiece, *Right and Left* of 1909, in which ordinary death is raised to a transcendent level of feeling and understanding.[19] At the decade's turning point Homer completed three of his most sensuous Maine oils: *On a Lee Shore* (pl. 18), *Eastern Point* (see pl. 13), and *West Point, Prout's Neck* (see pl. 14). With their exploding plumes of creamy surf, they are unsurpassed expressions of energy, humanity's no less than nature's. This was the imaginative power of his studio on a granite peninsula in southern Maine.

Exhibition Checklist of
Paintings and Drawings

Philip C. Beam

EDITOR'S NOTE: This annotated checklist includes paintings and related draw-
ings executed by Winslow Homer between 1883 and 1900 that are included in
the exhibition. It is not an exhaustive listing of the artist's oeuvre of the 1890s.
Paintings and drawings discussed in detail earlier in this book have been
illustrated in proximity to their text discussions as color plates and are
reproduced again here in black and white for purposes of easy reference. The
exhibition also includes documentary photographs. Not listed in this cata-
logue section, these images appear as black-and-white figures at relevant
points earlier in the book. All works in the exhibition are identified in this
volume by an asterisk (*) following their captions.

Studies 1884

1. *Fishermen on the Shore*, 1884
Charcoal and white chalk on brown paper mounted on board, 16 × 24 in. (40.1 × 61 cm)
Signed and dated, lower right: *Homer / 1884*
The Montclair Art Museum, New Jersey. Lang Fund Purchase
(Exhibited in Rochester and Washington only)
Plate 19

2. *Seacoast with Scrub Pines, Eastern Point*, circa 1884
Charcoal and white chalk on gray paper, 18 × 24³⁄₁₆ in. (45.9 × 61.6 cm)
The Cooper-Hewitt Museum, The Smithsonian Institution's National Museum of Design, New York. Gift of Charles Savage Homer, Jr. 1912–12–187
Plate 20

3. *Black Point, Scarborough*, circa 1884
Charcoal and white chalk on gray paper, 15⅜ × 23⅝ in. (39 × 60 cm)
The Cooper-Hewitt Museum, The Smithsonian Institution's National Museum of Design, New York. Gift of Charles Savage Homer, Jr. 1912–12–188
Plate 21

4. *Tree Roots, Prout's Neck*, circa 1884
Charcoal and white chalk on gray paper, 15 × 22¾ in. (39.5 × 58 cm)
The Cooper-Hewitt Museum, The Smithsonian Institution's National Museum of Design, New York. Gift of Charles Savage Homer, Jr. 1912–12–90
Plate 5; Figure 53

5. *Tree Roots on a Hillside, Prout's Neck*, circa 1884
Charcoal and white gouache on gray paper, 11¹¹⁄₁₆ × 23¼ in. (29.8 × 59.2 cm)
The Cooper-Hewitt Museum, The Smithsonian Institution's National Museum of Design, New York. Gift of Charles Savage Homer, Jr. 1912–12–91
Plate 22

6. *The Smuggler of Prout's Neck*, 1884
Charcoal and white chalk on gray paper, 15 × 23 in. (38.1 × 58.5 cm)
The Everson Museum of Art of Syracuse and Onondaga County, New York. Museum purchase with the help of Mrs. Leland W. Singer
Plate 23

There are several charcoal drawings of 1884 which illustrate Homer's exploration of the cliffs at Prout's Neck during his early days there and the accuracy he tried to achieve while educating himself in the myriad aspects of the rock formations. He did the same thing later in numerous studies of waves, the two groups of sketches becoming the basis for his program in marine painting. It was due to this early schooling that he was able to address larger elements of design with such command and control.

Figure 53 (no. 4).*

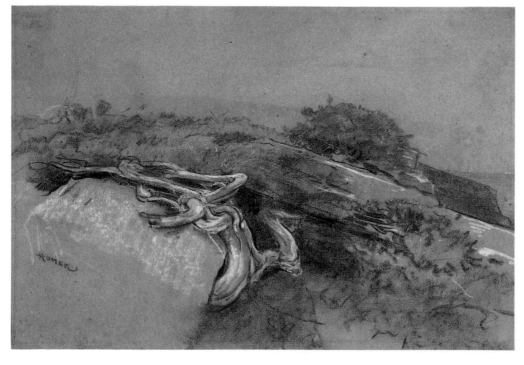

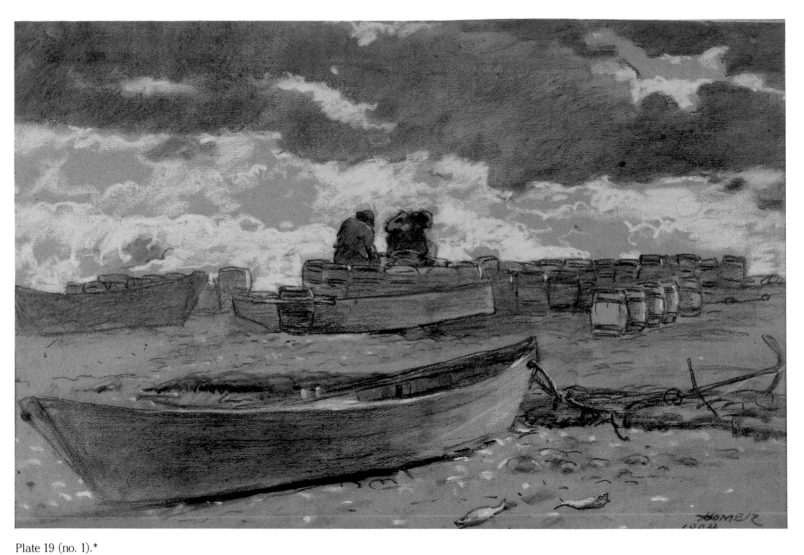

Plate 19 (no. 1).*

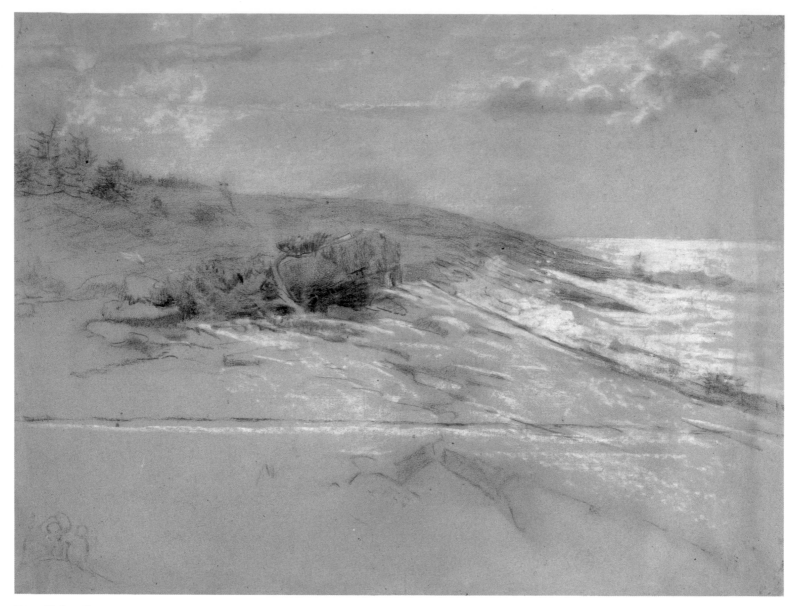

Plate 20 (no. 2).*

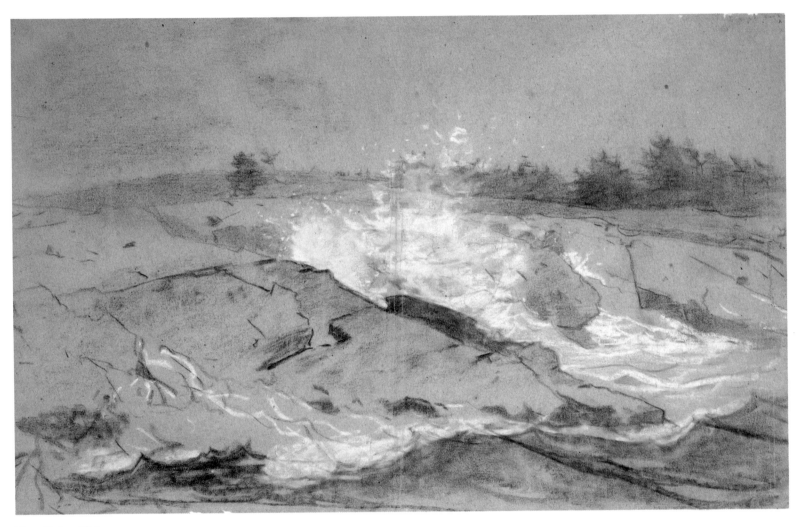

Plate 21 (no. 3).*

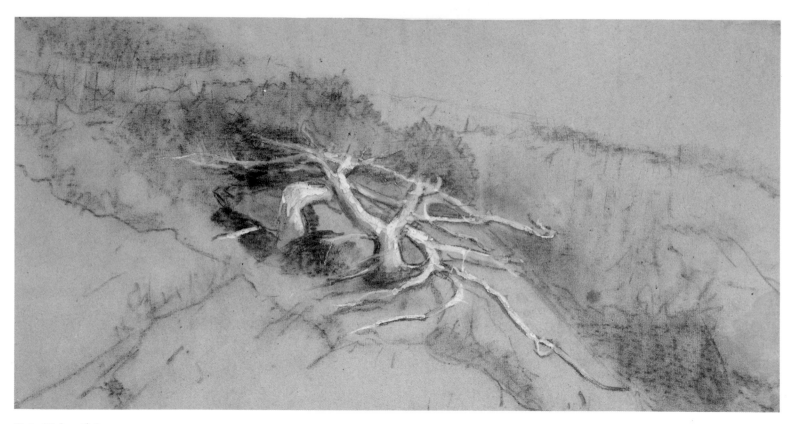

Plate 22 (no. 5).*

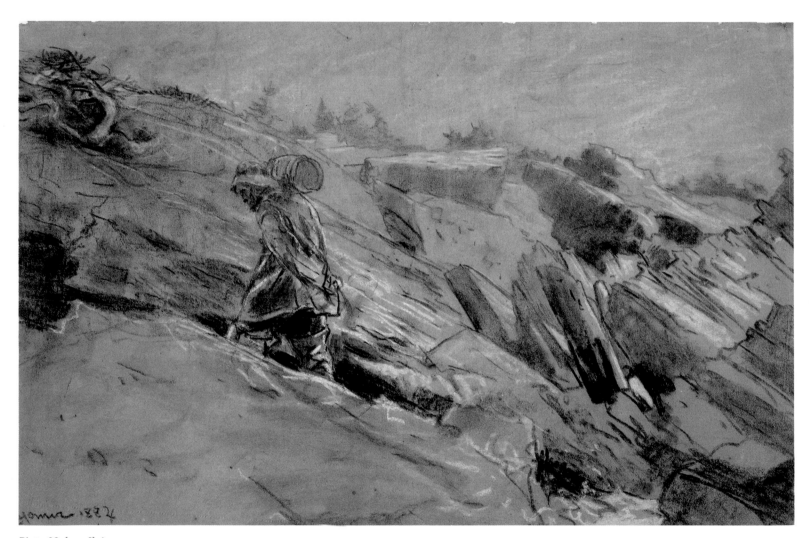

Plate 23 (no. 6).*

1890

7. *Cloud Shadows*, 1890
Oil on canvas, 24½ × 28 in. (62.3 × 71.2 cm)
Spencer Museum of Art, The University of Kansas, Lawrence. The William Bridges Thayer Memorial Collection
Plate 24

The ebb and flow of Homer's temperament caused him to fluctuate between the orderliness he inherited from his genteel mother and the superabundance of energy he derived from his forceful father. Consequently, during his nearly three decades at Prout's Neck, he often responded to the rugged environment by painting strong, powerful canvases, but from time to time he returned to gentler themes reminiscent of his days at Belmont and Houghton Farm. In a single year he would produce subjects as different as *Winter Coast* (fig. 47) and *Cloud Shadows* (pl. 24). The latter depicts something of the social side of life at Prout's Neck by presenting a handsome young woman talking quietly to an elderly man as they sit on an abandoned float in the vicinity of Ferry Beach, whose sandy expanses furnished a favorite setting for Homer's pictures of this sort. He used it as a background for *The Dunes* (1894; Museum of Fine Arts, Boston) and other similar pictures. The picture's appealing, gracious quality is enhanced by the young woman's respectful attention to her companion. She is featured, facing forward, and he is seated with his back to the viewer, their attitudes symbolizing a harmonious meeting of youth and old age, she in an attractive dress and he in the garb of an old salt. Nearby are accessories appropriate to his implied role of fisherman—a float, a large cask, and a fishing net.

Mrs. Albert Stevens (née Charlotte Googins) told this writer that the sitters were her sister, Mrs. Maude Sanborn Googins Libby (née Maude Googins), and her uncle, Benjamin Franklin Sanborn, both of whom Homer knew well and used as models several times. Although Maude Libby had been born in nearby Saco, she had moved to Prout's Neck when she was twelve, spending the rest of her life there. She posed for this picture when she was about eighteen and

also for one of the dancing figures, with Cora Googins Sanborn, in *A Summer Night* (pl. 6). These two young women were recognized as the belles of the area, a fact of which Homer was plainly aware.

In developing his composition to convey a reposeful spirit, Homer placed his seated figures at the bottom of the canvas and employed an equally low, gently sloping skyline, quite unlike the powerful diagonal he drew from the cliffs of the Neck. Above is a summer sky filled with slowly drifting, seasonal cumulus clouds that also contribute to the general serenity of the scene.

8. *A Summer Night*, 1890
Oil on canvas, 30³⁄₁₆ × 40⅛ in. (76.8 × 102 cm)
Signed and dated, lower left: *Homer 1890*
Musée d'Orsay, Paris
(Exhibited in Rochester only)
Plate 6; Figure 54

Homer spent the early part of 1890 in Florida and the spring in the Adirondacks fishing and painting watercolors. On his return to Prout's Neck for the warmer months, he inaugurated the decade that was to be the climax of his career in oil painting by producing one of his most brilliant pictures, *A Summer Night*.

The canvas derived from a subject that has delighted millions of human beings: the effects

Figure 54 (no. 8).*

of moonlight. Homer was exceptional in his ability to express his pleasure in permanent pictorial form. He was also favored by having at Prout's Neck an unexcelled opportunity to observe this phenomenon.

One of the pleasures of Prout's Neck during the summer are those times when the moon rises over Cape Elizabeth, to the east, to move across the sky beyond Stratton's Island and shine magnificently over the ocean. This is the visual display Homer captured in *A Summer Night*. He had an ideal point of observation from his studio balcony, from the cliffside lawn immediately below it, or from the nearby Ark.

Something of the genre illustrator lingers in this picture. The artist has included a group watching the scene from the ledges and two girls whose dancing figures provide a pictorial metaphor for the light dancing on the waves.[1]

Before he achieved his finished version of *A Summer Night*, Homer did his usual exploratory sketches. Charles Lowell Homer recalled an evening during the summer of 1890 when the family gathered on the rocks to watch the moonlight playing on the swells. After a while Winslow disappeared, and when the family returned to the Ark, he was sitting on his studio porch, putting the finishing touches to a sketch. The whole family admired the sketch as unusually beautiful and urged him to make a painting from it. Shortly thereafter, he set to work on *A Summer Night*.[2]

When he wrote his biography of the artist in 1911, William Howe Downes believed that Homer's moonlit scenes were painted "wholly by the light of the moon and never again retouched."[3] Alexander Bower, N.A., a professional painter of seascapes, asserted that it would be impossible to paint such an elaborate picture solely by evening light and that the subsequent development of the composition confirmed his opinion.[4]

There is a plausible compromise between Downes's and Bower's opinions and the evidence of Charles Lowell Homer. A watercolor exists that bears the same title and date and has all the marks of spontaneity one might expect in the

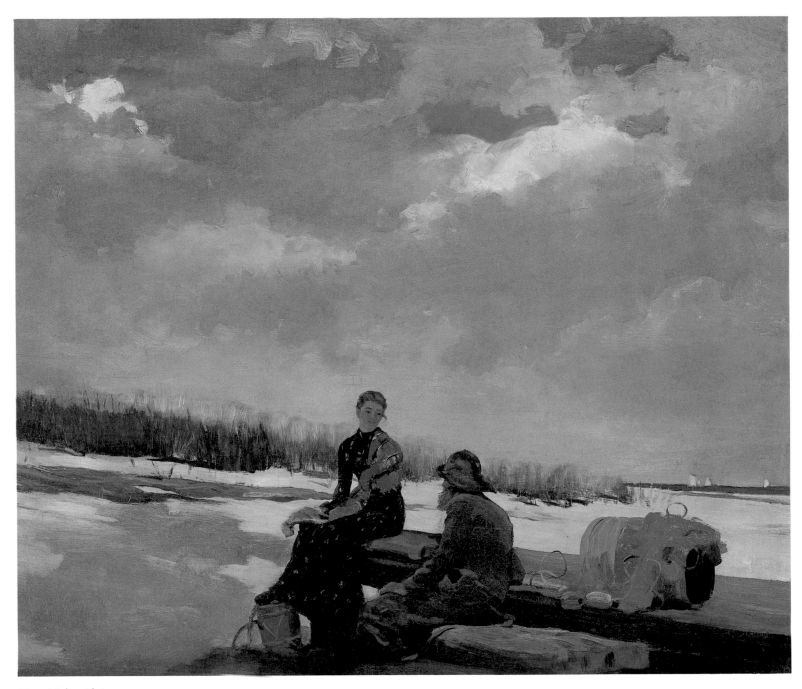

Plate 24 (no. 7).*

Figure 55. Winslow Homer, *A Summer Night*, 1890. Watercolor on paper, 14½ × 21½ in. (36.9 × 54.5 cm). Wadsworth Atheneum, Hartford, Connecticut. Gift of James Junius Goodwin. © Wadsworth Atheneum, 1923.82.

sketch Charles Lowell Homer described (fig. 54). It could well be the picture Homer painted under the inspiration of the moment in his studio and therefore could be the prototype of the celebrated canvas. The tonal washes were applied to capture the broad effects of light and dark, and a lack of light by which to see colors would not have been a hindrance. Homer sketched at least one other version of the scene, in oil, for the same purpose (Los Angeles County Museum of Art).

The sparkling effect of moonlight was a technical challenge not unlike that of rendering the sparks of fire in Homer's earlier *Camp Fire* (1880; Metropolitan Museum of Art, New York). Homer was bold enough to test his powers by introducing the pair of dancers in the foreground, who apparently are illuminated by the light from a nearby porch. He included another effective touch: a pinpoint flash of red light from Wood Island Light on the horizon, the only warm tone in the design.

Mrs. Munroe, housekeeper at the Ark during the 1890s, recalled that for the two dancing figures in *A Summer Night* Homer posed Maude

Sanborn Googins Libby and Cora Googins Sanborn on an old float at Ferry Beach. For about an hour each day through a whole week, he made rapid sketches of the two girls, moving around them, studying them from every point of view. In the finished oil their vitality contrasts with the rocklike silhouetted figures seated at the right.[5]

Homer had long been intrigued by moonlight. In 1874, in Gloucester, he had painted a watercolor called *Moonlight* (Canajoharie Library and Art Gallery, New York), a prototype of *A Summer Night* which depicts two lovers bemused by the evening spectacle. In 1880 he had executed a more objective sequel, *Eastern Point Light* (Art Museum, Princeton University), which represents two sailboats silhouetted against a moon-bathed sea. He never lost his love of nighttime spectacle. Although *A Summer Night* reached an unprecedented level of quality, Homer painted a sequel to it in 1894, *Moonlight, Wood Island Light* (pl. 15), a pure marine that is equally celebrated.

In *A Summer Night* and *Moonlight, Wood Island Light* Homer carried his conception to a

stage beyond the earlier watercolors. In the early watercolor *Moonlight* he placed the moon in the sky; in *Summer Night* and *Moonlight, Wood Island Light*, painted nearly twenty years later, he implied its presence (its light floods in from outside the frame). A distracting effect was avoided without any loss of luminosity. With his usual thoroughness, Homer moved, in *A Summer Night*, from precedents through experimental sketches to a design that was synthesized in various stages but that appears unstudied.

After Homer finished *A Summer Night*, he exhibited it in New York in 1891 with three other canvases: *Sunlight on the Coast* (pl. 12), *Winter Coast* (Philadelphia Museum of Art), and *A Signal of Distress* (Thyssen Collection, Lugano). The critic for the Boston *Transcript* (probably William Howe Downes) singled out *A Summer Night* for special praise, with prophetic insight, as "a new painting that deserves to be called great, a masterpiece of moonlight, and a truly inspired poem of the sea, as novel, so far as art is concerned, as if no one before Mr. Homer possessed the eyes to see or the soul to feel this nocturnal splendor and majesty."[6]

In spite of these accolades, Homer was unable to sell the picture for several years, a situation that was not unique even when he was at the height of his powers. In a letter dated December 18, 1890, he offered it first to Potter Palmer of Chicago, a leading collector of French Impressionist paintings. In an indifferent reply dated December 23, 1890, Palmer declined to purchase the canvas, returning it to Messrs. Reichard and Co.[7] Neither could Homer dispose of it through C. Klackner, his dealer in New York, or through the Doll and Richards Gallery, in Boston, for two thousand dollars.[8] In disappointment he lent it to the Cumberland Club in nearby Portland, Maine. Though the painting hung in the lounge for nearly a decade, the members were not moved to buy it.

In 1900, at the Exposition Universelle Internationale in Paris, Homer's brother Charles was honored with a bronze medal for his distinguished achievements in industrial chemistry. Homer himself was invited to serve on an American jury of twenty artists to select pictures to represent the country in the exposition's art show. Though he did not serve on the jury, Homer also was asked to exhibit some of his own work. He sent *Coast of Maine* (pl. 25), *The*

Plate 25. Winslow Homer, *Coast of Maine*, 1893. Oil on canvas, 24 × 30 in. (61 × 76.5 cm).
The Art Institute of Chicago. The Arthur Jerome Eddy Memorial Collection.

Fox Hunt (fig. 5), *The Lookout—"All's Well"* (fig. 45), and *A Summer Night*, which still belonged to him. The grand prizes went to Sargent and Whistler; gold medals were awarded to Edwin Austin Abbey, Alexander Brush, Abbott Thayer, William Merritt Chase, Cecilia Beaux, and Homer. The picture that impressed the French judges most of all was *A Summer Night*, which they decided to purchase for the Luxembourg Palace museum, then the government's showplace of contemporary art. (The picture is still one of the few major Homers on display in Europe.) Walter Pach recounted a meeting with Monet during which they talked of Homer, whom the French artist knew and admired through Homer's nocturne in the Luxembourg.[9]

Homer did not go to Paris to accept his medal. He was in the Adirondacks, and when his sister-in-law wrote to congratulate him, he replied from the North Woods Club on June 21, 1900:

Dear Mattie—

Your letter of congratulations on the medal was the most complete surprise, as I thought the medals all awarded before I left home. I do not know what it is but shall soon see. I was perfectly satisfied as it was, & thought the selection a good one.

The fishing is over here & I am sketching in watercolors. I go home next week leaving Thursday for New York.[10]

When Homer returned to Scarborough, Mrs. Henrietta Larrabee recalled, her father, Zenas Seavey, the local coachman and postman, took some mail to him, and among the parcels was one containing the medal. Mr. Seavey told his family that the artist was "very much moved by it."[11]

Figure 56 (no. 9).*

9. *Sunlight on the Coast*, 1890
Oil on canvas, 30¼ × 48½ in. (76.9 × 123.3 cm)
Signed and dated, lower left: *Winslow Homer 1890*
The Toledo Museum of Art. Gift of Edward Drummond Libbey
(Exhibited in Rochester only)
Plate 12; Figure 56

10. *Study: Waves*, 1890–1900
White crayon on blue blotting paper, 11¹⁄₁₆ × 19 in. (28.2 × 48.2 cm)
Cooper-Hewitt Museum, The Smithsonian Institution's National Museum of Design, New York. Gift of Charles Savage Homer, Jr. 1912–12–200
Plate 26

11. *Swells in the Ocean*, 1890–1900
Charcoal and white chalk on gray paper, 13¼ × 19⅞ in. (33.7 × 50.5 cm)
Cooper-Hewitt Museum, The Smithsonian Institution's National Museum of Design, New York. Gift of Charles Savage Homer, Jr. 1912–12–197
Plate 27

While completing *A Summer Night* (pl. 6) in the autumn of 1890, Homer finished another landmark oil, *Sunlight on the Coast*.

In 1885, in a watercolor entitled *Breaking Wave on a Shore Line* (private collection), he had examined the problem of light on moving water. By 1890 his skill had developed to the point that he could create, in *Sunlight on the Coast*, his first great pure marine in oil.

For twenty years Homer studied waves at Prout's Neck from every aspect and under every condition of light and weather (pls. 26, 27). Sometimes the broken, complex surfaces he depicted convey only a general impression; at other times he rendered one or two massive rollers that stand in for others he only suggested. Occasionally, he recorded the curious phenomenon of windswept whitecaps riding on mighty groundswells, each rolling in from a different direction, as in his oil *Backrush*.

Essential to Homer's wave studies was his accurate observation of three essential characteristics of great breakers. The first is the combination of churning, creamy foam and the massive force of literally tons of water which smash against the coast like a giant battering ram. The second is the apparent downhill motion on the face of an advancing wave. The third is the fact that offshore waves grow as they advance, until they resemble huge cylinders and move landward with a sliding, rolling motion. Homer's genius lay in his ability to combine a scientific understanding of these natural phenomena with a highly refined sense of design. In *Early Morning after a Storm at Sea* (1902; Cleveland Museum of Art) the qualities of airy foam and solid water are depicted; and in *Sunlight on the Coast*, the cylindrical wave form that is so difficult to represent.

Homer had experimented with pictures of surf and rocks even before his arrival at Prout's Neck, in one of his early attempts at pure seascape in oil, *Rocky Coast and Gulls* of 1869 (fig. 57). A comparison of *Rocky Coast and Gulls* with *Sunlight on the Coast* reveals how far he had come during the intervening twenty-one years, not only in his understanding of the behavior of the great waves but also in his coordination of content and design. In *Sunlight on the Coast* he arrived at a sequence of forms and areas which carries one from the dark mass of rocks in the lower left foreground through successive great breakers to the light sparkling on the sea on the distant horizon, that is, from the foreground to deep space along a logical path. Darks and lights are used to augment this progression. So apt was this arrangement that Homer employed it again for similar purposes with appropriate variations.

Along with masses of rocks and moving water illuminated by moonlight or sunsets, Homer exhibited a constant interest in daylight over the years and would return to this concern for some of his most striking scenes, beginning with *Sunlight on the Coast* and continuing through *Early Morning after a Storm at Sea* of 1902. He thus allied himself with the Luminists who preceded him.

Sunlight on the Coast was followed by a number of great marines that evidence practically no concern for humanity or its works, except for an occasional boat or lighthouse suggested in the background, usually to supply an essential design accent. These pure seascapes comprise only a small fraction of Homer's work. Even with nature playing an increasingly important role in his compositions he was too concerned with humanity to ignore it. This concern persisted to

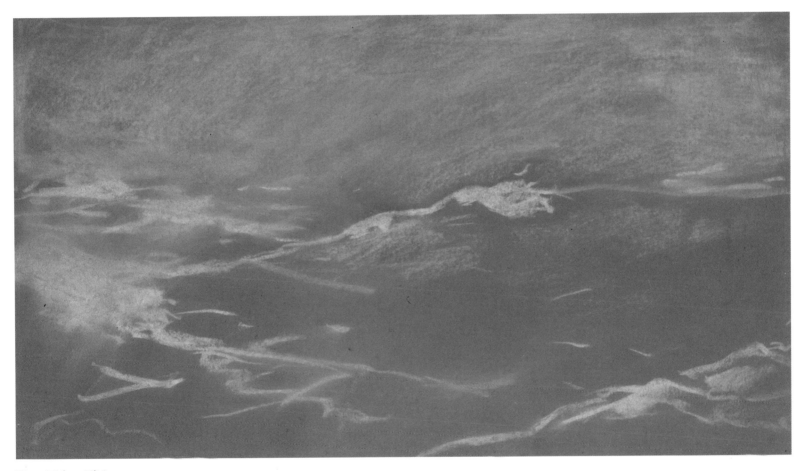

Plate 26 (no. 10).*

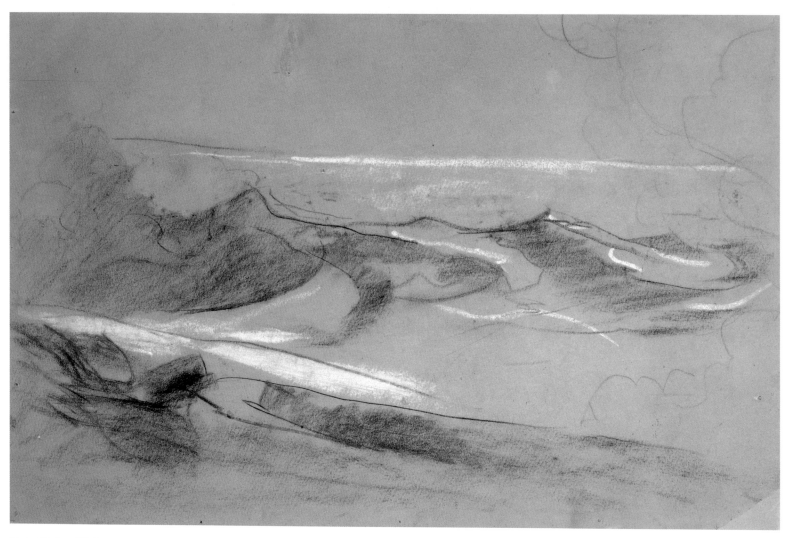

Plate 27 (no. 11).*

the last picture he finished, *Driftwood* of 1909.

Perhaps the most plausible explanation for the absence of people in many of these marines is that Homer painted them in the fall, after most of the summer visitors had left and when the fishing fleet was usually at sea. A summer resort out of season, like a school during a holiday, seems unnaturally deserted. In a stark oil, *Prout's Neck in Winter* (pl. 28), Homer underscored this desolation.

During 1890, as he indicated to Charles in a letter written on December 10,[12] Homer completed one of his best illustrative paintings of life at sea, *The Signal of Distress*. Showing the launching of a lifeboat in answer to a call for help, this picture reveals that he habitually pursued several themes simultaneously. *Sunlight on the Coast, Winter, Prout's Neck* (private collection), a pure landscape, and *The Signal of Distress* were displayed side by side in New York the following year. In a complimentary press notice, the critic of the *Evening Post* compared Homer's use of impasto to Courbet's rich handling of pigment and asserted that Homer showed greater ability in capturing movement in his marines than the French master.[13] So gratifying was the response to these pictures that Homer's New York dealer Klackner reproduced *The Signal of Distress* in the new process of photogravure.

The mastery of a medium for representing massive waves was, for Homer, another instance of achievement not easily won. Making them appear imposing in pictorial form was a different matter. He naturally tried to use watercolor first. *Rocky Coast, Prout's Neck* (1883; Worcester Art Museum, Massachusetts) and the brilliant *Prout's Neck, Breaking Wave* (1887; Art Institute of Chicago) were far ahead of their time and so technically adroit that they would have satisfied any lesser artist.[14]

But soon Homer was complaining to his family that although he could capture the racy movement of breakers and the feathery quality of spray, he could not convey the tremendous might and impact of massive waves or the bulk and resistance of rocks and cliffs through watercolor alone.

It was not until Homer turned to the heavier-bodied medium of oil that he began to execute his great coastal marines. While continuing to

Figure 57. Winslow Homer, *Rocky Coast and Gulls*, 1869. Oil on canvas, 16 × 28 in. (40.6 × 71.1 cm). Museum of Fine Arts, Boston. Bequest of Grenville H. Norcross.

use watercolor for countless other subjects, and even for special effects in his seascapes, he gradually abandoned it in his representations of the more imposing aspects of the cliffs and ocean at Prout's Neck. Thus, *Sunlight on the Coast* became a landmark in several ways. It demonstrated that the shift from watercolor to oil had been made with emphatic success and that the necessary trials were over. *Rocky Coast and Gulls* had provided a hint of the future, but *Sunlight on the Coast* approached perfection.

Although *Sunlight on the Coast* is virtually the opposite of *Winter Coast* (fig. 47), when the pair was exhibited in 1891 the latter was purchased for the John G. Johnson Collection of Philadelphia, where *Winter Coast* remains (now held by the Philadelphia Museum).

NOTES

1. Gordon Hendricks has pointed out that Homer originally called his picture *Buffalo Gal*, after the lyrics of a popular song of the day, "Buffalo Gal, won't you come out tonight and dance by the light of the moon?" (*The Life and Work of Winslow Homer* [New York: Harry N. Abrams, Inc., 1977], p. 202). The whimsical title has long since been replaced by the more appropriate *Summer Night*.

2. Charles Lowell Homer to author.

3. William Howe Downes, *The Life and Works of Winslow Homer* (Boston and New York: Houghton Mifflin, 1911), p. 170.

4. Alexander Bower to author.

5. Mrs. Munroe to author.

6. Boston *Transcript*, [1891], clipping, Homer scrapbook, Bowdoin College Museum of Art, Brunswick, acc. 1964.69.185.

7. Potter Palmer to Messrs. Reichard and Co., December 23, 1890, Bowdoin College Museum of Art, Brunswick, acc. 1964.69.38.

8. Alexander Bower to author, circa 1938. Alexander Bower, N.A., was for a decade director of the Portland Museum of Art and Art School, located across the street from the Cumberland Club, where he lunched daily. Charles Lowell Homer also dined there often. Both men knew the history of the picture's display there and described it to the author circa 1938.

9. Walter Pach to Professor Henry Andrews, Bowdoin College, to author.

10. Homer to Mattie Homer, June 21, 1900, Bowdoin College Museum of Art, Brunswick, acc. 1964.69.87a.

11. Henrietta Larrabee to author and Charles Lowell Homer.

12. Homer to Charles Homer, Jr., December 10, 1890, Bowdoin College Museum of Art, Brunswick, acc. 1964.69.42b.

13. New York *Evening Post*, [1891], clipping, Homer scrapbook, Bowdoin College Museum of Art, Brunswick, acc. 1964.69.185.

14. Donelson F. Hoopes provides a valuable treatment of Homer's exploratory watercolors at Prout's Neck and his use of the medium in general in *Winslow Homer Watercolors* (New York: Watson-Guptil, 1969).

Homer was much on the move in 1891—at Prout's Neck in April, in New York in early May and on June 17 to see Charles and Mattie off to Europe, and then off the following day to fish and paint watercolors in the Adirondacks. But he did paint one canvas during the warmer months that is unusual in that it pertains to Prout's Neck in the tourist season. He entitled it *Watching the Breakers* (pl. 1). Here he exploited fully, as he would many times in the following years, his understanding that the steep slope of the cliffs could be used to give his compositions a special dynamic quality. This practice almost became a hallmark of his association with the promontory and contributed to the impressiveness of the marines that evolved from that association.

A striking feature of *Watching the Breakers* is the flowing brushwork that describes the angular rocks, turbulent sky, and moving water. It is auto-graphic in the same way as the artist's flowing handwriting. Whether applied with brush or pen, the movements denote the deftness of his hand–eye coordination and bold assurance, extensions of prominent, long-time aspects of his personality.

At twenty-nine Homer had designed a magazine illustration for *Harper's Weekly* that portrayed soldiers playing football in camp after the Civil War. Although he enthusiastically depicted the mayhem of the game, he himself—being physically lean, wiry, and agile—preferred the swinging movements of dancing and skating and represented them often in his engravings. In later times Homer devoted himself to another rhythmic activity, fly casting. Similarly, he possessed an ear for music throughout his life, often strumming an old banjo and singing enthusiastically, if not well. He became a friend and admirer of classical musicians during his years in New York[1] and continued his interest in opera after he moved to Prout's Neck.

All of these attributes of a highly coordinated eye, ear, and hand were important components of Homer's personal talent. Through his brush they were projected into his pictures, contributing both unity and vigor, where appropriate, to *Watching the Breakers* and many other oils and watercolors. It is worth noting as an example of his artistic judgment that he painted the exquisite watercolor *Mink Pond* in the same year that he completed the vigorous *Watching the Breakers* and the powerful *West Wind* (pl. 3).

12. *The West Wind*, 1891
Oil on canvas, 30 × 43½ in. (53.3 × 83.8 cm)
Signed and dated, lower left: *Winslow Homer/1891*
Addison Gallery of American Art, Phillips Academy, Andover
Plate 3; Figure 58

In 1891 Homer returned to Prout's Neck from the Adirondacks in time for the fall storms and painted one of his finest representations of a force-seven autumnal gale in all its fury. He called it *The West Wind*. In this picture the great waves are almost level with the cliffs, so they must have attained a height of thirty or forty feet. The lashing wind whips mare's tails from the crests of the towering breakers, and the figure of a woman struggles along the path that runs over the top of High Cliff. As she stands silhouetted against the sky, her flowing cape and tam-o'-shanter held in place by an upraised arm, she is a visible sign of the force of the gale. These features combine to make the picture an outstanding example of an asymmetrical balance of forms along a sweeping diagonal.

Homer chose High Cliff as his setting because its natural slope is not only the loftiest incline on the Neck, but the winds attain their highest velocity there as they sweep unimpeded over its crown. Homer increased the effect of the wind's force by stressing the flattened character

Figure 58 (no. 12).*

of the wild grass and juniper bushes, which are perpetually assaulted by onshore gales. He obliged the solitary figure to lean into the wind in such a way that the viewer can hardly help identifying with her straining effort.

Something of the joy an artist knows when he believes he has created a successful picture was expressed by Homer in a letter he sent to Mattie Homer on December 29, 1891, after he put the finishing touches on *The West Wind*. Alone but exhilarated, he wrote:

> I do not live next door to the Post-Office & I cannot be as prompt as I would like in acknowledging such a fine present. I have proof that there is something fine in that wine, as I had taken a glass and was peeling vegetables for my dinner & thinking of the picture I had just finished & singing with a very loud voice: See! the Conquering Hero comes. & I sung it, 'Sound the Parsnips, Beat the Drum.!' I have just sent the picture off.[2]

Charles Lowell Homer stated that sometime before painting *The West Wind* his uncle had dined with John La Farge in New York.[3] The two men were friends, but held conflicting ideas about art, especially about color. Unlike Homer the cosmopolitan La Farge was an avowed admirer of European techniques, especially the rich color of the Venetians. He asserted that Homer used too much brown and that his paintings were too dull in tone. In reply Homer wagered a hundred dollars that he could paint a picture in browns that would be admired by critics and public alike.

After Reichard, the dealer who exhibited the picture in New York, reported the popularity of *The West Wind*, Homer wrote to La Farge, "*The West Wind* is brown. It is damned good! Send me your check for $100."[4] When Thomas B. Clarke, a wealthy patron of the arts, promptly bought the canvas for his collection, which ultimately included thirty-one examples of Homer's work, La Farge presumably paid up. This incident was exceptional, for Homer was a man of action who expressed himself most directly through his pictures, seldom theorizing about art with his family or anyone else.

The West Wind was sold by Clarke in the disposal of his collection in 1899. The prices realized from the sale, though high for the time, seem ridiculously low today. The sad fact was that American paintings regularly brought lower prices than comparable European pictures. The highest price in the sale was the forty-seven hundred dollars paid for *The Lookout—"All's Well"* (fig. 45) by the Museum of Fine Arts, Boston. That museum continued to show interest in Homer's work, as did the Carnegie Institute, the Metropolitan Museum of Art, the Brooklyn Museum, the Worcester Art Museum, and some of the more perceptive collectors in the Boston area just before and after his death. At the Clarke sale *The West Wind* was purchased by Samuel Untermeyer of Kansas City for $1,675. The late Bartlett H. Hayes, Jr., former director of the Addison Gallery of American Art, Phillips Academy, Andover, described its acquisition from Untermeyer.[5] When an alumnus and benefactor of the academy, Thomas Cochran, authorized the gallery's advisory committee to offer Untermeyer thirty thousand dollars for *The West Wind*, a large figure for that time, the latter flatly refused to sell the picture. In the ensuing tug-of-war, Cochran would not be denied and raised the bid to forty thousand dollars. Untermeyer finally yielded, and the painting went to its permanent home in the Addison Gallery in 1928.

NOTES

1. Among the Homer memorabilia at Bowdoin College is a photograph (acc. 1964.69.178) of four distinguished-looking members of a string quartet. An inscription on the back reads: *To our Friend and late Host, Winslow Homer, with the warmest regards of the Quartette*. The photograph is dated New York, October 1877, and is signed by Summerville, Jos. Lewenberg, A. Schauffler, and Emile Salinger.
2. Homer to Mattie Homer, December 29, 1891, Bowdoin College Museum of Art, Brunswick, acc. 1964.69.45b.
3. Charles Lowell Homer to author.
4. Ibid.
5. Excerpts from Patricia H. Edmonds, "An Oral History Interview of Bartlett H. Hayes, Jr., Director of the Addison Gallery, 1933–1969." *Phillips Academy Bulletin* (1987).

13. *Coast in Winter*, 1892
 Oil on canvas, 28⅜ × 48⅜ in. (72 × 122.8 cm)
 Signed and dated, lower left: *W. Homer 1892*
 Worcester Art Museum, Massachusetts.
 Theodore T. and Mary G. Ellis Collection
 (Exhibited in Rochester only)
 Plate 7; Figure 59

In 1892 Homer painted a group of twenty-six watercolors in the Adirondacks, some of the finest he ever rendered in that area. He returned to Prout's Neck for the fall and winter and painted *Coast in Winter* (pl. 7) in oil.

Although winter scenes do not abound in Homer's work in oil, he produced at least four other notable examples: *Winter Coast* (fig. 47), *The Fox Hunt* (fig. 5), *Watching the Breakers—A High Sea* (pl. 10), and *Below Zero* (fig. 48). Although these pictures differ in their connotations, they all derived from Homer's style of living on the coast of Maine.

The letters Homer wrote from Prout's Neck to members of his family in West Townsend, New York, or Galveston occasionally refer to sunsets and other natural phenomena, but most often describe the effects of cold which forced themselves upon his attention. Excerpts from these letters furnish a record of what Homer experienced as he painted his winter scenes:

[to his father on December 5, 1886]:
 I made a mistake in not getting a larger stove. It is very comfortable within ten feet of it. It heats the room within two feet of the floor, & water freezes anywhere within that space. I wear rubber boots & two pair of drawers—Water is scarce—I break four inches of ice to get any water.

Affectionately,
Winslow

P.S. Great storm last night.

It is not until over ten years later that Homer mentions a new stove.

[to Charles on December 10, 1890]:
 Am just home from a walk—very cold—vapor in high stringers all over the sea. I am getting in my ice, seven inches thick & clear as glass—. The most beautiful day of the winter.

[to Charles on December 17, 1890]:
 The snow is now deep & I am packing to leave soon—Foss tumbled off a load of lumber and hit his shoulder on the hard ground—Googins' eyes played out, laid up with blinders—every other man & all the women sick up & down the road with grippe—I am very well.

[to his Father on February 24, 1898]:
 This is my birthday Feby 24—St. Matthias day. Sea shines—clear sky—clear conscience—Storm bound & telegrams down.[1]

It was second nature for Homer to reflect on his surroundings in words and in paint. Most of his letters are statements of fact, not complaints. Indeed, in responding to his harsh environment at Prout's Neck, Homer was more likely to be optimistic, even ebullient, than otherwise. His nature allowed him to rise above difficulties, often with humorous comments that preserved his sense of balance and allowed him to enjoy life. He was especially appreciative of his excel-

Figure 59 (no. 13).*

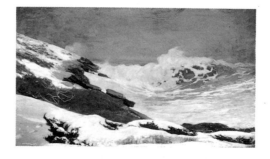

lent health. His positive attitude comes through in other letters to his family:

[to Charles on November 7, 1890]:
 You have no idea how fine it is here for me—the sun is low & shines in across my floor all day in my *two living rooms*, only think of all the room here with plenty to interest me—I shall stay here until the snow is four inches deep—then get out. . . . Football—Thanksgiving & other things will make no difference—this is the best place to be. . . . I am very well.

[to Charles on December 18, 1908]:
 Snowing today but much lighter than a bright sunny day for an indoor light, as the blue sky on a bright day will not give back as much light. The days are very short & I have little enough time to work—I am much interested and I enjoy my house so very much—I am very well.

Owing to Homer's usual inventiveness, his winter scenes present different aspects of the season. When Thomas B. Clarke, one of his steadiest patrons, bought *Coast in Winter* in 1892, he found it to be less stormy than *The West Wind* (pl. 3) and less bleak than *Winter Coast* (fig. 47). In the latter composition the incline of the cliffs is steep, the covering of snow is outlined and broken up by dark ledges, and a solitary hunter stands facing a stormy sky. The effect is impressive but harsh.

Coast in Winter appeals to the viewer in a milder way. Contrasts have been reduced and softened and the snow painted with subtler tones. In conceiving the design Homer adopted a position at the foot of the cliffs, looking upward, and introduced both movement and balance by employing a curved outline, resembling a flattened U, which carries the eye from the cresting wave at the right along swinging lines to the cliffs at the left.

Homer had used the same device in *The Life Line* (fig. 3) but for entirely different purposes. No threat to life or ship is present in the rocky background of *Coast in Winter*, and the waves are sweeping rather than violent. He used this design in later pictures as well. This method has been compared to Hokusai's *Great Wave* and its pendant, *The Tidal Wave*. Homer's compositions are worthy of the comparison.

In order to represent cresting waves with the accuracy shown in *Coast in Winter*, Homer studied them endlessly from his studio balcony, from the path along the cliffs, and from the decks of ships on which he traveled during his many journeys. For this purpose he often carried a small sketchbook in which he recorded the main configurations of waves in simple pencil drawings, sometimes highlighting them with a few strokes of chalk. A sketchbook of this sort is in the collection of Homer memorabilia at Bowdoin College and another is in the Cooper-Hewitt Museum, New York. They date from about 1898. By that time Homer was an expert on the sea, though he never ceased to explore it.

If winter can be made to appear almost warm, that was accomplished in *Coast in Winter*, much of whose appeal lies in the fact that it seems poised between violence and quietude.

14. *Prout's Neck in Winter*, circa 1892
 Oil on canvas mounted on board, 12½ × 22⅝ in. (31.7 × 57.5 cm)
 Collection of Rita and Daniel Fraad
 Plate 28

In his biography of Homer published in 1911, William Howe Downes writes, "We owe him a debt of gratitude for his interpretations of the austere beauty of the stern New England coast in winter, a kind of beauty which he was the first to set forth in all its richness and simplicity."[2] Whether Homer was, in fact, the first to depict winter so fully is unimportant. It is safe to say that no other American artist of his time portrayed wintry scenes more compellingly.

In *Prout's Neck in Winter* Homer forthrightly depicted an Arctic scene. Here the problem of appreciating winter on its own terms is reduced to its barest essentials. No hunter with whom we can identify is present, no fox whose plight we can gauge, and no waves whose moving rhythms we can admire. The artist has effaced himself

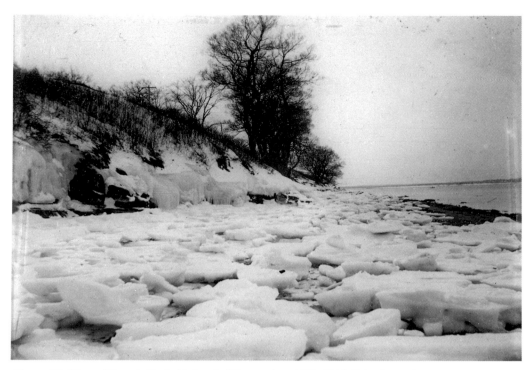

Figure 60. *View of Prout's Neck, Maine, in Winter*, circa 1890–1900. Print from glass plate by unknown photographer. Bowdoin College Museum of Art, Brunswick. Gift of the Homer family, 1964.*

except as a reporter of a scene that others avoid—the coast in the dead of winter, a seaside resort abandoned by its summer residents, an image graphically revealed in one of the artist's personal photographs (fig. 60).

In keeping with this stark message, Homer reduced his design to the simplest physical components. It consists of a stepladder arrangement of horizontal parallel lines ascending from the snow-covered ground through the unbroken plane of the slate-gray sea to the leaden sky, which is relieved only by suffused light.

15. *Watching from the Cliffs*, 1892
 Watercolor on paper, 14 × 20 in. (35.6 × 50.8 cm)
 Signed and dated, lower left: *Winslow Homer 1892*
 The Carnegie Museum of Art, Pittsburgh, Purchase, 1917
 Plate 29

Sometime during the warmer months of 1892, Homer employed High Cliff for the setting of a watercolor entitled *Watching from the Cliffs*. He

had used that crowning feature of the promontory the previous year for his noted oil *The West Wind* (pl. 3). In the later work he depicted it under different conditions and to convey a different meaning.

The once bare crest of the cliffs (today overgrown with vegetation) provided a natural observation post for three women shown looking out to sea. A mild breeze is indicated by the slant of smoke blowing from the chimney of one of the cottages that lined the rocky crest by 1892, but the day is a relatively calm one. Seagulls drift lazily overhead. The women might have been drawn by the waves rolling landward after a summer squall had passed.

It has been remarked that the human subjects in Homer's pictures are skillfully posed for the sake of an effective design but often do not look at each other or relate in a personal way. This appearance of detachment has been construed to imply an indifferent, even antisocial, attitude on Homer's part. But another interpretation is possible. Though the figures in this watercolor appear detached, their watchfulness suggests an activity found repeatedly in Homer's pictures

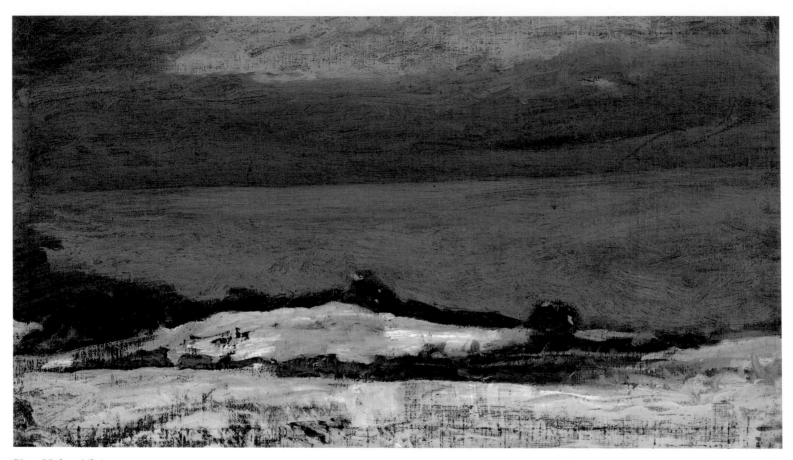

Plate 28 (no. 14).*

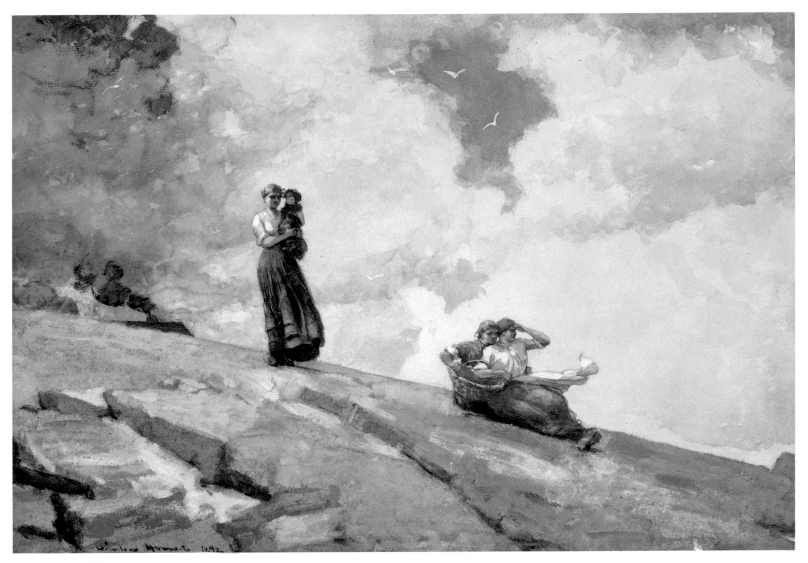

Plate 29 (no. 15).*

that reflects a side of his own character. A devoted observer of the natural and human scene, he was attracted to people who shared that interest.

This interest had come to the fore in the pictures Homer painted during his two-year stay in Cullercoats. Especially attracted to the sturdy women he found there, he represented them repeatedly in his watercolors, singly, in pairs, or in groups of three, usually standing upright. In all cases he emphasized their rugged, hardworking forms. He also observed that when they had time off from their labors, they frequently sat on one of the bluffs in the area, looking out to sea. Homer joined them in this practice, which became a long-time professional habit of watching the ever-changing ocean and constant shifting of sunlight, reflections, and clouds.

A fine example from this group of watercolors is *Looking Out to Sea* (Fogg Art Museum, Harvard University, Cambridge). Even more relevant to *Watching from the Cliffs* is a watercolor of the same subject painted in 1881, during Homer's first year in England (private collection). The prototype for the later version, it is somewhat simpler in form or less developed.

Though derived from past experience abroad, *Watching from the Cliffs* also describes a moment in history that would soon pass. By the end of the century the fishing industry Homer had discovered at Cullercoats, and again near Prout's Neck during the 1880s, was being transformed by steam trawlers and was fated to become a forgotten calling within a few decades. In his pictures Homer would continue to cling to the old way of life while both Prout's Neck and Cullercoats were transformed into summer resorts.

In keeping with the peaceful nature of the scene recorded in *Watching from the Cliffs*, Homer softened his colors and employed grayish blue tones for the figures' garments. The freely brushed watercolors captured the moving clouds overhead but left the rocky cliffs somewhat softer than their actual bold outlines. But in rendering the latter Homer offset any tendency to dullness by introducing a subtle play of tones and many nuances of hue, and the bold subdivision of the composition by the crest of High Cliff furnishes the strength necessary for a clear and striking image.

NOTES

1. Homer to Charles Homer, Sr., December 5, 1886, acc. 1964.69.28; to Charles Homer, Jr., December 10, 1890, acc. 1964.69.426; to Charles Homer, Jr., December 17, 1890, acc. 1964.69.109b; to Charles Homer, Sr., February 24, 1898, acc. 1964.69.706b (all Bowdoin College Museum of Art, Brunswick).

2. William Howe Downes, *The Life and Works of Winslow Homer* (Boston and New York: Houghton Mifflin, 1911), p. 191.

In 1893 Homer limited his production, painting no watercolors in the Adirondacks, but he created one of his masterpieces in oil, *The Fox Hunt* (fig. 5). Along with thousands of other Americans he paid his sole visit to Chicago, to attend the World's Columbian Exposition, where he exhibited fifteen paintings and was awarded a gold medal for his noted oil *The Gale* (Worcester Art Museum, Massachusetts). As a memento of the visit he painted a monochromatic picture, *The Fountains at Night, World's Columbian Exposition, Chicago* (fig. 50). Before the year ended he had finished another oil, which differed from any of the others produced to that point but spoke eloquently of his many autumns at Prout's Neck. He gave it a title with wide implications: *Coast of Maine* (pl. 25).

Homer was such a close observer of his surroundings that friends regarded him as an expert on the tiniest flowers of the area, possibly an inheritance from his flower-painting mother. His comprehensive view was induced inevitably by the character of the promontory on which he had chosen to live. The crest of the cliffs and the adjoining path received less attention in his work, however, than the ocean and characteristic rock wall. Consequently, *Coast of Maine* not only

stands in marked contrast to such grand views as *High Cliff* but almost stands alone. However, such is the varied nature of Prout's Neck that the spectacular scene and intimate close-up were inspired by the same view toward Eastern Point. Sections alongside Kettle Cove and the Gilbert Rocks provide prospects similar to the one represented in *Coast of Maine*. The wild terrain and the mixture of wind-twisted juniper bushes—stripped by the endless assault of ocean spray and wind—and jagged rocks can be found along the entire coast of Maine.

It is possible to consider these wild scenes to be repulsive or fascinating. In all likelihood Homer recognized both reactions, feeling an instinctive admiration for the survival power of the juniper trees and the barberry bushes in the face of unrelenting attacks by the elements, not unlike his own will to persist in the often harsh climate of Prout's Neck. Indeed, he found the twisted shapes of the wild juniper especially engaging, and in a preparatory charcoal study of the same year, called *Tree Roots on a Hillside, Prout's Neck* (pl. 22), he drew a portrait of one of the trees, merely indicating its surroundings.

In creating *Coast of Maine* from this rugged inspiration, Homer showed his intuitive ability

to impose artistic order on the raw material of nature by applying appropriate means. By using his favorite diagonal subdivision, derived from the sloping cliffs themselves, he divided the picture into two clear, manageable areas and then adjusted his brushwork to convey the misty clouds and spray above and the enduring wild bushes and rocks below. The contrast between the two areas provides complementary effects. Throughout the lower portion of the canvas he stressed the harmony of attitudes of rocks and bushes as well as the angularity of the one and the twisted curves of the other, and made both directional signs for the invisible but ever-present onshore winds. The color scheme is equally appropriate in its neutral, somber tones.

Although Homer did not duplicate *Coast of Maine* in oil, he painted a similar watercolor in 1894, *The Watch, Eastern Shore* (private collection). Together with his watercolor *North Woods* of the same year (Currier Gallery of Art, Manchester, New Hampshire), he had them reproduced by the Louis Prang Company of Boston as chromolithographs, with the directions reversed, of course. Only a few impressions were made, as the process was accurate but fragile, and examples of both titles are now rare.

16. *High Cliff, Coast of Maine*, 1894
Oil on canvas, 30⅛ × 38¼ in. (76.2 × 96.5 cm)
Signed and dated, lower right: *Homer;* on added piece of canvas, lower right: *Homer / 1894*
National Museum of American Art, Smithsonian Institution, Washington, D.C. Gift of William T. Evans
Plate 9; Figure 61

The year 1894 marked a high point in Homer's production of his Prout's Neck marines in oil, both numerically and qualitatively. Although he painted only a few watercolors in the Adirondacks during June, he brought to a climax the coastal scenes he had begun in 1883. In creating *High Cliff, Coast of Maine* Homer employed the grandest portion of Prout's Neck cliffs for one of his most imposing compositions. In the process he captured and underscored another of the facets of the ocean and its relationship with the land.

As its name implies, High Cliff is the crowning feature of Prout's Neck. It can be viewed from the west and east with quite different results. Homer had used the view from the west effectively to separate land from sky in his dynamic design for *The West Wind* (pl. 3).

High Cliff, however, is far more impressive when viewed toward its eastern side. Here the

Figure 61 (no. 16).*

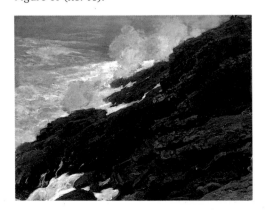

towering quality of the great mass of bare rocks is most awesome, and that effect is even more impressive when their dark forms are seen against a luminous sky as the sun passes toward the west in the afternoon and illuminates the distant ocean. Nature has furnished a small cliff on the eastern side that affords a perfect platform for viewing the cliffs. Thus, unlike the small outline of Cannon Rock, the great slopes of High Cliff are immediately striking as they sweep upward from the waters far below to the crests (fig. 62).

The angle of the rise, at its steepest here, cooperates with art by providing uniformly sloping ridges in the great syncline. Here Homer could transfer what he saw to canvas with a maximum of respect and a minimum of alteration. It was an opportunity he exploited fully.

Always implicit in Homer's marines is the timeless but constantly changing conflict between land and water. In some of his seascapes he interpreted the contest in favor of the ocean; in others it is equally balanced. In *High Cliff, Coast of Maine* he rightly emphasized the mighty rocks, allowing them to occupy nearly two-thirds of the picture area. A further reason for this division arose from the character of the waterfront at this point, midway between Prout's western and eastern extremities. Because of the steep slope of the cliffs and their sheer height, the waves can ascend the ledges only partially before their force is spent, even on the stormiest days.

This deliberate imbalance is made plain through Homer's powerful design. With artful subtlety he introduced a few human figures on the top of the cliffs, far overhead. Their minute scale reinforces the magnitude of the giant slopes of High Cliff.

In his execution of *High Cliff* Homer again demonstrated his genius for the appropriate handling of his medium to intensify natural effects. He made the rugged slopes of High Cliff more rugged still by applying oil pigments with a broad brush and in heavy impastos—for defining the rocks—and in lighter, more fluid strokes—for depicting the moving water. The

solidity of the rocks was thus emphasized and the movement of the other, enhanced, each playing a contrapuntal role. Although Homer fits comfortably into the general category of nineteenth-century realism, *High Cliff* proves that he knew the difference between duplicating a natural source and committing it to canvas through the art of picture making.

In view of its magnificence, the history of *High Cliff* is astonishing. Homer's inability to sell it drove him to wonder in letters to his family whether there was any point in continuing to paint. The picture was not bought until 1903, when William T. Evans acquired it for twelve hundred dollars.

17. *Sea and Rocks during a Storm*, 1894
Watercolor on paper, 14½ × 21¼ in. (36.9 × 54.1 cm)
Signed and dated, lower right: *Homer / 1894*
Collection of Jean and Alvin Snowiss
Plate 30

In 1894 Homer used High Cliff as the source of inspiration for another painting. The medium employed was, in this instance, watercolor, and the title given the picture was *Sea and Rocks during a Storm*. Whether Homer created the watercolor before *High Cliff* (pl. 9), using it as a preparatory means of developing his conception, as was sometimes his practice, cannot be related for certain, nor is it crucial to the watercolor's meaning. What is significant is that he demonstrated through the two media his ability to extract powerful designs from a common natural motif and to handle each composition in a suitable manner. In *High Cliff* he elected to view the massive formation from a position above average eye level, thus inviting the viewer to look downward. Owing to the location of the marginal way along the crest of the cliffs, this angle would have been the one most commonly seen. The net effect was to emphasize the rocky cliffs and reduce the role of the waves far below. In producing the watercolor Homer viewed High Cliff from a lower level, allowing the waves a more prominent role. A number of times he em-

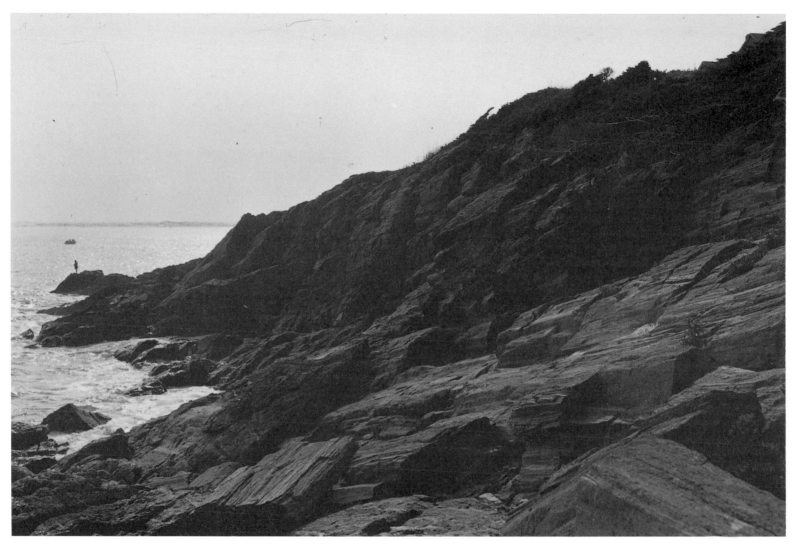

Figure 62. *High Cliff, Prout's Neck, Maine, Looking West from Kettle Cove*, 1950. Photograph by Philip C. Beam. Charles Lowell Homer, Winslow Homer's nephew, is shown fishing on the rocks.

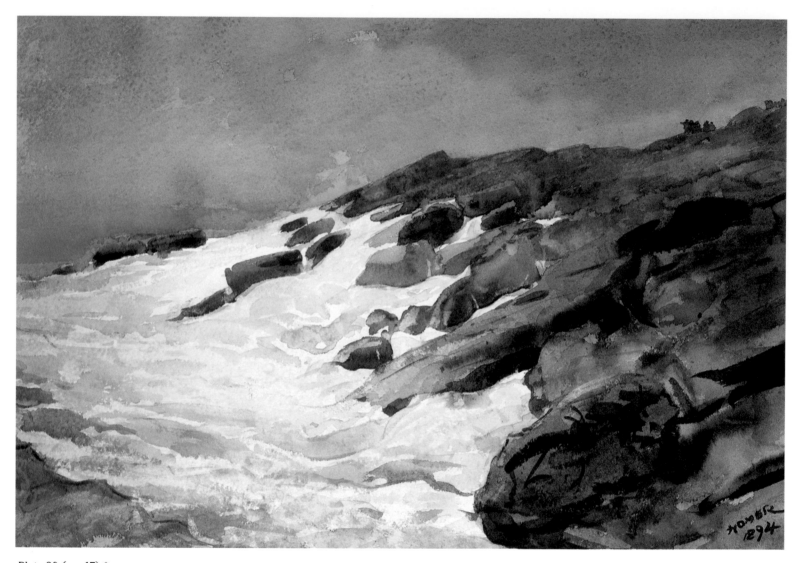

Plate 30 (no. 17).*

ployed this upward-looking view from the water's edge for striking effects, notably in *The Life Line* (fig. 3), *Watching the Breakers—A High Sea* (pl. 10), *Backrush*, and *The Artist's Studio in an Afternoon Fog* (pl. 2).

In the 1894 watercolor he proved again his sense of propriety in the handling of all media. He used the fluid qualities of watercolor to emphasize the more prominent movement of the waves. The composition shows the grand diagonal lines of the slope so strongly present in the oil as well as the subdivision of that picture into dark and light and warm and cool tones identified with the rocks and waves. In both pictures Homer adroitly inserted a cluster of tiny human spectators on top of the cliffs to magnify their scale.

Sea and Rocks during a Storm is related to the series of exploratory studies of the oceanfront which Homer began in watercolor as early as 1883 and brought to a climax in the 1890s along with his interpretations in oil. While the lighter medium of watercolor cannot match the substantiality of oil on canvas, its use for conveying the racy movement of the waves and their foamy residue was augmented by a breadth of handling which makes *Sea and Rocks* both brilliantly conceived and strongly executed.

From 1890 to 1894 Homer created a large number of watercolors, over fifty in the Adirondacks alone, which are now considered to be among the finest to come from his brush. *Sea and Rocks during a Storm* is representative of this development.

18. *Weatherbeaten*, 1894
Oil on canvas, 28 × 48 in. (71.2 × 122.1 cm)
Signed and dated, lower right: *Homer / 1894*
Portland Art Museum, Maine. Bequest of Charles Shipman Payson, 1988
Plate 31

In 1959, when James W. Fosburgh wrote, "Great art has been called the expression of the universal in terms of the particular,"[1] he was describing Homer's paintings of the Adirondacks. But his description could be applied equally to Homer's marines, and especially to a canvas he painted in 1894. Originally called *Storm Beaten*, it is now known as *Weatherbeaten*.

About one hundred yards east of High Cliff, between Kettle Cove and South Cove, lie the Gilbert Rocks. The formations there were known

intimately to Homer through personal experience, which he renewed almost daily by walking along the marginal path toward Eastern Point in every kind of weather. The Gilbert Rocks consist of horizontal slablike ledges rather than steeply sloping cliffs. The waves that beat on them are not forced to ascend to lofty heights, but are deflected and divided into sharp-edged, angular breakers, and their crests are viewed just a little below eye level. It is this meeting of surf and rocks that Homer represented in *Weatherbeaten*.

The title connotes the daily behavior of the waves, the eternal inward roll of swells and breakers, the rhythmically repeated motion of advancing and ebbing tides. It is the function of *Weatherbeaten* to define the endlessly revived assault of the Atlantic on a specific portion of the promontory of Prout's Neck, as the waves seek to erode the land and the rocks withstand their attack. That the ledges are weatherbeaten is the inevitable result, but they have persisted over eons of geological time. *Weatherbeaten*, like *Coast in Winter* (pl. 7), strikes a middle note between extremes of quietude and fury.

The essential ingredient in this process was Homer's understanding, which transferred the natural contest to canvas, giving it the reality of a local scene while causing it to symbolize a universal phenomenon. Though the forces depicted in *Weatherbeaten* are moderate compared to those in some of Homer's stormier scenes, the rich colors make it a striking picture. Though

Figure 63 (no. 19).*

Homer's Americanism often is emphasized, *Weatherbeaten* could illustrate the northern shores of Scotland, Land's End at the southern tip of England, or the western coast of Ireland—any of hundreds of places around the earth where ocean meets land in a never-ending encounter.

Weatherbeaten, originally sold for two thousand dollars, was awarded the gold medal of honor at the Pennsylvania Academy of the Fine Arts, Philadelphia, in 1896. For many years it was the centerpiece of the collection of Homer's pictures formed by the late Charles Shipman Payson.

19. *The Fisher Girl*, 1894
Oil on canvas, 27¾ × 27¾ in. (70.5 × 70.5 cm)
Signed and dated, lower right: *Homer / 94*
Mead Art Museum, Amherst College, Massachusetts. Gift of George D. Pratt '93
Plate 11; Figure 63

The summer and autumn of 1894 saw Homer working with sustained intensity, making it one of his most fruitful years. He produced four of his most famous canvases and several others nearly as fine. One of them, *The Fisher Girl*, continued a theme originally conceived in England in 1881. There, at Cullercoats and in the Tynemouth area, he had seen sturdy fisher girls climbing the point with heavy nets over their shoulders and had depicted them in a watercolor, *On the Cliffs* (Museum of Fine Arts, Boston). In 1883 he had revived the idea at Prout's Neck, using local models, but had become absorbed instead in the ledge formations in *Women on the Beach* (private collection). In 1894, in *The Fisher Girl*, he concentrated on one massive figure, hiding all extraneous details in a coastal mist. His model was Ida Meserve, from nearby Pine Point, who had posed six years earlier for his etching *Mending the Tears*. She recalled that he hired her for the whole month of May, paying her for every day, regardless of the weather.[2]

In the background of *The Fisher Girl* are the cliffs of Prout's Neck, near Cannon Rock, and at the lower right some rose hips on straggly stems supply the red accents Homer often used, especially when the general tonality of a picture was somber. The square frame is divided by the strong diagonal slope of the cliffs into two equal halves, one of Homer's favorite modes of organization, which serves as a foil for the upright

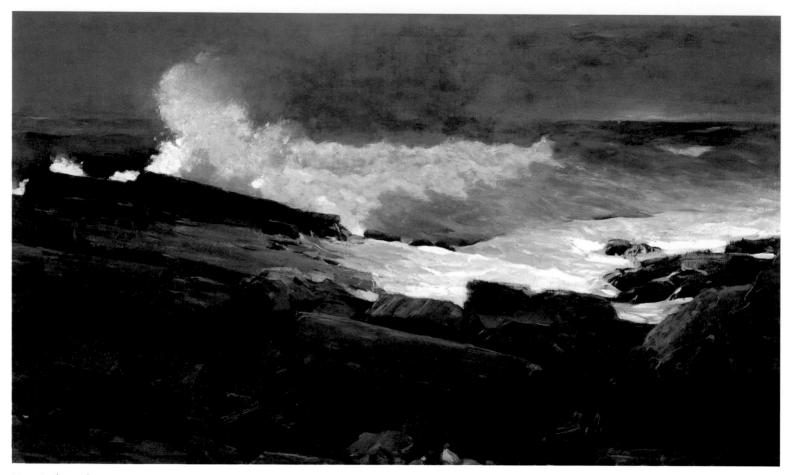

Plate 31 (no. 18).*

posture of the girl. Her strongly modeled figure stands firmly on her feet, in contrast with the misty background and the implications of vast distances. The arm and hand she raises above her eyes as she peers out to sea echo Homer's own practice of looking toward the horizon year after year.

Ida Meserve gave a graphic description of the artist at work. He was all business while painting, very serious and hardly speaking, although after each session he would talk affably and recount numerous stories. Once he had determined his conception, he would paint directly on the canvas with little preparation. Extremely considerate, he worked with her only about an hour each day, in order to avoid tiring her, although he would continue to paint afterward without a model. As he approached the completion of the picture, he painted rapidly and intensely.[3]

Homer first called this picture *The Fog*, but the figure of the girl became its dominant feature. When it was sold for $750 in 1904 to Burton Mansfield, the artist entitled it *The Fisher Girl*. Mansfield's nephew, the late Professor Thomas Means of Bowdoin College, stated that Homer once told his uncle that the picture was "A most careful study direct from nature of the best single figure that I remember having painted."[4] Actually, Meserve stopped posing about the end of May while the picture was in its early stages, as she was to be married to Charles Harding that summer. Meanwhile the artist went off to the Adirondacks for some fishing and an active period of watercolor painting. His model returned, as Mrs. Harding, to pose in the late fall, and the painting was finished in November.

Meserve's encounter with Homer is cited because it is exceptional. Normally, he insisted on absolute privacy while he was working; members of his own family used prearranged signals if an interruption was necessary. Few people who saw him painting left any description of the process.

In daily life Meserve was one of a group of local models Homer used to continue the series of fisher girls and similar themes he had begun abroad. According to Mrs. Henrietta Seavey Larrabee, others were Hattie Carter, Maude Libby, and Sadie Richardson, who posed good-naturedly for Homer, thereby gaining some measure of immortality.[5] They suggest his eye for simple, appealing human behavior derived from

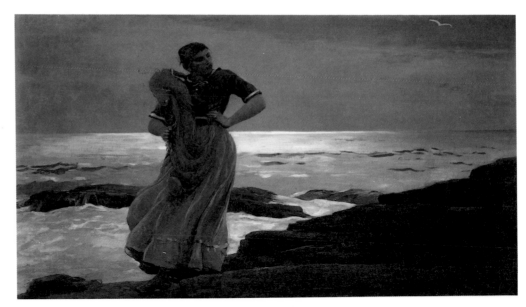

Figure 64. Winslow Homer, *A Light on the Sea*, 1897. Oil on canvas, 28 × 48 in. (71.1 × 122 cm). The Corcoran Gallery of Art, Washington, D.C. Museum Purchase, Gallery Fund.

his long experience as a magazine illustrator. Homer also employed the daughters of local fishermen. These working girls had strong arms and often regular, almost classical features, and were handsome rather than pretty. Outstanding among them, according to all who knew her (and an existing photograph), was Cora Googins Sanborn. Eighteen when Homer first met and employed her, she bore a striking resemblance to red-headed Maggie Storey, the central figure in the watercolor *A Voice from the Cliffs* (1883; private collection). Storey was Homer's favorite model at Cullercoats. Meserve, though not so tall, was cast in the same mold.

The Fisher Girl is also related to Homer's long-term methods of picture making. Early in his career he had developed the habit of grouping the scores of feminine figures he represented in pairs or trios, usually standing and facing in the same direction for the sake of rhythmic repetition and a harmony of attitudes. Figures in pairs appeared in numerous designs, apparently representing his favorite arrangement. He adopted this approach before he went to England and continued it long after he returned, in the last of his English-derived compositions, *Early Evening* (1907; Freer Gallery of Art, Washington, D.C.). In a numerically smaller but important group, he arranged his figures in balanced trios, as in the

noted watercolor *A Voice from the Cliffs* and its duplication in oil, *Hark! The Lark!* (1882; Milwaukee Art Center).

From time to time Homer departed from either the dual or triple format and represented a female figure alone, giving her the center of the stage, as in *The Fisher Girl*. When attention was not shared, the model gained extra strength. Notable examples created over a span of several decades are the drawing entitled *Flamborough Head* (1882; Art Institute of Chicago), *The Wreck* (pl. 4), *Girl with Red Stockings* (1882; Museum of Fine Arts, Boston), *Inside the Bar*, *The Gale*, and the large oil *A Light on the Sea* of 1897 (fig. 64). *The Fisher Girl*, in Homer's own estimation, ranked high in this company.

A constant in Homer's study of women is the fact that he never depicted a nude female figure, and there is nothing in the slightest degree prurient in any of his work. Through *The Fisher Girl* he reasserted his respect for the working-class women he had come to admire in England. He did not cease to portray genteel young ladies, depicting them respectfully in such canvases as *Watching the Breakers* (pl. 10). But he decreased his attention to them while repeating his tributes to laboring people of many kinds in innumerable watercolor portrayals of guides, fishermen, hunters, and lumberjacks.

20. *Sunshine and Shadow, Prout's Neck*, 1894
Watercolor on paper, 15 × 21½ in. (38.5 × 54.7 cm)
Signed and dated, lower left: *Winslow Homer 1894*
The Art Institute of Chicago. Mr. and Mrs. Martin A. Ryerson Collection
Plate 32

21. *Ocean Seen from a Cliff*, circa 1894
Watercolor on paper, 14 × 21¾ in. (35.6 × 55.4 cm)
Inscribed and signed, lower right: *Sketch W. Homer*
Cooper-Hewitt Museum, The Smithsonian Institution's National Museum of Design, New York. Gift of Charles Savage Homer, Jr. 1912–12–186
Plate 33

In 1894 Homer painted a watercolor of the coast, *Sunshine and Shadow, Prout's Neck*, which contrasts with all of the oils he painted that same year. He may have regarded the long summer months, when the ocean is often placid for weeks on end, as comparatively tame. But there was another side to Homer's nature that allowed him to appreciate repose and to avoid wasting the quieter months. He regularly put the finishing touches on watercolors he had started during his travels to the northern woods or tropical lands. He would stroll along the beaches, walk the cliffs, or sit on his balcony watching the sea or smoking his pipe and reflecting. His hours of fishing from boat or shoreline encouraged patience. His letters often convey contentment rather than restlessness.

Despite his excellent health, Homer was not a perpetual-motion machine. As rest restored his energies, he was able to work with renewed concentration. He would then create paintings extolling the virtues of quietude for both mind and body. He did this repeatedly in his watercolors of fishing in the Adirondacks, Canada, or tropical waters. Nor did he cease to express his enjoyment of restful scenes when at Prout's Neck. During the summers of the mid-1890s he painted a series of watercolors of the ocean in its calmer moods: the sketch *Ocean Seen from a Cliff* (circa 1894; pl. 33), *Prout's Neck, Evening* (1895; Art Institute of Chicago), and *Breaking Storm, Maine Coast* (1894; Art Institute of Chicago).

Sunshine and Shadow, Prout's Neck partakes of the group's principal features and is outstanding within it. Like the others, it suggests that Homer intended to do a series of studies—rendered almost as simply and quickly as sketches—to treat a single problem from a variety of points of view. In *Sunshine and Shadow* he did not attempt to convey characteristics more readily represented in oil: the massiveness of the cliffs or the weight of advancing breakers.

With watercolor Homer was able to suggest the moist atmosphere and the clouds moving overhead, the light reflected from the distant horizon and dancing over rippling waves. The cliffs in the foreground lack the substance of those rendered in oil, but the rocks at the water's edge are silhouetted boldly enough to make them impressive.

The general effect of *Sunshine and Shadow* encourages a perception of the ocean's vastness, which is emphasized by the horizontal lines and requires few details. Homer seldom exploited watercolor more brilliantly than in this rendering of wild juniper trees with a minimum of rapidly drawn strokes. The economy and precision of his brushwork, reminiscent of Far Eastern calligraphy, make *Sunshine and Shadow* a superb example of watercolor painting.

22. *The Artist's Studio in an Afternoon Fog*, 1894
Oil on canvas, 24 × 30 in. (61 × 76.2 cm)
Signed and dated, lower right: *Winslow Homer 1894*
Memorial Art Gallery of the University of Rochester, New York, R. T. Miller Fund, 41.32
Plate 2; Figure 65

When Winslow Homer painted *The Artist's Studio in an Afternoon Fog*, he expressed two ideas that were both typical and unique for him. The fog he recorded frequently enshrouds the coast of Maine during the summer months. The filtering of the rays of the sun as it descends over Saco Bay to the west and softens the scene with a yellowing hue is a display Homer must have witnessed numerous times as he returned from his late afternoon walks above the cliffs. Typical, too, is the manner in which he organized this painting through bands of tone, so that the eye is led upward from the water's edge through the deep brown shadows of a Baroque canopy to the buildings silhouetted above the cliffs by the glowing orb of the sun. Within this spectacle natural details have been suppressed and major areas organized for emphasis by means of tonal contrasts. Causing the buildings, the Ark near the ocean and the studio on the right, to loom larger in size and importance than they do in actuality was also an established device of Homer, recalling the license employed freely by major Western masters.

The Artist's Studio in an Afternoon Fog is unique among Homer's marines and, indeed, is different from any of the hundreds of other pictures he created. Nowhere else does he depict the two buildings, the Ark and his studio, which were more important to him than any other structures on Prout's Neck or anywhere else. He depicted them together because they were inseparable in their connotations and played crucial roles in his practical and emotional life.

Compared to the sumptuous home and grounds of Augustus Saint-Gaudens's residence in New Hampshire, Church's castle, Olana, overlooking the Hudson, Sargent's mansion in London, or Rubens's palace in Antwerp, Homer's wooden studio-home is a pathetically small dwelling for a major artist, as modest as a compact car beside a Rolls-Royce. Yet it occupied a position on the cliffs at Prout's Neck that made it ideal for a painter of the sea. Its very modesty was an asset. Its small scale was adequate for Homer's personal needs, which were always simple; the simplicity of upkeep, in fact, freed him to paint for long hours without interruption, as long as daylight lasted. By the time dusk approached, Homer, an early riser, had availed himself of a long workday, having wasted little time. It was a form of efficiency he valued.

Another unique feature of the studio was its balcony. Over the years Homer would spend end-

Figure 65 (no. 22).*

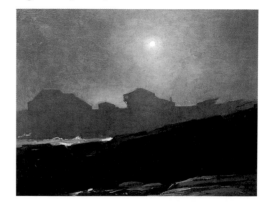

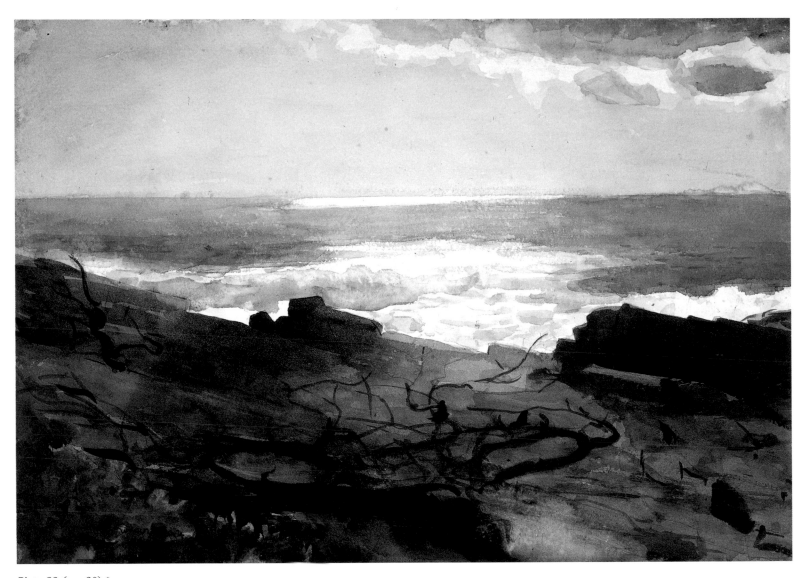

Plate 32 (no. 20).*

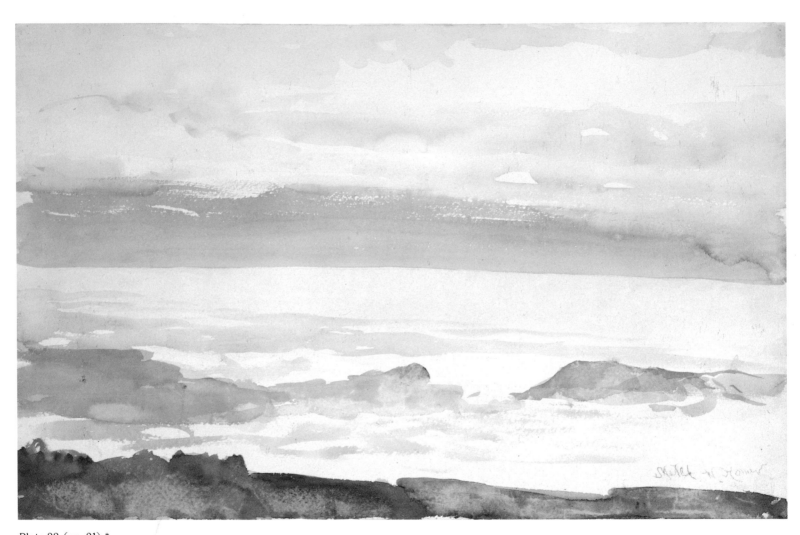

Plate 33 (no. 21).*

less hours sitting there with his eyes turned seaward. When his sister-in-law observed this apparent inactivity from the nearby Ark, the practice was so unlike that of her industrial-chemist husband and his regular office routine that it bothered her. If visitors asked what her brother-in-law was doing, she would reply, "He isn't *doing* anything."[6] To Homer, however, these hours on the balcony were never wasted, as he educated himself in the infinite changes of weather and waves. Equally important, after years of meeting editorial deadlines for his magazine illustrations, he would not force his inspiration or descend to his painting room until he was ready to create a picture that would be original and significant.

After painting hours ended, Homer would start his daily walk along the cliffs, where he could observe the rock formations through every kind of weather and condition of lighting or storm. If his work had gone well he could accept a well-earned period of relaxation by chatting with friends along the way or by fishing from the rocks at the water's edge, a recreation he never ceased to enjoy (fig. 66). Outside working hours, he was devoted to his family, and having them next door during the summer months meant that when he was not engrossed in a painting, he could join them almost daily for noontime dinner and for afternoon visits on the seaside porch, as is recorded in photographs (figs. 41, 42)

The nearness of his family provided another

benefit in the form of members of the Ark's staff, who assisted Homer in a limited but useful way. Mrs. Munroe, housekeeper at the Ark during the 1890s, not only supervised the noon dinners Homer attended but also did his mending. Lewis Wright, the workman-servant of the Ark, butler for social occasions sponsored by Mattie Homer, and personal aide to Homer's father, gladly assisted the artist, to whom he was devoted, in various ways.

Outsiders performed additional services. John Gatchell and Henry Lee, whom Homer immortalized as models in his paintings, did double duty as handymen. Len Libby, a quiet youth, was allowed to prepare an occasional lunch when Homer was engaged by a subject and to tidy up the studio after the session was over. Libby often fetched the mail at Oak Hill Station and reported that Homer subscribed to a large number of journals, read them assiduously, and thereby kept in touch with the outside world.[7]

In these ways Homer was enabled to follow a way of life which was exactly suited to his purposes and whose very simplicity allowed him to devote maximum time and energy to artistic creation. Finally, the studio was the home to which he always returned.

When, in 1901, a decade and a half later, Homer built a cottage for rental purposes and engaged John Calvin Stevens of Portland to provide the architectural design, he presented this painting to Stevens in lieu of a fee, referring to it

Figure 67 (no. 23).*

as "a sketch."[8] Since Homer was very pleased with the work of the Stevens brothers and referred to them as "brother artists," a description he did not bestow lightly, "sketch" must have meant only that the picture was relatively small. In all other respects Homer must have intended it to be a gift of something that was special to him. It was, moreover, an appropriate one, since Stevens, as a young man, had supplied the plans for the conversion of the studio at the outset of Homer's sojourn on the Neck.

23. *Moonlight, Wood Island Light*, 1894
 Oil on canvas, 30¾ × 40¼ in. (87.1 × 102.2 cm)
 Signed and dated, lower left: *W. H. 1894*
 The Metropolitan Museum of Art, New York.
 Gift of George A. Hearn in memory of Arthur Hoppock Hearn, 1911
 Plate 15; Figure 67

In *Moonlight, Wood Island Light* Homer has presented two beacons that illuminate the vast darkness of the open sea at night: the moon and the coastal lighthouse. In this nocturnal view of the rocks beneath the Ark and Homer's studio on the southeast tip of the Neck, the moon is nearly hidden by a dark cloud, and the red flare of Wood Island Light to the south is thus made more prominent in the black sky. The moon's beam is concentrated and intense as it breaks slightly from behind the cloud. It silvers a patch of ocean, reflects brilliantly off the breaking waves, and renders the rocks of Prout's shoreline visible as dark, ominous silhouettes.

Homer's first biographer, William Howe Downes, subscribed to the theory that the artist, ever the realist, painted such moonlit scenes

Figure 66. *Winslow Homer Fishing for Tautog from the Rocks at Prout's Neck, Maine*, circa 1890–1900. Silver print by unknown photographer. Bowdoin College Museum of Art, Brunswick. Gift of the Homer family, 1964.*

directly from nature. Homer himself apparently cultivated a belief in this extraordinary notion, since on one occasion he reportedly told fellow artist Frank Benson that he painted *The Lookout—"All's Well"* (fig. 45) entirely by moonlight and never reworked it.[9] Of Homer's work on *Moonlight, Wood Island Light*, Downes tells us:

> One night in the summer of 1894, he was sitting on a bench, smoking, with his nephew, in front of the studio. It was a beautiful evening, with quite a sea running, but not much wind. Of a sudden, Winslow Homer rose from his seat, and said: "I've got an idea! Good night, Arthur!" He almost ran into the studio, seized his painting outfit, emerged from the house, and clambered down over the rocks towards the shore. He worked there uninterruptedly until one o'clock in the morning. The picture called "Moonlight, Wood Island Light," was the result of that impulse and four or five hours' work.[10]

Goodrich and Beam have rightly questioned the accuracy of both Homer's claim and Downes's anecdote, citing the difficulties the artist would have encountered in mixing colors in the dark. Moreover, it would have been problematic for him to handle a canvas of such size on the wet, windswept rocks.[11] It seems more likely that in creating *Moonlight, Wood Island Light* Homer relied on his own highly developed color sense and on studies of the scene made in watercolor or in oil on panel, works similar to his preparatory studies for *A Summer Night* (pl. 6; fig. 55) and *Sunset, Saco Bay* (pl. 37).

Moonlight, Wood Island Light was purchased by Thomas B. Clarke from Reichard and Company in February 1895. It was included in exhibitions at the Century Association, New York, and at the Carnegie Institute, Pittsburgh, in 1895; at the Pennsylvania Academy of the Fine Arts, Philadelphia, in 1896; and at the Union League Club, New York, in 1898. Like *Northeaster* (pl. 17), *Cannon Rock* (pl. 16), and *Maine Coast* (1896; Metropolitan Museum of Art, New York),

the picture eventually was acquired by George Hearn and was presented by him to the Metropolitan Museum.[12] [P.J.]

24. *Herring Fishing*, 1894
 Watercolor on paper, 13⅝ × 20½ in. (34.6 × 52.1 cm)
 Signed and dated, lower left: *Winslow Homer 1894*; inscribed on reverse, upper left: *No. 19, Herring Fishing*
 Collection of Mr. and Mrs. C. Thomas May, Jr.
 Plate 34

Homer sometimes seems to have had a mind as retentive as the memory bank of a computer. Occasionally, it brought to the forefront of his thoughts a theme he had examined long before that still stirred him. He would then reexamine it, probably in the hope of treating it from a new point of view in the midst of quite different subjects. An example of this process is the watercolor *Herring Fishing*. Nearly ten years earlier he had created a series of similar studies which arose from the following circumstances. In 1884 a large school of herring entered the waters between Stratton's Island and Prout's Neck and attracted a fleet of schooners from up and down the coast. Roswell Googins, who was thirteen at the time, stated that Homer engaged him to row him out to the fleet, where he made sketch after sketch of the fishermen and their boats.[13] During the ensuing months he made variations of the subject ranging from the complex *Haul of Herring* (Museum of Fine Arts, Boston) to the quietly dramatic *Study* (1884–85; Cooper-Hewitt Museum, The Smithsonian Institution's National Museum of Design, New York). This last design crystallized Homer's thoughts and was translated into the noted oil painting *The Herring Net* (1885; Art Institute of Chicago), a high point in a succession of brilliant studies of the life of the deep-sea fisherman which had its inception along the North Sea coast and included such memorable paintings as *The Fog Warning* and *Eight Bells*. Although, according to members of Homer's family, he never visited the Grand Banks

of Newfoundland, he listened carefully to tales told by the fishermen of Pine Point who had sailed there and never forgot them.

For Homer to return mentally to Newfoundland in *Herring Fishing* exemplifies a touch of nostalgia. Owing to a combination of causes, such as the substitution of huge seines for the gill nets shown in the watercolor, the schools of fish had been depleted, and the fishing industry was dying out in the area of Prout's Neck. The watercolor itself is rendered so freely that it conveys a mystical air and a reverence for the sailors who followed a precarious calling. They fished in pairs in order to haul in the heavy nets and also for safety. More than one fisherman who rowed the speedy but tipsy dories owed his life to a dory mate who kept him from falling overboard and drowning in the frigid North Atlantic. Few could swim, and they could not have done so in their heavy clothing in any case. Though simply stated, a bond of dependence in the face of danger is implied in the picture, contributing added subtlety.

NOTES

1. James W. Fosburgh, *Winslow Homer in the Adirondacks* (Blue Mountain Lake, New York: Adirondack Museum, 1959), p. 15.
2. Mrs. Ida Meserve Harding to author, circa 1938.
3. Ibid.
4. Ibid.
5. Mrs. Henrietta Seavey Larrabee to author, 1938.
6. Charles Lowell Homer to author.
7. Leonard Libby to author.
8. Homer to John Calvin Stevens, June 26, 1901, Bowdoin College Museum of Art, Brunswick, acc. 1988.38.12.
9. Lloyd Goodrich, *Winslow Homer* (New York, Macmillan Co. for the Whitney Museum of American Art, 1944), p. 142.
10. Downes, p. 173.
11. Goodrich, p. 142; Philip C. Beam, *Winslow Homer at Prout's Neck*, exh. cat. (Brunswick: Bowdoin College Museum of Art, 1966), p. 120
12. Complete provenance and exhibition history are given in Natalie Spassky, *American Paintings in the Metropolitan Museum of Art, Volume II* (Princeton: Princeton University Press, 1985), pp. 468–71.
13. Roswell Googins to author.

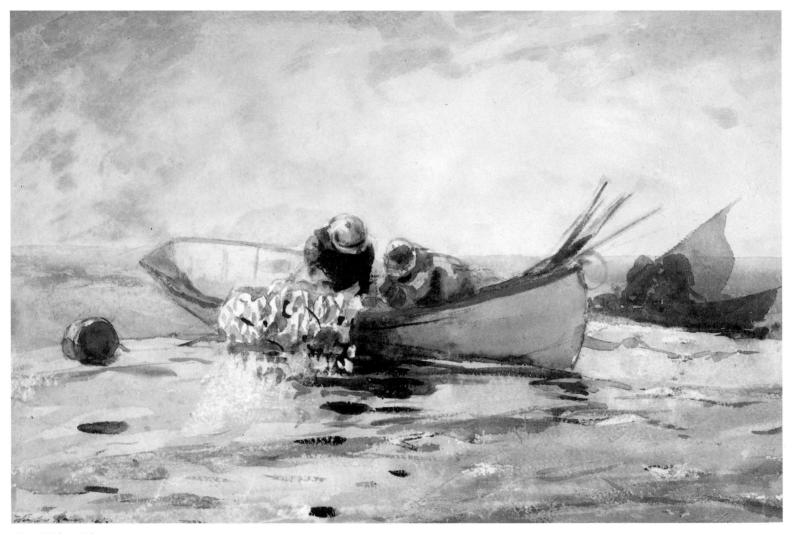

Plate 34 (no. 24).*

25. *View of the Sea from the Cliffs*, 1895
 Pencil on paper, 6⅜ × 9¹¹⁄₁₆ in. (16.3 × 24.7 cm)
 Cooper-Hewitt Museum, The Smithsonian
 Institution's National Museum of Design,
 New York. Gift of Charles Savage Homer, Jr.
 1912–12–241
 Plate 35

26. *People Overlooking a Bay*, 1895
 Pencil on paper, 4⅞ × 7⅞ in. (12.4 × 20 cm)
 Cooper-Hewitt Museum, The Smithsonian
 Institution's National Museum of Design,
 New York. Gift of Charles Savage Homer, Jr.
 1912–12–248
 Plate 36

The year 1895 saw no lessening of Homer's activity. In August and September he paid a significant visit to Quebec City and the province of Quebec and painted some of his finest watercolors at Lake Tourilli, along the Saint Anne River valley, and at Lake Saint John on the upper Saguenay River.[1] He would return to these locales to great effect in subsequent years.[2] But he also devoted his energies in important ways to painting and sketching the sea at Prout's Neck during the summer and autumn.[3]

27. *Cannon Rock*, 1895
 Oil on canvas, 39⁹⁄₁₆ × 39⅛ in. (99.5 × 99.3 cm)
 Signed and dated, lower right: *Homer / 1895*
 The Metropolitan Museum of Art, New York.
 Gift of George A. Hearn, 1906
 Plate 16; Figure 68

In 1895, when Homer was approaching the summit of his powers as a marine painter in both watercolor and oil, he composed two of his most noted canvases, *Cannon Rock* and *Northeaster* (pls. 16, 17). Each is a masterpiece but for quite different reasons, showing the scope and versatility of his work. And each provides an object lesson in picture making.

Cannon Rock was derived from a picturesque, unique formation located about one hundred yards east of Homer's studio. When first seen from the top of the cliffs, it appears to be surprisingly small and distant. Visitors easily overlook it on their initial encounter with Prout's Neck. Homer's art intensified its presence through a variety of judicious alterations.

In transforming the raw material of nature into an artistically organized picture, Homer used both artistic license and synthesis. He began by moving his point of view from the crest of the cliffs to a location closer to Cannon Rock, thus enlarging its effect. After separating the small motif from the massive rocks around it by placing it within a frame, he rearranged the relatively horizontal ledges and boxlike cleft into a dark, imposing triangle. The result was an interior enframement that rivets attention on his main motif. In addition, he changed the direction of Cannon Rock's lateral, easterly orientation so that it points out to the incoming wave, thus linking the rock below with the breaker above.

Homer revised nature further after he observed that the offshore wave appears only at low tide, as it breaks over a submerged shelf, whereas the ocean fills the cleft only at high tide.

Figure 68 (no. 27).*

This distinction between the natural source and the composition can be discerned clearly by comparing a photograph of the forms (fig. 69) with Homer's canvas.

Charles Lowell Homer tested this objective comparison one afternoon by climbing for an hour over the ledges around Cannon Rock and viewing it from all possible angles. He concluded that his uncle only could have painted the picture as he did if he had viewed the rock from a tall ladder, been ten feet tall, and worked at several different times of day and tide.[4]

In carrying out this experiment Charles Homer was mindful of an assertion his uncle had made to John W. Beatty that after he had selected a subject he painted it exactly as he saw it and *"never changed it."*[5] Fortunately, he did not do this, in fact. It was, whether he knew it or not, his inner vision that gave *Cannon Rock* its grandeur as a picture.

In the long run much of the actual art of picture making is intuitive, defies exact analogies, and is best understood through its results.[6] Whatever method Homer used in conceiving *Cannon Rock*, it remains one of his most enjoyable marines. Its meaning falls somewhere in between those of his marines that represent the ocean on a rampage and others that depict it as so placid and mirrorlike that the artist described it as being as dull as a millpond. *Cannon Rock* speaks for the middle months of the year, when the tides rise and fall in an endless rhythm. It is the epitome of the mundane, the normal, and is neither dull nor excessively stimulating.

After Homer captured the essence of the milder months in *Cannon Rock* during the summer of 1895, he was treated in the fall to one of the more powerful equinoctial storms that batter the coast with the approach of winter. He responded by painting *Northeaster* before the year's end. Over the years it has been described as the quintessence of his seascapes. Among his pure marines it represents the most powerful of his stormy scenes and is endowed with his most powerful design. These two attributes were

Plate 35 (no. 25).*

Plate 36 (no. 26).*

Figure 69. *Cannon Rock, Prout's Neck, Maine, at High Tide*. Photograph by Philip C. Beam, 1950.

Homer enframed the light spray and the brilliantly colored wave that dominate the foreground of the picture. Through this arrangement the viewer's eye is led into the distance along the diagonal line of recession, Homer's favorite method for establishing prominent, logical steps. He thereby presented the elemental forces of nature with maximum effect and, by avoiding details, preserved the symbolic implications of earth, water, and sky. But it is the organization of the parts which makes their message apparent.[9]

Some viewers have questioned the credibility of the huge clouds of spray, whose billowing mass seems as solid as concrete. Charles Lowell Homer watched the autumn storms for several years until one appeared that was comparable to the scene in the artist's *Northeaster*. Such storms are the exceptional ones that approach hurricane force. On October 12, 1937, Charles Homer was able to photograph a mass of spray as formidable and solid as its counterpart in Homer's painting, verifying the accuracy of the artist's report (fig. 70). On that day, Charles Homer recalled, the waves drove toward the coast at eye level, much as they do in the painting, a condition that occurs only when they reach mountainous heights. Furthermore, he was able to identify the formation that inspired the artist to paint his picture. About one hundred yards west of High Cliff there is, among the sloping ledges, a huge boulder that presents a vertical face to the sea. In order to reach it, the waves must ascend fifty or sixty feet and be driven by an extraordinary storm. But when they do reach it and smash against its face, the crests rise high into the air in dense clouds of spray.[10]

When viewing *Northeaster* in a quiet gallery, it is difficult to imagine the physical conditions under which such scenes are observed for the sake of a painting or photograph. By the time the equinoctial storms arrive at Prout's Neck, the summer residents have departed, and all but a few of the hardiest natives have sought shelter. As the winds rise, footing along the cliffs becomes dangerous, and the spray is hurled landward like shot. Nevertheless, Homer's older brother told his biographer Downes, long after everyone else had retreated under cover, the artist would stand on the cliffs, clad in his foul-weather gear, as if transfixed by the natural drama.[11]

Some romantic or primeval streak in Homer's nature made him exult in the ocean's rampages

noted by Forbes Watson in 1942, when he perceived Homer's feeling for the elemental forces of nature and the artist's own elemental vitality. Watson offered a further insight when he applauded Homer's talent for reducing his grander themes to their pictorial essentials.[7] *Northeaster* is a model for the coordination of idea and design.[8]

In this painting Homer has depicted an Atlantic storm at the height of its fury, but has reduced the scene, for pictorial purposes, to its four major components. In the lower left foreground he rendered a sufficient sample of the rocky cliffs to identify the crest of Prout's Neck. Rising from it is a massive cloud of spray and, beyond that, a stupendous wave that crashes downward with the force of an avalanche. He painted this awesome breaker with his most vibrant brushstrokes. In the upper right distance are giant offshore breakers enshrouded in mist that indicate the limitless expanse of ocean beyond.

Through his placement of the dark brown rocks below and the ominous gray sky above,

as well as endure the attendant discomforts.[12] The emotion this experience aroused became the driving force behind the elements of both representation and design. In this way he resembled J. M. W. Turner, who had himself bound to the mast of a ship in order to witness a storm at sea and revel in it. The results Turner and Homer achieved were remarkable in the history of modern marine painting and only are matched in literature by such galvanizing accounts as Joseph Conrad's *Typhoon* (1903).

Northeaster was exceptional even in Homer's work, for the height of a major storm is not the best time to observe the waves. Rather, the momentum generated by a riled-up sea will furnish a rhythmic procession of breakers over several days after the gale has subsided. It was this more tolerable aftermath that Homer presented in one of his most satisfying marines, *Early Morning after a Storm at Sea*. For pure energy, however, Homer never excelled *Northeaster*, which is rivaled only by a few of Courbet's strongest seascapes during the second half of the nineteenth century.

In 1902 the Pennsylvania Academy of the Fine Arts, Philadelphia, the oldest art school in the country, confirmed this assessment when *Northeaster* was exhibited there, awarding Homer the Temple Gold Medal. In the same year the Charleston, South Carolina, Exposition awarded its gold medal to *Cannon Rock*.

Figure 70. *An Equinoctial Storm, Prout's Neck, Maine*, October 12, 1937. Photograph by Charles Lowell Homer.

NOTES

1. Gene Teitelbaum, editor-in-chief of *Winslow Homer: An Annual*, featured Homer's Canadian pictures in 1987, underscoring the importance of his trips north; see Gene Teitelbaum, "Winslow Homer in Canada," *Winslow Homer: An Annual* 2 (1987), pp. 3–23.

2. An illuminating account of Homer's visits to the Tourilli Club and other parts of Canada is Frank Sleeper and Robert Cantwell, "Odyssey of an Angler," *Sports Illustrated* 37 (December 25, 1972), pp. 62–73, which deals with the artist's devotion to fishing and his related activities as an artist. A special merit of the article is that Sleeper visited the places where Homer had fished and painted.

3. See Patricia Condon Johnson, "Winslow Homer," *Sporting Classics* (Camden, South Carolina, 1986), a sympathetic review of Homer's enthusiasm for the outdoor life.

4. Charles Lowell Homer to author.

5. J. W. Beatty, "Introductory Note," in Downes, p. XXVII.

6. The products of genius can be recognized to the point of almost universal acclaim, but the term itself is notoriously difficult to define. The best of dictionaries cope badly with the term because of the elusive nature of things primarily spiritual. Among painters, this is an area in which action speaks louder than words.

7. Forbes Watson, "Winslow Homer," *American Magazine of Art* 29, no. 10 (October 1936) pp. 625–38.

8. In giving one of his most awesome marines the title *Northeaster*, Homer acted advisedly. To those who live on the New England coast the term signifies a special season of the year, when winter is in the offing. At that time the Caribbean-bred hurricanes and lingering warmth of the ocean clash with polar tongues from Canada to produce meteorological conflicts on an increasingly magnificent scale. The resulting northeasters are as spectacular as any storms of the year.

9. Although Homer exhibited a highly refined taste in his handling of color, especially in his watercolors, he did not rely on intuition alone in developing his color designs, nor did he favor representational truth to the exclusion of aesthetic values. According to Beatty, Homer acquired Michel Chevreul's book on the law of contrasts in colors, read it until the pages were "dog-eared," and referred to it as his Bible (Goodrich, p. 223). Kristin Hoermann reports that Homer was aware of Chevreul's principles as early as 1860, the beginning of his painting career; see "A Hand Formed to Use the Brush," in Marc Simpson et al., *Winslow Homer: Paintings of the Civil War* (San Francisco: Bedford Arts Publishers for the Fine Arts Museums of San Francisco, 1988), p. 105. Applying these laws over the years may have become second nature to him, but, like most geniuses, his practice was based from the outset on a combination of logic and sensibility. In "Winslow Homer in His Art," *Smithsonian Studies in American Art* 1, no. 1 (Spring 1987), pp. 31–45, Jules D. Prown demonstrates that in the pursuit of his art Homer was a thinking man who knew what he was doing, even in his most realistic or romantic efforts, a characteristic not always attributed to him in comparisons with the highly intellectual Thomas Eakins.

10. Some of Homer's rare remarks go to the heart of the matter in revealing his guiding ideas. An apt one to consider in relation to *Northeaster*, made to John W. Beatty, underscores the artist's emphasis on selectivity: "The rare thing is to find a painter who knows a good thing when he sees it" (Downes, p. XXVI). This was a central theme in Homer's encounter with the cliffs of Prout's Neck.

11. Downes, p. XXVI.

12. From his first-hand acquaintance with Homer, Beatty was able to report that "when the lowering clouds gathered above the horizon, and tumultuous waves ran along the rock-bound coast, and up the shelving, precipitous rocks [of Prout's Neck], his interest became intense" (ibid., p. XXVI).

1896

28. *Sunset, Saco Bay*, 1896
 Oil on board, 13½ × 19½ in. (34.3 × 49.5 cm)
 Collection of IBM Corporation, Armonk, New York
 (Exhibited in Rochester and Washington only)
 Plate 37

29. *Saco Bay*, 1896
 Oil on canvas, 25 × 38½ in. (60.5 × 96.4 cm)
 Signed and dated, lower right: *Homer 1896*
 Sterling and Francine Clark Art Institute, Williamstown, Massachusetts
 (Exhibited in Williamstown only)
 Plate 38

In 1896 Homer painted only a limited number of watercolors but produced four important oils at Prout's Neck, one of which marked a high point in the recognition of his talent. The four are entitled *The Lookout—"All's Well"* (fig. 45), *Saco Bay* (pl. 38), *The Wreck* (pl. 4), and *Watching the Breakers—A High Sea* (pl. 10). These pictures examine the relationship between humanity and the sea at different seasons. *The Lookout—"All's Well"* speaks for safe passage on the sea throughout the year; *Saco Bay*, for the summer months; *The Wreck*, for safety overwhelmed by an autumn storm; and *Watching the Breakers*, for a winter tempest.

A friend, Mrs. Addie Kaler Vaill, said that Homer sometimes would paint in the afternoon at a shack near Ferry Beach, on Saco Bay, and would walk home backwards most of the way to observe the descending sun. Occasionally, he would carry a piece of cardboard, illustration board, or wood on which he would make a quick oil study of some passing instance of natural beauty, much as Monet did with his studies of haystacks.[1] A brilliant example is *Sunset, Saco Bay*, a rapidly rendered oil study. Here are no subdued tones—the sunset bursts through the dark cloud masses in riotous colors painted in full, fatty strokes. One does not miss the details in the sweeping brushwork because of the completeness of the impression, which conveys the artist's most spontaneous thoughts.

When Homer created his larger oil version, *Saco Bay*, he developed his design along more subdued and formal lines. He chose for his setting a sloping formation in the vicinity of West Point (fig. 71), a little more than one hundred yards from his studio. It was a natural pedestal for human figures, and he engaged two local girls, Sadie Sylvester and Cora Sanborn, to pose on the crest in costumes resembling those of English fisher girls, with one carrying a lobster trap and the other, a net. Since he did not want to be distracted by any antics while working, he asked Cora's uncle, Benjamin Franklin Sanborn, to meet the Victorian requirement of a chaperone by "carrying his pencils." The project proceeded without any difficulties.[2]

The girls and the rocks stand out in dark silhouette against the sun setting beyond Saco Bay and intensifying the glowing surface of the ocean and tones of the twilight. The sun itself is barely indicated, but the canvas is suffused with its warmth. The composition, an admirable example of abstract relationships presented through the clear interplay of horizontal and vertical lines, is nonetheless conducive to the establishment of a mood. While many other artists, such as Turner and Frederic Edwin Church, painted brilliant sunset scenes, both literal and symbolic, Homer worked directly and honestly from his own experience.

When *Saco Bay* was exhibited at the Pennsylvania Academy of the Fine Arts, Philadelphia, in 1896, it was called *Saco Bay, Coming Storm*. Its glowing colors suggested a change of title when it was shown at the Society of American Artists Exhibition a year later, when it was acquired by the Lotos Club of New York from its purchase fund for one thousand dollars. At that time the

Figure 71. *Checkley Point and Saco Bay, Prout's Neck, Maine*, 1945. Photograph by Robert Macbeth. Charles Lowell Homer is shown standing on the rock.

Plate 37 (no. 28).*

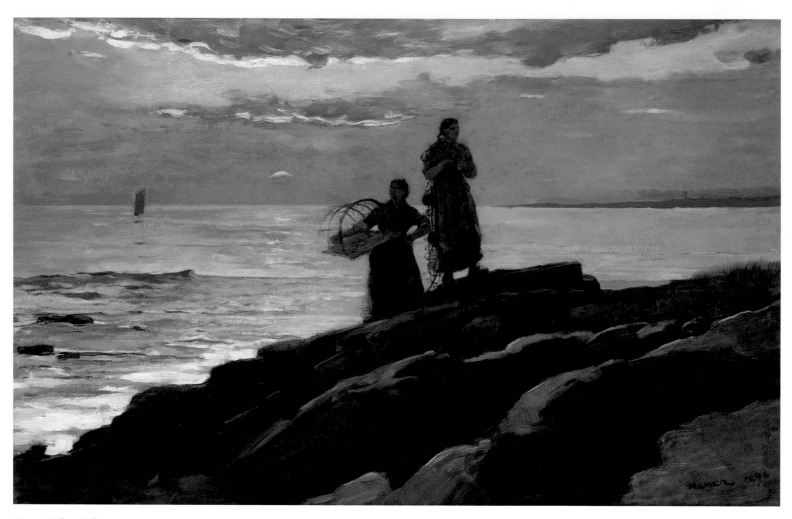

Plate 38 (no. 29).*

picture was condemned by critics for its "harsh" colors, and one advised Homer to confine himself to monochromatic media (drawings, engravings, etchings), a charge reasserted after the artist's death along with the presumption that he had become color-blind.[3] The American public of the day was conditioned to prefer the golden sunsets of the Hudson River School or Claude Lorrain, and by those standards Homer's sunsets seemed garish. The late work of Turner or the large, bold paintings of Church, the French Impressionists, and Van Gogh gradually served to moderate that point of view. Homer was ahead of his time when he simply responded to a natural display.

30. *The Wreck*, 1896
 Oil on canvas, 30⅜ × 48⁵⁄₁₆ in. (76.2 × 121.9 cm)
 Signed and dated, lower right: *Winslow Homer / 1896*
 The Carnegie Museum of Art, Pittsburgh. Purchase, 1896
 (Exhibited in Rochester only)
 Plate 4; Figure 72

With the advent of the autumn storms Homer turned away from a summer idyll in his third important canvas of 1896, *The Wreck*, which marked another return to his earlier perils-of-the-sea pictures. The subject of rescues had become meaningful to him in northern England and in Atlantic City, New Jersey, where he had studied the methods of the coast guard. The theme was established in his oeuvre at the outset of his residence at Prout's Neck with his great painting *The Life Line* (fig. 3). An interest in the dangers inherent in seafaring life was to continue to the end of his career in such watercolors as *The Wrecked Schooner* (1910; Saint Louis Art Museum). His conception of dramatic presentation altered with the years, however, shifting from the outright illustration of hazards, as in *The Wreck of the Iron Crown*, *The Life Line*, and *Undertow* (fig. 4), to indirect expression and understatement.

As many have pointed out, much of the power of *The Wreck*'s message derives from the fact that though there is a gripping air of urgency about the coast guards' activity, the wreck itself is out of sight and left to our imagination.

As he had done before, Homer related both the authentic and dramatic properties of *The Wreck* to ideas he had derived from his resi-

dence at Prout's Neck. In addition to the dunes, there were, nearby, on the seaward section of Eastern Point, rocks that posed a lethal hazard to any boat that ventured toward adjacent Higgins Beach in stormy weather. A catastrophe was possible at any time, and a noted wreck did occur when the schooner *Fanny and Edith* was driven ashore there and destroyed in December 1900.

Today the dunes have become covered by rampant foliage, but their undulating character in 1896 provided Homer with a motif he could use in harmony with the curved lifeguard boat; indeed, he extended it throughout the picture as a unifying factor. He also borrowed from a local source by dressing his favorite male model, John Gatchell, in oilskins and using him as the principal actor in the unfolding drama, as he had done recently in *The Lookout* (fig. 45) and many times before.

Homer was sixty when he completed *The Wreck*, and his control of his medium and the years of experience behind it are apparent. These qualities were, for a change, appreciated as soon as the picture was exhibited, at the first Carnegie International in Pittsburgh in 1896. Homer was awarded the first prize for an American picture, the Chronological Gold

Medal, and a cash purchase award of five thousand dollars. Although the Carnegie Institute retained the canvas, this was the largest compensation Homer had received up to that time. It confirmed the confidence placed in him by a longtime friend and admirer, John W. Beatty, then the institute's director.

Homer remained modestly at Prout's Neck when the award for *The Wreck* was announced but soon had to answer the letters of congratulations which arrived. To his patron and good friend Thomas B. Clarke he wrote from Scarborough on December 9, 1896:

My dear Mr. Clarke.—
 I thank you for your kind note of congratulations on my success. It is certainly a most tremendous & unprecedented honor and distinction that I have received from Pittsburgh. Let us hope that it is not too late in my case to be of value to American art in something that I may yet possibly do, from this encouragement.[4]

There were, of course, still those who were wedded to European styles and could not understand Homer's originality and independence from academic norms. We read in the Pittsburgh

Figure 72 (no. 30).*

Dispatch of December 6, 1896: "The first prize picture, Winslow Homer's 'Wreck' is a striking example of the best American school, vigorous in conception and careful in detail and finish. But had Sir John Lavery's 'Lady in Brown' been eligible for the prize, it would have had strong claims for the prize as combining the best quality of Whistler's atmosphere with the detail of Carolus Duran's portraiture."[5] Since Sir John Lavery was not American, he received only a "first medal" in the Carnegie International. Others went to Jean-Francois Raffaëllis's *Notre Dame* (private collection) and Cecilia Beaux's *Ernesta* (private collection), while the second-prize money was awarded to Gari Melchers's *Shipbuilder* (private collection), described as a good example of American painting in the French style.

At this time Richard Muther, one of the foremost European critics, lamented that American art was a "mere resumé of European art."[6] These conflicting views illustrate the attitudes with which Homer had to contend while preserving his integrity. The isolation of Prout's Neck often must have been a safeguard for clear thinking. He must have been grateful to have had a few discerning friends, such as Beatty and Clarke. And, of course, he had the unwavering support of his family, to whom he expressed his appreciation in a brief but sincere letter written from Scarborough on December 10, 1896:

> Dear Charlie and Mattie:
>
> I thank you for your kind letters—I have been most deeply moved by the many expressions of friendship that I have received, as well as this great distinction conferred on me at Pittsburgh.
>
> Yours affectionately,
> Winslow[7]

31. *Watching the Breakers—A High Sea*, 1896
Oil on canvas, 24 × 38¼ in. (61 × 97.2 cm)
Signed and dated, lower left: *Winslow Homer 1896*
Canajoharie Library and Art Gallery, New York
Plate 10; Figure 73

Responding to the progression of the seasons, Homer painted his fourth oil in 1896, *Watching*

Figure 73 (no. 31).*

the Breakers—A High Sea. Another of his representations of wintry, stormy seas, it presents them from a different point of view, one in which nature and its spectators play interrelated roles.

In capturing on canvas the bleak but impressive scene portrayed in *Watching the Breakers—A High Sea*, Homer employed appropriately simple but subtle methods. He drew on years of experience working within the limits of black-and-white engravings to simplify and clarify his design, using a clear-cut pattern of forms with lucid outlines, relatively flat tonal areas, and an effective juxtaposition of contrasting values to intensify the composition's visual impact.

Watching the Breakers expressed his position in a way that was both personal and exceptional. Only an extraordinary storm would have attracted viewers at this deserted time of year. Homer undoubtedly would have been among them, if not actually alone. He doubtless witnessed, with or without company, many storms of the magnitude of the tempest depicted in *Watching the Breakers*, with high seas driving in at eye level to burst into huge clouds of spray against the rocks. Through his painting he seems to have been declaring that this was a sight more people should see. Through art he extended an invitation to enjoy the display without the attendant physical cost, much like the rare climber who can describe what the world looks like from the top of Mount Everest. In either case the reward to nonpresent viewers is of a lesser order, but it is available permanently and, with the use of some imagination, is not a negligible experience.

For his color scheme Homer employed almost neutral tones suitable to the stark days of winter, with its gray, overcast sky, but relieved its

sobriety with a few accents, as he had done in his earlier *Watching the Breakers* (pl. 1). The spectators, two men and a woman with their backs to the viewer, are accentuated by the dark coat and red hood of the female figure and the oilskins of the men. In organizing his spatial design Homer carried the viewer's eye into the distance by means of a series of simple bands. There is, however, an underlying subtlety in the arrangement of the receding planes. Rather than retreating in simple parallel lines, they diverge gradually from the sloping line of the cliff to the horizontal surface suitable to the distant waves. This is picture making of a high order. With this composition Homer completed one of his final major presentations of winter on the coast of Maine.

Through the medium of the four major oils Homer completed at Prout's Neck in 1896, he demonstrated again his range of interest in different subjects and his ability to provide appropriate color schemes. Each color design was suitable for a nocturne, a sunset, an autumn storm, or a wintry tempest. In each case Homer took his cue from nature but added his own command of color organization to make the canvases intrinsically and artistically harmonious to their subjects, which is the essence of artistic control.

NOTES

1. Mrs. Addie Kaler Vaill to author.
2. Charles Lowell Homer to author.
3. Cox, pp. 51–52. Cox admired Homer's strength and honesty but regarded his execution as "too strident" and "too crude" (p. 40). In appraising the artist's color he stated: "If Homer was never extraordinarily sensitive to color, there is some evidence that in his late days he became partially color-blind" (pp. 51–52). The evidence Cox refers to is *The Gulf Stream* (pl. 8): "He may well have added the unexplained and unrelated touch of pure scarlet on the stern of the boat at the time when his sight was beginning to fail" (p. 52). Fortunately, these contemporary opinions have long since been reversed.
4. Homer to Thomas B. Clarke, December 9, 1896, quoted in Beam, pp. 150–51.
5. Unsigned review, Pittsburgh *Dispatch*, December 6, 1896, clipping, Homer scrapbook, Bowdoin College Museum of Art, Brunswick, acc. 1964.69.185.
6. Richard Muther, *The History of Modern Painting* (London and New York: J. M. Dent, 1907), vol. 4, pp. 313–14.
7. Homer to Charles Homer, Jr., and Mattie Homer, December 10, 1896, Bowdoin College Museum of Art, Brunswick, acc. 1964.69.64.

During the summer of 1897 Homer returned to the rugged environment of Quebec province, which was becoming one of his favorite haunts, to fish and paint some of his boldest watercolors. Back at Prout's Neck in September for the fall months, he painted two important oils: *Wild Geese in Flight* (fig. 52) and *A Light on the Sea* (fig. 64). He took time out in October to visit his friend John W. Beatty in Pittsburgh and attend the annual exhibition at the Carnegie Institute.

In the large canvas *A Light on the Sea,* Homer underscored another of his perennial interests. He had been enamored of effects of light long before he settled at Prout's Neck, painting *A Summer Night* (pl. 6) and entitling the first of the pure marines he executed there *Sunlight on the Coast* (pl. 12). Light was a prominent feature of *Eight Bells* and *The Herring Net* and played a leading role in *Early Morning after a Storm at Sea*. Homer even made artificial illumination a key element in *The Fountains at Night, World's Columbian Exhibition, Chicago* of 1893, when electric lighting was used to glamorize the world's fair (fig. 50). And he used it later to spectacular effect in *Searchlight, Harbor Entrance, Santiago de Cuba* (1901; Metropolitan Museum of Art, New York).

In *A Light on the Sea*, illumination shares the picture area with a large human image, one of the larger figures that perpetuated Homer's memories of the fisherwomen of England's North Sea coast. The model was Ida Meserve Harding, who had posed for *The Fisher Girl* (pl. 11) in profile, looking out over a mist-enshrouded sea. Here she is positioned frontally but looking aside, in *contraposto*, with her strong arms thrust outward at balanced angles. She stands to the left of the design's center but looks toward the right, in one of Homer's favorite asymmetrical designs.

Both the figure's angular posture and the sharp light on the horizon play important parts in the design. The dark, upright woman complements the strong horizontality of the rocky base on which she stands and the clearly defined horizon. By using these devices Homer stressed the three-dimensional form of her body. The lone seagull gliding across the upper canvas makes a simple but neat contribution to the composition. Though the rocky setting seems generic, it represents a formation Homer knew intimately. It was within a short distance of his studio, and he fished from it frequently.

Through his longtime interest in the intangible, moving, and seemingly infinite elements of nature, light, and atmosphere, Homer allied himself with the Impressionists who were his contemporaries. But he was never willing to go to the extremes they adopted. Trained in the clear outlines of engraving and a master of three-dimensional modeling by the 1870s, Homer was never willing to sacrifice the substantial world for the transitory. Rather, when he painted his marines it was essential for him to balance the elements of rocks, waves, and human figures.

A Light on the Sea is therefore another illustration of Homer's respect for equilibrium. A variation on a continuing theme, it is not unlike Cézanne's redressing of the extremes of Impressionism in the 1890s. Homer appears to have meant this painting to be a significant statement, for he assigned it large dimensions and made the human subject one of his most commanding examples. This emphasis was timely, because he would eventually end his tributes to the fisher girls of Cullercoats.

When Homer exhibited *A Light on the Sea* for the first time, at the Carnegie Institute, Pittsburgh, in October 1897, and made one of his few appearances as a juror, in deference to his friend John W. Beatty,[1] critics thought his model vulgar and stiffly posed. The picture met with the same reception in February 1898 at one of the exhibitions at the Union League Club in New York. The Corcoran Gallery of Art, Washington, D.C., finally bought it for twenty-five hundred dollars for its permanent collection in 1907.

NOTE

1. In a letter dated October 6, 1887, Beatty invites Homer to serve on a jury scheduled to meet on October 14 (Bowdoin College Museum of Art, Brunswick, acc. 1964.49.14).

1898–99

During 1898 Homer traveled widely, especially in the tropics, where he painted some of his best-known watercolors, including *Rum Cay*, *Turtle Pound*, *Hurricane, Bahamas* (Metropolitan Museum of Art, New York), and *Natural Bridge, Nassau* (Metropolitan Museum of Art). His father died in August at eighty-nine, the same age as his grandfather.

In 1899 Homer visited Nassau and Bermuda again and finished *Sloop, Bermuda* and *Flower Garden and Bungalow* (both Metropolitan Museum of Art, New York) and other noted watercolors during the winter. He painted relatively few pictures in oil but stayed at Prout's Neck late in the year to finish one of his most celebrated canvases, *The Gulf Stream* (pl. 8). A highlight of that year was the sale of the collection of Thomas B. Clarke, who had accumulated thirty-one paintings by Homer, the largest group ever acquired by one patron.

A letter Homer wrote to his brother Charles on November 25 reveals some of his thoughts as the century ended and he reflected on his life at age sixty-three. Unlike his father, Homer was not a formally religious person and rarely entered Saint James Episcopal Church, which was about seventy yards from his studio. But he did have a personal credo inspired by his love of nature and his feeling for the larger mysteries of life, which he expressed to Charles: "I am so very thankful for all *'His Mercies'*—that I now write to you. There is certainly some strange power that has some overlook on me & directing my life. That I am in the right place at present there is no doubt about—as I have found something interesting to work at—in my own field—& time & place & material to do it."[1]

NOTE

1. Homer to Charles Homer, Jr., November 25, 1899, Bowdoin College Museum of Art, Brunswick, acc. 1964.69.125b.

1900

32. *On a Lee Shore*, 1900
Oil on canvas, 39 × 39 in. (99.1 × 99.1 cm)
Signed, lower left: *Homer*
Museum of Art, Rhode Island School of
Design, Providence. Jesse H. Metcalf Fund
Plate 18; Figure 74

The year 1900 was a propitious one for Homer
and his family. When he exhibited *A Summer
Night* (pl. 6) at the Exposition Universelle in
Paris, the jury for the Fine Arts Section awarded
him a gold medal. More important still, the
French government purchased the picture for its
national collections. This was the most pres-
tigious recognition Homer had received to date,
and it made his name known internationally.

The year marked another turning point for
Homer, concluding a remarkable decade now
regarded as the climax of his career. Although
not dramatic, changes did occur. During this
productive year he created several major works,
notably *On a Lee Shore* and *Eastern Point* (pls.
18, 13). Thereafter he did not feel pressed to work
as continuously as he had through the previous
decades. Having been awarded international ac-
claim, he probably felt that he had earned the
right to relax unless the creative spirit moved
him.[1] He continued to travel, paying special
visits to Canada and the tropics, and painted
some of his best watercolors in these contrasting
locales.

In *On a Lee Shore* Homer expressed interests
that had occupied his mind for many years.
Ostensibly, the picture represents the period
when late summer squalls herald the autumnal
storms that batter the oceanfront at Prout's Neck.
Not a pure marine, this composition contains a
two-masted schooner sailing eastward over the
distant waves, apparently safe from the formida-
ble rocks in the foreground.

This was a scene Homer had witnessed many
times as ships regularly sailed between Boston
and Portland harbor. When the swells were high
and breakers sent up the clouds of spray shown
in the canvas, the boats would sail inside of

Stratton's Island for protection but would maneu-
ver as far as possible from the promontory of
Prout's Neck. Hence the two-sided meaning of
"lee" in the title: a sheltered place or an onshore
wind.

From the time he settled on the Neck, Homer
recognized that it was more than a source of
pictorial motifs or a convenient place to watch
sunsets or moonlit seas. The New England coast
was the most dangerous for shipping of all of
America's shorelines. Observation taught Homer
that Prout's Neck was one of the most hazardous
areas of all. He announced that fact in the first
major oil he completed there, the dramatic *Life
Line* of 1884 (fig. 3), and continued the warning
in one of his last watercolors, *The Wrecked
Schooner*, based on the destruction of the
Washington B. Thomas on Stratton's Island. The
passage between these two land masses, so in-
viting for pleasure boats during the calm sum-
mer, was also a potential graveyard for ships, as
Homer reported in *The Wreck* (pl. 4).

The vessel that struggles along proudly in the
distance in *On a Lee Shore* appears small, but it

Figure 74 (no. 32).*

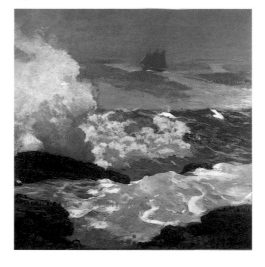

is a symbol of something Homer had long ad-
mired. His pictures demonstrate that he had a
lifelong love affair with boats of all kinds—from
rowboats and scows through canoes, dories,
skiffs, sloops, and schooners. He even included
a Venetian-style gondola in *The Fountains at
Night, World's Columbian Exhibition, Chicago*
(fig. 50). He was especially fond of the graceful
shapes of canoes and sailboats and the way they
rested on the water or glided over it. He admired,
too, the ability of those who could maneuver
them through dangerous waters, as he showed in
his pictures of guides shooting the white-water
rapids of the Saguenay River in Canada.

When Homer represented sailboats in action,
he must have felt a twinge of nostalgia, for the
days of such boats were numbered. The glory of
New England when clipper ships rounded the
globe, they were steadily being replaced at the
turn of the century by the smoke-belching steam-
boats of a new era. Though Homer traveled on
steamboats, he only depicted a few. His senti-
mental favorites continued to be ships with
masts and sails manned by seamen and fisher-
men of the old school.

These and similar thoughts gave more than
passing meaning to Homer's sighting of a boat
tacking between Stratton's Island and Prout's
Neck on a stormy day, following it to safety, and
making it the subject of *On a Lee Shore*. Along
with *Kissing the Moon* this is one of his last
salutes in oil to the bravery of people who over-
came the perils of the sea.

When Homer showed *On a Lee Shore* pub-
licly for the first time, at the O'Brien Gallery in
Chicago, a visitor thought the rock formations
were similar to those in *Maine Coast* and asked
whether the picture was a replica. Homer replied
that he had only painted one replica in his whole
career: the watercolor *A Voice from the Cliffs*,
which he had based on his canvas *Hark! The
Lark!* O'Brien sold *On a Lee Shore* to Dr. F. W.
Gunsaulus, president of the Armour Institute
of Technology, in 1900. The following year
Gunsaulus lent the picture to the Museum of

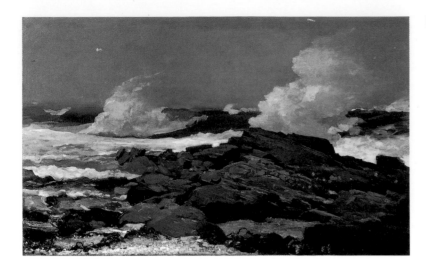

Figure 75 (no. 33).*

Homer—*Prout's Neck, Winter of 1897–98* (Bowdoin College Museum of Art, Brunswick) that it had met its fate among the lobsters. Not only had spray clouded the window, but the rocks made any hauling of the sled around the Neck impossible.[3]

Homer owned Eastern Point, having acquired it in an exchange of properties with his brother Arthur, in September 1898. Even before he became its owner he had seen the site's pictorial possibilities, especially at high tide. One of the earliest watercolors he painted at Prout's Neck was *Surf at Eastern Point* (private collection). His favorite mare's tails are the only hint in that picture of the weight and power of the waves which he would bring to vigorous culmination in *Eastern Point*, his final tribute to that extremity of the Neck.

Art of the Rhode Island School of Design, Providence, for an exhibition, and that institution bought it for its permanent collection.

33. *Eastern Point*, 1900
Oil on canvas, 30½ × 48½ in. (76.8 × 123.2 cm)
Signed and dated, lower right: *Winslow Homer / Oct. 14th 1900*
Sterling and Francine Clark Art Institute, Williamstown, Massachusetts
Plate 13; Figure 75

For the two other canvases he painted in 1900, Homer returned to pure marines. *Eastern Point* represents a stormy day, and *West Point, Prout's Neck* (pl. 14) is his last depiction of a sunset.

In the center of the dramatic *Eastern Point*, surrounded by churning waves, is Black Rock, a formation just offshore from the eastern end of the Neck and its termination at the end of South Cove (fig. 76). The picture might be perceived as a portrait of that low-lying, perpetually sea-washed ledge. In this regard Homer had precursors in William Haseltine, who painted Indian Rock at Narragansett, and William Trost Richards of Newport, who combined surf and rocks in the manner Homer brought to full development, though neither felt the power of the sea as deeply as he did. Haseltine's and Richards's ocean was one of calm beauty and gently breaking waves.

Homer's biographer William Howe Downes believed that Homer painted *Eastern Point* from his "portable painting-house."[2] Charles Lowell

Homer corrected this misunderstanding. He explained that the artist's well-meaning brother Charles had presented him with a small shed mounted on floatlike runners. Although Homer may have attempted to use it, he reported in a humorous ink sketch of 1898 entitled *Bachelor*

34. *West Point, Prout's Neck*, 1900
Oil on canvas, 30¹⁄₁₆ × 48⅛ in. (76.3 × 122.2 cm)
Signed and dated, lower right: *Homer 1900*
Sterling and Francine Clark Art Institute, Williamstown, Massachusetts
Plate 14; Figure 77

Figure 76. *Eastern Point, Prout's Neck, Maine, Showing Black Rock at High Tide*, 1955. Photograph by Philip C. Beam.

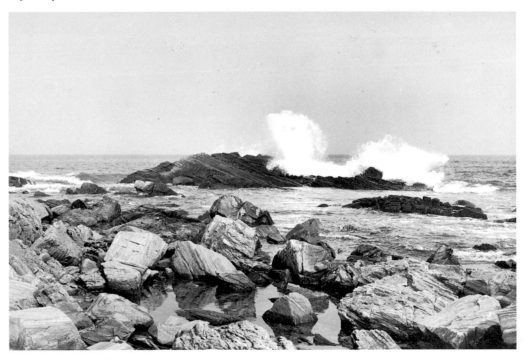

For his other pure marine of 1900, Homer painted *West Point, Prout's Neck*. It was an appropriate pendant to *Eastern Point* (pl. 13), for the rocky face of Prout's Neck ends on the west, as it does on the east, in ledges that merge into Checkley Point, where the famous Checkley House once stood.

In this brilliant, colorful canvas Homer depicted, beyond the dark foreground ledges, the flat stretch of Saco Bay and distant beaches of Pine Point and Old Orchard beneath a sky illuminated by a flaming sunset. The technical boldness with which he painted this oil was based on a confidence that came from years of experience and a refined command of design. The waves churning between the rocks have been translated into conventions he had evolved to convey a striking but simplified impression.

Like the best of the Japanese masters, Homer was able to sacrifice reality, even physical possibility—as in the sinuously curling plume of spray—for aesthetic effect without seeming implausible. Our minds tell us that a wave could not behave like this, but the design is so delightful that we feel it should.

In describing how *West Point* evolved in a letter to his dealer Knoedler, Winslow wrote: "The picture is painted fifteen minutes after sunset, not one minute before, as up to that minute the clouds over the sun would have their edges lighted with a brilliant glow of color, but now the sun has got beyond their immediate range and they are in shadow. You can see that it took many days of careful observation to get this, with a high sea and the tide just right."[4] When *West Point* is compared with these words, it is evident why it appears to be at once an example of accurate perception and as decorative and abstract as a Japanese screen. In it Homer combined his interests in design, composition, and the close observation of nature. The first two related him to the masters of Far Eastern painting and calligraphy, and the third, to the Western scientists of his own day. This approach to art placed a special stamp on painting in the later nineteenth century. The picture also contains the suggestion of another international influence, the curvilinear forms of Art Nouveau.

It should not be surprising to find these signs of sophistication in Homer's usually forthright work by 1900. Though he left no written evidence of the fact, he surely must have discussed Japanese art and other stylistic refinements with

Figure 77 (no. 34).*

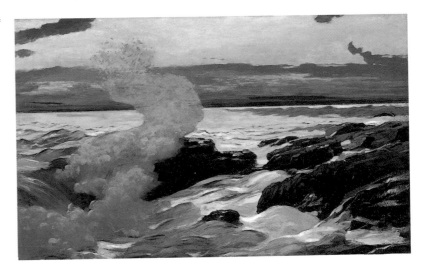

John La Farge at more than one of their meetings.[5] Even before La Farge visited the Orient in 1886 and 1890, he not only had collected Japanese works of art—especially the ukiyo-e prints of Hiroshige and others, which Homer could have seen—but, as Henry Adams has shown, had discerned the principles of logical balance underlying asymmetrical Japanese designs.[6]

The union of style and realism Homer applied in *West Point* was not invariably appreciated when he painted it, and he was unable to sell the picture in his lifetime. Offered for sale by the Babcock Gallery of New York as late as 1942, it now resides in the same collection as *Eastern Point*.

It was fitting that Homer should entitle one of his last marines in oil *West Point*, for it was that area of the Neck which he had first explored and painted some seventeen years before. By completing *West Point* and *Eastern Point* in 1900, Homer created pictorial parentheses for the whole promontory of Prout's Neck. Although the cliffs were only one-half mile in length, within that extent there was an almost bewildering variety of formations, inlets, clefts, and undulating crests. From these Homer increasingly selected those configurations that lent themselves to pictorial designs. Giving them such titles as *High Cliff*, *Cannon Rock*, and *Eastern Point, Prout's Neck*, he endowed them with both specific and general associations with their sources.

Homer took ten years to complete these representations of the cliffs, a culminating decade

based on years of tireless observation and activity. Whether one visits Prout's Neck today and sees it through his eyes or perceives its high points indirectly through his pictures, the union of natural attractiveness and profound interpretation offers a great, unique, and enduring personal gift. It is almost impossible to imagine another artist who would have accepted the hardships and solitude he regularly endured to achieve it.

NOTES

1. When Mattie Homer commissioned Boyer Gonzales to paint a watercolor of Winslow in a characteristic pose about 1900, Gonzales depicted him fishing from the rocks at Prout's Neck, as he did whenever he was free. Although the watercolor is no longer extant, a photograph of it is on file at the Bowdoin College Museum of Art, Brunswick.

2. Downes, pp. 176–77.

3. Winslow Homer, *Bachelor Homes—Prout's Neck, Winter of 1897–1898*. Ink on paper. Bowdoin College Museum of Art, Brunswick 1964.69.81. The artist depicted his portable painting house overrun by lobsters. The story of the portable studio was related to the author by Charles Lowell Homer circa 1938.

4. Winslow Homer to Knoedler, quoted in Lloyd Goodrich, *Winslow Homer* (New York: Macmillan Co. for the Whitney Museum of American Art, 1944), p. 165.

5. An illuminating consideration of Homer's relation to Japanese art and the role of his friendship with John La Farge can be found in Sally Mills, *Japanese Influences in American Art, 1853–1900* (Williamstown: Sterling and Francine Clark Art Institute, 1981).

6. Henry Adams, "A Fish by John La Farge," *Art Bulletin* 65, no. 2 (June 1980), p. 178.

Selected Bibliography

Adams, Henry. *The Education of Henry Adams: An Autobiography*. 1907. Reprint. Dunwoody, Georgia: Norman S. Berg, 1975.

Adams, Henry. "Mortal Themes: Winslow Homer," *Art in America* 71 (February 1983): 112–26.

Arnheim, Rudolf. "On the Late Style." In *New Essays on the Psychology of Art*, 285–93. Berkeley, Los Angeles, and London: University of California Press, 1986.

"Artists' Studios." *Art Journal* [London], n. s. 19 (1880): 249–52.

"Artists' Studios." *Art Journal* [London], n. s. 20 (1881): 109–12.

Baldinger, Wallace S. "The Art of Eakins, Homer, and Ryder: A Social Re-evaluation." *Art Quarterly* 9 (Summer 1946): 212–33.

Beam, Philip C. *Winslow Homer at Prout's Neck*. Boston and Toronto: Little, Brown and Company, 1966.

———. *Winslow Homer at Prout's Neck*. Exh. cat. Brunswick: Bowdoin College Museum of Art, 1966.

———. "Winslow Homer's Father." *New England Quarterly* 20 (March 1947): 51–74.

———. *Winslow Homer Watercolors*. Exh. cat. Brunswick: Bowdoin College Museum of Art, 1983.

Berman, Avis. "Historic Houses: Winslow Homer at Prout's Neck—Exalted by a Rugged Coast." *Architectural Digest* 41 (July 1984): 136–44.

Blaugrund, Annette. "The Tenth Street Studio Building: A Roster, 1857–1895." *American Art Journal* 14 (Spring 1982): 64–71.

———. "The Tenth Street Studio Building." Ph.D. diss., Columbia University, 1987.

Boime, Albert. "Blacks in Shark-Infested Waters: Visual Encodings of Racism in Copley and Homer." *Smithsonian Studies in American Art* 3, no. 1 (Winter 1989): 18–47.

Bolton, Theodore. "The Art of Winslow Homer: An Estimate in 1932." *Fine Arts* 18 (February 1932): 23–27.

Boon, John. "An American Artist in Cullercoats." *America in Britain* 20 (1982): 5–10.

Boyesen, Hjalmar Hjorth. *Literary and Social Silhouettes*. New York: Harper and Brothers, 1894.

Brief Account of the Family of Homer or de Homere, of Ettingshall, County Stafford, England, and Boston, Massachusetts. Albany, New York: Joel Munsell's Sons, 1889.

Brinton, Christian. "La Peinture américaine moderne." *L'Art et les artistes* (October 1912): 13–22.

———. "Winslow Homer." *Scribner's* 49 (January 1911): 9–23.

Bruce, Robert V. *The Launching of Modern American Science*. New York: Alfred Knopf, 1987.

Caffin, Charles. "American Painters of the Sea." *Critic* (December 1903): 548–61.

———. *The Story of American Painting*. New York: Frederick A. Stokes, 1907.

Canby, Henry Seidel. *The Age of Confidence: Life in the Nineties*. New York: Farrar and Rinehart, circa 1934.

Catalogue of a Loan Exhibition of Paintings by Winslow Homer. Exh. cat. New York: Metropolitan Museum of Art, 1911.

Centenary Exhibition of Works by Winslow Homer. Exh. cat. Pittsburgh: Department of Fine Arts, Carnegie Institute, 1937.

Champney, Lizzie W. "The Summer Haunts of American Artists." *Century* 30 (1885): 845–60.

Chase, J. Eastman. "Some Recollections of Winslow Homer." *Harper's Weekly* 54 (October 22, 1910): 13.

Chevreul, Michel. *The Principles of Harmony and Contrast of Colors and Their Application to the Arts, by M. E. Chevreul. With a Special Introduction and Explanatory Notes by Faber Birren*. 1839. Reprint. New York, London, and Amsterdam: Reinhold Publishing Corporation, 1967.

Child, George Chaplin, M.D. *The Great Architect: Benedicite; Illustrations of the Power, Wisdom, and Goodness of God, as Manifested in His Works*. 2 vols. in 1. New York: G. P. Putnam and Sons, 1871.

Cikovsky, Nicolai, Jr. "Homer around 1900." *Studies in the History of Art* 26 (Washington, D.C.: National Gallery of Art, 1990).

Coffin, W. A. "Painter of the Sea." *Century* 58 (September 1899): 651–54.

Cohn, Marjorie B. *Wash and Gouache: A Study of the Development of the Materials of Watercolor*. Cambridge, Mass.: Fogg Art Museum, Harvard University, 1977.

Cook, Clarence. *Art and Artists of Our Time*. 3 vols. New York: Selmar Hess, 1888.

Cooper, Helen. *Winslow Homer Watercolors*. New Haven and London: Yale University Press for the National Gallery of Art, 1986.

Cox, Kenyon. "The Art of Winslow Homer." *Scribner's* 56 (September 1914): 377–88.

———. *Winslow Homer*. New York: Frederic Fairchild Sherman, 1914.

Curry, David Park. *Winslow Homer: The Croquet Game*. Exh. cat. New Haven: Yale University Art Gallery, 1984.

Davis, Melinda Dempster. *Winslow Homer: An Annotated Bibliography of Periodical Literature*. Metuchen, New Jersey: Scarecrow Press, 1975.

Dinnerstein, Lois. "Artists in Their Studios." *American Heritage* 34 (February/March 1983): 81–89.

Downes, William Howe. "American Painters of the Sea." *American Magazine of Art* 23 (November 1931): 360–74.

———. *The Life and Works of Winslow Homer*. Boston and New York: Houghton Mifflin Company, 1911.

——— and Frank Torrey Robinson. "Later American Masters." *New England Magazine* (April 1986): 131–51.

Flexner, James Thomas. *The World of Winslow Homer*. New York: Time, 1966.

Fowler, Frank. "An Exponent of Design in Painting." *Scribner's* 33 (May 1903): 638–40.

Gardner, Albert Ten Eyck. *Winslow Homer, American Artist: His World and His Work*. New York: Clarkson N. Potter, 1961.

Gerdts, William H. "Winslow Homer in Cullercoats." *Yale University Art Gallery Bulletin* 36 (Spring 1977): 18–35.

Goodman, Walter. "Artists' Studios: As They Were and As They Are—I." *Magazine of Art* 25 (June 1901): 357–62.

Goodrich, Lloyd. *American Watercolor and Winslow Homer*. Exh. cat. Minneapolis: Walker Art Center, 1945.

————. *The Graphic Art of Winslow Homer*. Exh. cat. New York: Museum of Graphic Art, 1968.

————. "Realism and Romanticism in Homer, Eakins, and Ryder." *Art Quarterly* 12 (Winter 1949): 17–29.

————. *Winslow Homer*. New York: Macmillan Co. for the Whitney Museum of American Art, 1944.

————. *Winslow Homer Centenary Exhibition*. Exh. cat. New York: Whitney Museum of American Art, 1936.

———— and Abigail Booth Gerdts. *Winslow Homer in Monochrome*. Exh. cat. New York: M. Knoedler and Co., 1986.

Gorer, Geoffrey. *The American People: A Study in National Character*. New York: W. W. Norton and Company, 1948.

Gorren, Aline. "American Society and the Artist." *Scribner's* 26 (November 1899): 628–33.

Graham, Lois Homer, "An Intimate Glimpse of Winslow Homer's Art." *Vassar Journal of Undergraduate Studies* 10 (May 1936): 1–16.

"A Great Painter of the Ocean." *Current Literature* (July 1908): 54–57.

Gregg, Richard N. *The Artist's Studio in American Painting, 1840–1983*. Exh. cat. Allentown, Pennsylvania: Allentown Art Museum, 1983.

H., L. L. "The Brushians: A Sketch of Genial Sketchers." *Pine Tree Magazine* 5 (April 1906): 213–23.

Hendricks, Gordon. *The Life and Work of Winslow Homer*. New York: Harry N. Abrams, 1979.

Hess, Thomas. "Come Back to the Raft Ag'in, Winslow Homer Honey." *New York Magazine* (June 11, 1973): 75–76.

"Historic Properties Survey: Prout's Neck." Maine Historic Preservation Commission, Augusta, Maine [1988].

Hoeber, Arthur. "Winslow Homer, A Painter of the Sea." *World's Work* (February 1911): 1409–17.

Holland, Rupert Sargent. *The Story of Prout's Neck*. Prout's Neck: Prout's Neck Association, [circa 1924].

Homer and the Sea. Exh. cat. Richmond: Virginia Museum of Fine Arts, 1964.

Hoopes, Donelson F. *Winslow Homer Watercolors*. New York: Watson-Guptil, 1969.

Howells, William Dean. *The Landlord at Lion's Head*. New York and London: Harper and Brothers, 1896.

Hungerford, Edward. "Our Summer Migration." *Century* 20 (1891): 567–76.

Huth, Hans. *Nature and the American: Three Centuries of Changing Attitudes*. Berkeley and Los Angeles: University of California Press, 1957.

Ingalls, Hunter. "Elements in the Development of Winslow Homer." *Art Journal* 24 (Fall 1964): 18–22.

Isham, Samuel. *History of American Painting*. New York: Macmillan, 1905.

James, Henry. *The American Scene*. New York and London: Harper and Brothers, 1907.

————. "On Some Pictures Lately Exhibited." *Galaxy* (July 1875): 90–94.

Knipe, Tony, et al. *Winslow Homer: All the Cullercoats Pictures*. Exh. cat. Sunderland, England: Northern Centre for Contemporary Art, 1988.

Konolige, Kit and Frederica. *The Power of Their Glory—America's Ruling Class: The Episcopalians*. New York: Wyden Books, 1978.

La Farge, John. *Considerations on Painting*. New York and London: Macmillan, 1900.

Landscape in Maine, 1820–1970: A Sesquicentennial Exhibition. Exh. cat. Waterville, Maine: Colby College Art Museum, 1970.

Libby, Dorothy Shaw. *Scarborough Becomes a Town*. Freeport, Maine: Bond Wheelwright Company, 1955.

Locke, John Staples. *Shores of Saco Bay: A Historical Guide to Biddeford Pool, Old Orchard Beach, Pine Point, Prout's Neck*. Boston: J. S. Locke, 1880.

McAllister, Ward. *Society as I Have Found It*. New York: Cassell Publishing Co., circa 1890.

Macbeth, Robert. *Winslow Homer*. Exh. cat. New York: Living American Art, 1936.

Macdonald, William. "A State of Summer Resorts." *Nation* 65 (August 19, 1897): 145–46.

Maury, Matthew Fontaine. *The Physical Geography of the Sea*. New York: Harper and Brothers, 1855.

Mechlin, Leila. "Winslow Homer." *International Studio* 34 (June 1908): 125–29.

Mills, Sally. *Japanese Influences in American Art, 1853–1900*. Exh. cat. Williamstown, Massachusetts: Sterling and Francine Clark Art Institute, 1981.

Morton, Frederick W. "The Art of Winslow Homer." *Brush and Pencil* 10 (April 1902): 40–54.

Moulton, Augustus F. *Old Prout's Neck*. Portland, Maine: Marks Printing House, 1924.

Munson, Graham. "Winslow Homer of Prout's Neck, Maine." *Dalhousie Review* 97 (Summer 1967): 222–34.

Muther, Richard. *The History of Modern Painting*. 4 vols. London and New York: J. M. Dent, 1907.

Newton, Roger Hale. "Our Summer Resort Architecture—An American Phenomenon and Social Document." *Art Quarterly* (Autumn 1941): 292–318.

Nichols, H. Hobart. *Fine Arts Exhibit, United States of America, Paris Exposition, 1900*. Exh. cat. New York: Noyes, Platt and Company, 1900.

Pach, Walter. "Winslow Homer et la signification de son oeuvre." *L'Art et les artistes* (November 1912): 73–79.

Peppiatt, Michael, and Alice Bellony-Rewald. *Imagination's Chamber: Artists and Their Studios*. Boston: Little, Brown and Company—A New York Graphic Society Book, 1982.

Phillips, Sandra S., et al. *Charmed Places: Hudson River Artists and Their Houses, Studios, and Vistas*. New York: Harry N. Abrams in association with the Edith C. Blum Institute, Bard College, and the Vassar College Art Gallery, 1988.

Porter, Fairfield. "Portraits of Americans: Homer." In Rackstraw Downes, ed. *Fairfield Porter: Art on Its Own Terms. Selected Criticism, 1939–1975*. New York: Taplinger, 1979.

Prouts Then and Now, 1888–1970. Portland, Maine: Prouts Neck Association, 1971.

Prown, Jules. "Winslow Homer in His Art." *Smithsonian Studies in American Art* 1, no. 1 (Spring 1987): 31–45.

[Ransom, Susan]. "Stevens Gift of Winslow Homer Letters." *Between the Lions: The Newsletter of the Bowdoin College Museum of Art* 9 (Spring 1989): 1–2.

"Record of Deeds," 1883–1910. Cumberland County Court House, Portland, Maine.

"A Residence at Prout's Neck, Maine." *Scientific American Building Monthly* (July 1904): 6, 17.

Reuterdahl, Henry. "Winslow Homer: An Appreciation from a Sea-Going Viewpoint." *Craftsman* 20 (April 1911): 8–17.

Rosenthal, Gertrude, ed. *From El Greco to Pollock: Early and Late Works by European and American Artists*. Exh. cat. Baltimore: Baltimore Museum of Art, 1968.

The Scarboro Register—1905, Compiled by Mitchell and Campbell. Brunswick, Maine: H. E. Mitchell Co., 1905.

Scully, Vincent, Jr. *The Shingle Style and the Stick Style: Architectural Theory and Design from Richardson to the Origins of Wright*. New Haven and London: Yale University Press, 1971.

Seligman, Herbert J. "Bachelor of Maine: Winslow Homer." *Down East* (January 1958): 27–30.

Sheldon, George W. "American Painters—Winslow Homer and F. A. Bridgman." *Art Journal* 4 (August 1878): 227.

————. *Hours with Art and Artists*. 1882. Facsimile. New York and London: Garland Publishing, 1978.

Shettleworth, Earle G., Jr., and William David Barry. *American Domestic Architecture: A Late Victorian Stylebook by John Calvin Stevens and Albert Winslow Cobb*. Watkins Glen, New York: American Life Foundation and Study Institute, 1978.

————. " 'Brother Artists': John Calvin Stevens and Winslow Homer." *Bowdoin* 61, no. 4 (Fall 1988): 16–19.

Simpson, Marc, et al. *Winslow Homer: Paintings of the Civil War*. San Francisco: Bedford Arts Publishers for the Fine Arts Museums of San Francisco, 1988.

Spanton, John, ed. *Chevreul on Colours, or The Laws of Contrast of Colour; And Their Applications to the Arts . . . By M. E. Chevreul. . . .* London: Routledge, Waines, and Routledge, 1859.

Spassky, Natalie. *American Paintings in the Metropolitan Museum of Art, Volume II*. Princeton: Princeton University Press, 1985.

Starkweather, William. "He Painted the Might of the Sea: Winslow Homer, Man and Artist." *Mentor* (July 1925): 45–50.

Stebbins, Theodore, Jr., et al. *A New World: Masterpieces of American Painting, 1760–1910*. Exh. cat. Boston: Museum of Fine Arts, 1983.

Stein, Roger B. *Seascape and the American Imagination*. Exh. cat. New York: Clarkson N. Potter in association with the Whitney Museum of American Art, 1975.

Stepanek, Stephanie Loeb. *Winslow Homer*. Exh. cat. Boston: Museum of Fine Arts, 1977.

Stevens, John Calvin. "Charles Frederick Kimball: An Appreciation of Maine's Greatest Landscape Painter." *Pine Tree Magazine* 5 (April 1906): I–VII.

"The Strange Hermitage of Winslow Homer on the Maine Coast." *Boston Herald*, [1884], clipping, Homer scrapbook, Bowdoin College Museum of Art, Brunswick, acc. 1964.69.185, p. 55.

Strickler, Susan E., ed. *American Traditions in Watercolor*. Exh. cat. New York: Abbeville Press, 1987.

Stuart's Atlas of the State of Maine, 1894–95. South Paris, Maine: J. H. Stuart and Co., 1895.

Tatham, David. *Winslow Homer and the New England Poets*. Worcester, Massachusetts: American Antiquarian Society, 1979.

————. "Winslow Homer at the Front." *American Art Journal* 11, no. 3 (Summer 1979): 86–87.

————. *Winslow Homer's Books: A Descriptive List of Books Once Owned by Winslow Homer and Now the Property of the Margaret Woodbury Strong Museum, Rochester, New York*. Syracuse: Syracuse University, Department of Fine Arts, 1976.

————. "Winslow Homer's Library." *American Art Journal* 9 (May 1977): 92–97.

Van Rensselaer, Mrs. Schuyler. "An American Artist in England." *Century* (November 1883): 13–21.

————. *Six Portraits*. Boston and New York: Houghton Mifflin Company, 1889.

Walsh, John J., Jr. "Winslow Homer: Early Work and the Japanese Print." M.A. thesis, Columbia University, 1965.

Ware, Moses Weld. *Beacon Lights in the History of Prout's Neck*. Scarborough, Maine: Prout's Neck Association, n.d.

Watson, Forbes. "Winslow Homer." *American Magazine of Art* 29, no. 10 (October 1936): 624–37.

Weinberg, H. Barbara. "Thomas B. Clarke: Foremost Patron of American Art from 1872 to 1899." *American Art Journal* 7 (May 1976): 52–83.

Weir, John Ferguson. *The Recollections of John Ferguson Weir, Director of the Yale School of Fine Arts, 1869–1913*. Ed. Theodore Sizer. New York and New Haven: New-York Historical Society and Associates in Fine Arts at Yale University, 1957.

Weitenkampf, Frank. "The Intimate Homer: Winslow Homer's Sketches." *Art Quarterly* 6 (Autumn 1943): 306–21.

Williams, Raymond. *The Country and the City*. London: Paladin, 1973.

Wilmerding, John. *A History of American Marine Painting*. Boston and Toronto: Little, Brown and Company and Peabody Museum of Salem, Massachusetts, 1968.

————. *Winslow Homer*. New York, Washington, and London: Praeger, 1972.

————. "Winslow Homer's Creative Process." *Antiques* 108 (November 1975): 965–71.

————. "Winslow Homer's English Period." *American Art Journal* 7 (November 1975): 60–69.

————. "Winslow Homer's *Right and Left*." *Studies in the History of Art* 9. Washington, D.C.: National Gallery of Art, 1980: 59–85.

"Winslow Homer." *Portland Evening Express and Advertiser*, Saturday, November 12, 1910, clipping, scrapbook, Portland Museum of Art, Maine.

Winslow Homer, 1836–1910: A Selection from the Cooper-Hewitt Collection, Smithsonian Institution. Exh. cat. Washington, D.C.: Smithsonian Institution Press, 1972.

Winslow Homer and the New England Coast. Exh. cat. New York: Whitney Museum of American Art, Fairfield County, 1984.

Winslow Homer: A Retrospective Exhibition. Exh. cat. Boston: Museum of Fine Arts in collaboration with National Gallery of Art and Metropolitan Museum of Art, 1959.

Winslow Homer Drawings, 1875–1885: Houghton Farm to Prout's Neck. Essay by David Tatham. Exh. cat. Syracuse: Joe and Emily Lowe Art Gallery, 1979.

"Winslow Homer Museum Provided for in Widow's Will." *Museum News* 15 (November 1, 1937): 5.

Wood, Peter H., and Karen C. C. Dalton. *Winslow Homer's Images of Blacks*. Exh. cat. Austin: University of Texas Press, 1988.

Wooley, Mary E. "The Development of the Love of Romantic Scenery in America." *American Historical Review* 3 (1897–98): 56–66.

Young, J. W. "The Art of Winslow Homer—America's First Great Outdoor Painter." *Fine Arts Journal* 19 (February 1908): 57–63.

Index

Page numbers in *italics* refer to illustrations.

Photograph Credits

Courtesy Philip C. Beam: figs. 7–11, 13, 16, 18, 42, 44, 62, 69–71, 76

Courtney Frisse: pl. 23

David Henry: pl. 2; fig. 65

Courtesy Lois Homer Graham: fig. 30

Courtesy Kennedy Galleries, Inc., New York: pl. 30

Courtesy Maine Historical Society, Portland: fig. 32

Ken Pelka: pls. 5, 20–22, 26, 27, 33, 35, 36; fig. 54

Richard Stoner: pl. 4; fig. 71

Joseph Szaszfai: fig. 48

Malcolm Varon: pl. 37